Art for the workers

W. L. GUTTSMAN

MANCHESTER UNIVERSITY PRESS
Manchester and New York

distributed exclusively in the USA by St. Martin's Press

ART FOR THE WORKERS

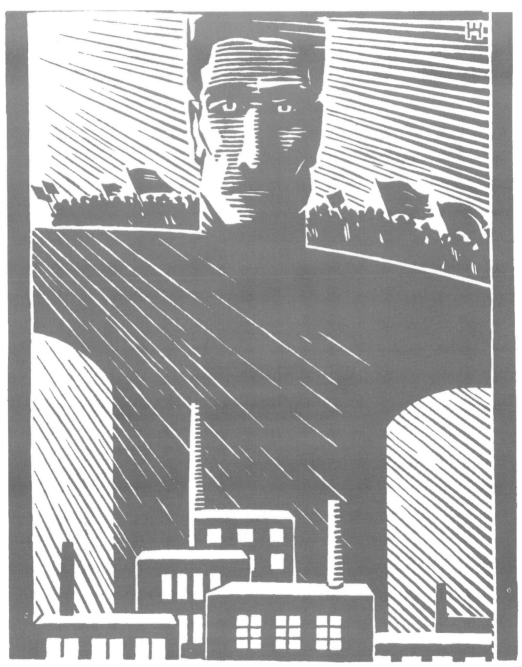

Ideology and the visual arts in Weimar Germany

Published by Manchester University Press
Oxford Road, Manchester M13 9NR, UK
and Room 400, 175 Fifth Avenue, New York, NY 10010, USA

Distributed exclusively in the USA
by St. Martin's Press, Inc., 175 Fifth Avenue, New York,
NY 10010, USA

Distributed exclusively in Canada by
UBC Press, University of British Columbia, 6344 Memorial Road,
Vancouver, BC, Canada V6T 1Z2

British Library Cataloguing-in-Publication Data
A catalogue record for this book is available from the British Library

Library of Congress Cataloging-in-Publication Data
Guttsman, W. L.
 Art for the workers / W. L. Guttsman.
 p. cm.
 ISBN 0–7190–3634–8
 1. Social problems in art. 2. Working class in art. 3. Art—
Political aspects—Germany. 4. Art and revolutions—Germany—
History—20th century. I. Title.
N8243.S65G88 1997
701'.03'094309042—dc21 96–44406

ISBN 0 7190 3634 8 *hardback*

First published 1997
00 99 98 97 10 9 8 7 6 5 4 3 2 1

Set by Graphicraft Typesetters Limited, Hong Kong
Printed in Great Britain
by Redwood Books, Trowbridge

Contents

Plates

Abbreviations

AF *Arbeiterfotograf*
AfSG ASG Archiv für Sozialgeschichte
AIZ *Arbeiter Illustrierte Zeitung*
AK 'Vorwärts und nicht vergessen . . .' Arbeiter Kultur in Hamburg
 1982
ARBKD, ASSO Assoziation der revolutionären Bildenden Künstler
 Deutschlands
BK *Bildende Kunst*
DWJ *Der Wahre Jakob*
HWJ *History Workshop Journal*
IAH Internationale Arbeiter Hilfe
Ifa Interessengemeinschaft für Arbeiterkultur
IWK Internationale Wissenschaftliche Korrespondenz zur Geschichte des
 Sozialismus und der Arbeiterbewegung
KAPD Kommunistische Arbeiterpartei Deutschlands
KPD Kommunistische Partei Deutschlands
MASCH Marxistische Arbeiter Schulen
NZ *Neue Zeit*
Pttg Parteitag
REVOLUTION Revolution und Realismus. Revolutionäre Kunst in
 Deutschland, 1919–1933. Exhibition in Berlin, Staatliche Museen.
 1978
SAJ Sozialistische Arbeiter Jugend
Schmidt Schmidt, D. (ed.), *Manifeste 1905–1933* (Dresden, 1965)
Schneede Schneede, U. M. (ed.), *Die Zwanziger Jahre: Manifeste und
 Documente Deutscher Künstler* (Cologne, 1979)
SM *Sozialistische Monatshefte*
SPD Sozial Demokratische Partei Deutschlands
USPD Unabhängige Sozial Demokratische Partei Deutschlands
V und Z *Volk und Zeit*
WgdW *Wem gehört die Welt: Kunst und Gesellschaft in der Weimarer
 Republic* (Berlin, 1976)

Preface

This is my third book to discuss aspects of the life and politics of the German working class and its institutions. The first was a book on the rise of the German Social Democratic Party and its expansion as a mass organisation from persecuted minority to a party of government. There followed a book on workers' culture in Germany during the period of the Weimar Republic. This dealt with the development and activities of the many cultural and recreational organisations created by the German Labour Movement. They were supported by a large number of workers and have long been recognised to have formed a unique feature of German working-class life already before 1914 and especially in the years of the Weimar Republic.

Before 1914 the system was closely linked with the Social Democratic Party but the split in the German Labour Movement after 1918 into a social democratic and a Communist wing, and the inter-party and intra-party discussion on the role of culture in education and politics, formed a major theme of *Workers' Culture in Weimar Germany*, which was published in 1990.

This ideological and organisational cleavage between a reformist Social Democratic Party (SPD) and a Communist Party which adhered to revolutionary tactics also forms a focal point in the present study. I discuss the visual art which reached German workers in the years 1890–1933 both in terms of established workers' culture and with reference to the role of art in the process of political communication and agitation.

The changing emphasis of successive studies determined the character of the research. The history of the SPD had been fairly extensively covered in the secondary literature, and the relevant material was comparatively easily available. The source material for the present study was not so easily defined and, once defined, it was often not easily accessible.

The research demanded work in German archives, libraries and museums and it often involved tracking down obscure and ephemeral material. A full list of libraries, museums and archives visited is given at the end of this preface. Here I would like to list only two institutions to which I am particularly indebted. In the divided Germany they acted *de facto* as the central collections for German labour history in West and East. They were respectively the Archiv der sozialen Demokratie (ASD) in the Friedrich Ebert Stiftung in Bonn and the collection of book and manuscript material now known as the Archiv der Parteien und Massenorganisationen der ehemaligen DDR, long known under its more partisan name of Institut für Marxismus Leninismus

(IML) in East Berlin. The latter was particularly important for my work, as it houses the archive of the German Communist Party. Like the Ebert Stiftung, it also contains a large library which offered much useful material, including files of illustrated magazines and books.

I was helped by many curators, archivists and librarians who gave me advice and who responded efficiently and speedily to requests by visitors such as myself, whose appetite for books and documents was great and whose time was limited.

Research in Germany nevertheless extended over many summers and the work could not have been accomplished without the support of foundations and other grant-giving bodies. I received help from the Leverhulme Foundation in the form of an Emeritus Fellowship for two years and I also received a research grant from the Berlin Historische Kommission which enabled me to spend time in Berlin in the late summer of 1992.

Last but not least I received much intellectual and visual stimulation from a period as Scholar in Residence in the Rifkind Centre for German Expressionist Studies at the Los Angeles County Museum of Art in 1991. The collection is especially rich in drawings and prints with political themes, and it holds most of the expressionist magazines where many original expressionist drawings first appeared. I am most grateful to the Rifkind Foundation and above all to Mr Robert Gore Rifkind for the award which made this visit possible.

In the course of such periods of research leave I received help and advice from many quarters and from many scholars and experts. They are too numerous to mention individually but I should like to acknowledge my particular indebtedness to some friends and colleagues and colleagues who became friends. They at times smoothed my path, gave me advice and willingly engaged in discussions of matters arising from my research. I list them here in no special order and with their academic or institutional affiliation at that time: Dr Alastair Grieve, University of East Anglia, Professor Richard Evans, London University, Dr Christa Hempel-Küter, Hamburg, Herr Horst Ziska, Dr Rüdiger Zimmermann, Archiv der sozialen Demokratie, Bonn, Dr Ursula Horn, Humboldt Universität and the Akademie der Wissenschaften, Berlin, Dr Horst Groschopp, Humboldt Universität, Berlin, Herbert Pietsch, Editor, *Mitteilungen aus der Kulturwissenschaftlichen Forschung*, Berlin, Herr Heinz Sommers, Archiv der Massenorganisationen und Parteien, Berlin, Dr Henryk Skrzypczak, Historische Kommission zu Berlin, Dr Richard Sheppard, Oxford University, Dr Rainer Noltenius, Fritz Hüser Institut für deutsche und ausländische Arbeiterliteratur, Dortmund. In the course of producing the manuscript of this book I received help from Lotte Hobbis, Alex Luckhurst and Joan Luckhurst and above all from members of my family who advised and assisted me and suffered with me some of the pains of authorship.

Apart from personal and professional contact I should like to acknowledge here with much gratitude the assistance from many academic and other pub-

lic institutions – archives, libraries and museums and galleries. My research and my quest for illustrative material extended over a wide area of Germany and I list the institutions which I visited and where I worked in geographical order. Their staff were not only invariably helpful, they took great trouble to ferret out often obscure pictures and prints and other illustrative material. Berlin: Akademie der Künste (West Berlin), Deutsche Akademie der Künste (DDR), Bauhaus Archiv, Geheimes Staatsarchiv in Berlin Dahlem, Berliner Landesarchiv, Archiv der Staatlichen Museen (DDR), Staatsbibliothek, Historische Kommission (partial archive from ADGB), Deutsches Museum für Geschichte (under DDR Museum für Deutsche Geschichte); Bremen: Staatsarchiv; Dresden: Staatsarchiv; Dortmund: Fritz Hüser Institut; Hamburg: Staatsarchiv, Ernst Thaelmann Gedenkstaette; Potsdam: Staatsarchiv, Landesarchiv; London: British Library of Political Science (London School of Economics), National Art Library (Victoria and Albert Museum), British Library.

FOR JANET AND VALERIE

Art, ideology and the working class 1

'Visual art is the Cinderella among the cultural activities of the German worker.' So wrote Berlin art teacher Otto Greiner in 1929 in *Sozialistische Bildung* (Socialist Journal), a journal devoted to the problems of working-class culture and education.[1] This book will probe this assertion. It will investigate the reception of art in the working-class milieu, but it will cast its net more widely and look at the interplay of the visual arts and at the development of socialist and Communist ideologies and policies.

The political parties and other mass organisations of the Labour Movement used the visual arts to varying degrees in their attempts to broaden the scope of their followers' cultural activities and to raise the cultural awareness of the working class. The two parties of the Left, Social Democrats and Communists, used existing art and, more interestingly, commissioned new art and design to be used for agitation and propaganda. Indeed, we can look at the images projected by them in the political battle as an extension of the written word. At the same time, a number of artists were influenced by left-wing thinking and this, in turn, influenced their art.

The specific link between art and politics has been studied and popularised in the discussion of German avant-garde art. I am concerned here with a relationship between art and politics which parallels that between individual workers and works of art. I shall therefore look at the institutional links between Weimar art and Weimar working-class politics. This, I hope, will open new vistas on the wider question about the effect of art on the character of the individual.

Individuals could be affected by art both through new and existing cultural norms and their own taste and through outside influences, including museums and education. This study will look at the second element, concentrating on documentary evidence on the history and institutions of the Labour Movement and the bodies and individuals connected with it.

The study covers the period from the beginning of the German Labour Movement in the middle of the nineteenth century to the

Nazi takeover of power in 1933. Within this longer period the years of the Weimar Republic, 1918–33, will be at the centre of the discussion. The paintings, drawings, prints, sculpture and, not least, the architecture of these so-called 'golden years' of the Weimar Republic are possibly more original than those of any other recent period. They are especially rich in works of social and political significance.

This committed and engaged art provided a major stimulus for this study,[2] and to my mind it still occupies a salient place in the total artistic creation of the period.[3] It thus constitutes an important background to what is presented here; it does not constitute the starting point. I am looking at the visual arts as objects which the workers may have seen throughout their lifetimes and which may or may not have influenced them.

More specifically, I am concerned with works of art from the point of view of how they were received by German workers and their families, and the potential impression which art may have made on them. This art reached the workers by a variety of channels, including those established by the political parties and other organisations. The latter channels are of special interest in the context of this study.

In the most general terms I also discuss the popularisation of art throughout the working class, both as a potential 'learning process' by workers and as a process of dissemination and popularisation of art and images by their 'educators' and by the 'leaders' and functionaries of the parties and their organisations. Finally I deal with those artists who expressed sympathy with the workers' cause and who supported it, individually or collectively, through their art and occasionally through their writing.

At the most basic and unsophisticated level, the first clear influence of the arts may occur in the home, through its physical environment, its furnishing, decorations and pictures. In practice, the relatively low level of manual workers' earnings and the poor standard of working-class dwellings permitted little choice in furnishings, and even less scope for aesthetic considerations in the selection of furniture, which was largely acquired second-hand.[4]

One area of proletarian domestic life in which aesthetics came to the fore was the custom of displaying prints from series of illustrations produced specially for the home. The illustrations found in working-class homes were commonly known as *Wandschmuck*, literally wall decorations. They were produced in sizeable editions by a few firms specialising in this field, initially for a middle-class market. Prices ranged from less than one Mark to 10 Marks and more. By the middle of the nineteenth century their popularity was enhanced by new colour

printing techniques, chromolithography and oleograph, which permitted the production of large prints and the use of strong colours.

German working-class families followed this custom of decorating their homes. In the second half of the nineteenth century German workers were on the whole well educated and politically mature. Many of them were highly skilled, although compared with British workers their standard of living was relatively low. However, in spite of a low income, the percentage of total family expenditure used for cultural and recreational activities was relatively high. At the beginning of the twentieth century, working-class households with an annual income of under 2,000 Marks spent annually just over 60 Marks on cultural and recreational activities. Three-quarters of this went on newspapers, magazines and membership dues.[5]

These popular prints would be in line with what the worker could afford to buy, and the *Wandschmuck* which found its way into working-class homes was, by all accounts, not significantly different from that in middle-class homes, except that the former bought fewer and cheaper prints.

Figures from south Germany, based on inventories for the period 1850–80, show that the households of artisans and manual workers contained on average 2.5 prints per household compared with 7.4 pictures in the households of civil servants and manufacturers.[6] These figures hide the fact that a significant number of workers' households owned no pictures whatsoever, and the importance of print ownership needs to be tested further. If we look at the prints themselves, they represent a mixture of the merely pretty and the moralistic and exhortatory. They were the creations of commercial artists, working to order; only in a few instances were they copies of original works of art and then often with a new title or in a bowdlerised form.

Among the pictures displayed in the home there were also portrait prints – and later photographs – of national leaders, mostly the Emperor or Bismarck. Some workers would later display portraits of working-class leaders distributed by the Social Democratic Party, above all Karl Marx, Ferdinand Lassalle and August Bebel, alongside their writings. The socialist books would be grouped on a shelf together with the Bible, cheap colportage novels bought from travelling vendors and perhaps Bebel's *Die Frau und der Sozialismus* (Women and Socialism), probably the most popular of all socialist classics.

The prints were genre scenes, animal scenes, landscapes or still lifes. They were virtually all innocuous and hence undemanding and uncontroversial. The pictures which were placed above the living room sofa or above the double bed might show elves dancing in the

moonlight or children playing with a dog or cat. There might also be bucolic scenes – peasants at a dance – or hunting scenes. Only 'the world of daily work' is entirely absent; even artisans and peasants are shown only in a romantic radiance.[7]

Moral exhortations were not absent from the illustrations: trite proverbs were common, effectively inviting devotion and acquiescence. In general the sugary oleograph in its elaborate frame was not expected to make intellectual demands on the viewers or lead them to question the order of things.

We cannot deduce too much from the rather poor data which we have about pictures in workers' homes. The commercial and mass-produced portfolios of prints do not constitute a new folk art, and there is no evidence to suggest that workers bought types of illustrations different from those purchased by others, so that it is difficult to speak of a crystallisation of a working-class taste, let alone of a working-class aesthetics in respect of the visual arts. It would be more accurate to regard the acquisition of *Wandschmuck* as an aspect of the marketplace and of the consumption of goods. This period was experiencing the beginning of a packaging revolution and the growth of advertising, with a first emphasis on design and on the decorative advertisement.[8] Limited income and restricted living space affected the number of pictures in working-class households, but there is no suggestion that politically biased prints replaced the merely popular and pretty.[9]

Political prints were, however, produced in very large editions in the form of double-page illustrations in the annual *Mai Zeitungen*, the broadsheets which the Social Democratic Party issued for the 1 May celebrations. Such prints were also issued separately, and generally in better quality, which suggests that there was demand for these *Schmuckblätter* (pull-out decorative sheets) as illustrations for the home. These large, elaborate and artistic drawings are discussed at length in the next chapter. What is significant is that while they are generally political they are also often strongly decorative, reminding the viewer that May Day was also celebrated as a spring holiday.

This suggests other lines of interpretation of this visual and, apparently, ideological confusion. The contradictory illustrations and opposing symbols in the proletarian home highlight this. They may be the survival of an older set of images and icons, but they may also be cases of 'double loyalty' on the part of sections of the working class. They may involve both community and class, representing communality through shared symbols in the home, such as the framed print and the decorative floral border of the 1 May broadsheet, and an

appeal to class solidarity made through the design in the centre of the drawing and the portrait of the socialist leader.[10]

It is an interesting phenomenon that walls in proletarian homes were decorated with prints which differed from those seen among the bourgeoisie only in quality, not in content. Having such prints might have helped to some extent to form taste but it was not likely to acquaint the worker with the visual arts. This would normally be done within a national system of education by teaching arts subjects at an age when children's minds are receptive to ideas and uncorrupted. In Wilhelmine Germany there was no such teaching.

The failure of the state to offer to the majority of its citizens, who only attended the *Volksschulen*, the elementary schools, an education worthy of the name, such as that offered to the children of the bourgeoisie in the grammar schools, was a major cause of working-class grievance. Although the Labour Movement did not see it as its task to provide basic knowledge, the limitations of the public education system stimulated the desire for the movement to create its own adult education system.

Education to the age of twelve was introduced in Prussia and in most of the German states during the first quarter of the nineteenth century, and it was to contribute greatly to the industrialisation of the country. The *Volksschulen* aimed to create a literate, a numerate and, not least, an obedient workforce which would produce suitable recruits for industry and for the national army based on conscription. The effect of the socialisation of the youth of the nation through the educational system contributed materially to the successful development of German industry and to the victories of the army in the war of 1870/1. Both were able to recruit generations of youths competent in the 'three R's'. The victory of Sedan and the successful struggle for Germany's industrial supremacy in Europe may be attributed to the virtues of the German schoolteacher, wielding cane and drumming in the multiplication tables.

Broadly speaking, working-class education in Germany throughout the nineteenth century was governed by the demands of the state and of the economy. This applied also to the element formally defined as visual art but which usually went by the name of 'Zeichnen', i.e. instruction in drawing. Its principal aim was the dissemination of skills which would be useful for crafts, industry and other forms of employment. The practice lay in the copying and scaling of objects to train the eye and help in future work in industry.

Altogether the general approach to art education was until the end of the nineteenth century formal and 'academic', but this policy was

challenged by a conference in 1901 in Dresden of administrators, teachers and artists who wished to give the subject a much more liberal and original character. In their view instruction in art should be oriented more towards the awakening of aesthetic feeling and to the appreciation of colour and form. Furthermore, the art studied should be the art of more recent years with which the present generation could more easily identify, rather than that of the classical period.

Drawing and other craft skills were to remain central to the instruction in art but they should contribute to the stimulation of feeling and lead to an understanding of art. 'The instruction in drawing should no longer concentrate on the precise reproduction of shapes or of ornaments.' Instead the pupils should be encouraged to observe and reproduce 'the essential and creative aspects of the objects'.[11]

These proposals were supported by art masters and by artists who argued that the stimulation of taste and visual sensitivity would not inhibit the development of mechanical skills and that a more aesthetic approach to art teaching was not contrary to the national interest. It would enrich the life of individuals and enable them to take a full part in the life of the nation.

A weighty warning voice came, however, from one of the senior civil servants present at the conference. Professor Pflinzer, supported by his colleague Professor Thieme, declared that the reformers were in danger of throwing out the baby with the bathwater. They should not forget that the essential aim of the instruction in drawing was to instruct the great masses of the nation and in particular those to be engaged in handicraft, in the essential skills. Teachers, he urged, should heed this and bear it in mind in future discussions.[12]

The new ideas on art education had some influence in a few politically progressive authorities and in the new boarding schools (*Landschulheime*) attended by middle-class children. There is little evidence of their having had an early effect on the education of children in the elementary schools and hence on art education of working-class children. The proletariat and its children were, after all, destined to be the future hewers of wood and carriers of water. They could not be expected to understand the relative grandeur and sophistication of many works of art. The working class could appreciate only simpler and popular works, not masterpieces or grand monuments.[13]

The distinction just made, between the largely informal influence of the visual arts on the individual and the schooling of the senses and the formation of aesthetic taste and sensibility on the one hand,

and the institutionalisation of the visual arts through the medium of the Labour Movement on the other, follows the basic terminological distinction between workers' culture and Labour Movement culture (*Arbeiterkultur* and *Arbeiterbewegungskultur*). This has been widely accepted by modern historians.[14] What we might term a worker's 'visual culture' is less formal and less easily defined and described than other forms of artistic and cultural activities like music and amateur dramatics, which sprang up in the working-class milieu uninfluenced by political practice or even in opposition to it. Such influences go back further than the constitution of workers' political organisations but they also continue after these groups are founded.[15]

It is clearly in respect of taste in the visual arts, rather than in more formally organised cultural activities such as music and drama, that *Arbeiterkultur* and *Arbeiterbewegungskultur*, informal traditions and the activities of workers' cultural organisations, existed and operated side by side. In the visual arts, as in other areas of cultural activities, ideologically committed organisations and individuals would seek to improve the 'low' standard and uncritical visual taste of the broad masses of the working class, including those organised in the Labour Movement.[16] Given the informal character of the formation of taste within the life and leisure-time activities of workers and their families, we have little insight into the original 'primitive' aesthetic views of the majority except in reaction to views specifically introduced. Our analysis must concentrate on the actions of working-class institutions and on the discussions about the role and function of visual art in the Labour Movement.

Such discussions reached their climax during the Weimar Republic, but they go back to the beginning of the movement. From the start the workers' parties put a high price on education and on culture for the workers fighting for their emancipation. The large and vigorous socialist cultural societies and institutions are the outcome of per-spectives linking socialism and culture. Such views help our under-standing of workers' culture, including the culture of the visual arts, and an account of the at times controversial development in this field should help our understanding of the role and function of the visual arts in the Labour Movement.

The ideal of an educated working class was already held by Ferdinand Lassalle, the leader of the General German Workers' Associ-ation, the Allgemeiner Deutscher Arbeiterverein, one of the working-class organisations which in 1875 united with the followers of Bebel and Liebknecht – and through them the followers of Marx and Engels – to form the German Socialist Workers' Party, later known as the

German Social Democratic Party (Sozial Demokratische Partei Deutschlands, SPD). Unlike the negative views on the state held by Marx and Engels, Lassalle's view of the state embodied the whole community. The workers, destined to become the dominant group in the state, were to make themselves moral and cultured in the process. In his *Arbeiterprogramm* (Workers' Programme) addressed to the workers of the Berlin machine-tool manufacturer Borsig, the German labour aristocrats *par excellence*, Lassalle spoke of the quest for the material improvement of the working class, which 'would end with the victory of the idea, the progress of culture and with a flowering of morality such as the world had never seen before'.[17]

The Social Democratic Workers' Party, the party of Bebel and Liebknecht, had strong links with the new Workers' Education Societies, founded largely by progressive sections of the bourgeoisie in conjunction with the political leaders of the working class. *Wissen und Bildung* (knowledge and education), in the widest sense, was conceived not only as a necessary adjunct to political agitation and representation, but also as important for the worker's personal and material development.[18]

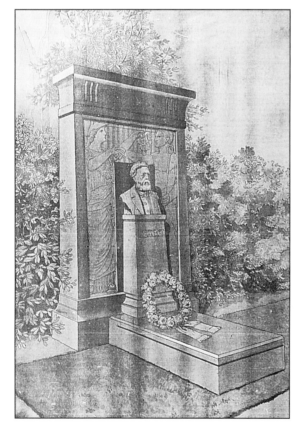

1 Funerary monument to Wilhelm Liebknecht, Berlin (1902)

No one among the early leaders of the social democratic movement can be more clearly identified with the idea that *Bildung* (education) formed an important strand in the development of the German worker than Wilhelm Liebknecht, the joint chairman of the party and the only early leader with a university education. He was a strong believer in the humanist ideals as they had been passed down in the Enlightenment and expressed in the writings of the classical authors. His culture was essentially the high culture of the past as expressed in the writings of the classical philosophers and in the works of the great poets, musicians, painters and other artists. As if to symbolise his humanist beliefs, the monument erected on his grave in Berlin in 1902 was similar to a classical tomb (Plate 1).[19]

In his famous 1873 lecture *Wissen ist Macht, Macht ist Wissen* (Knowledge is power, power is knowledge), Liebknecht spoke of the need of workers to acquire knowledge in order to liberate their class. He equally stressed that only when the working class had been fully liberated could true *Bildung* be attained. The bourgeois state, based on exploitation, could not pursue the genuine ideals of culture; only the socialist state would be a true *Kulturstaat* (cultural state) in which access to education and to the arts would be freely available to all.[20] And although Liebknecht acknowledged the distortion and the limitations of contemporary culture through the class character of bourgeois society, he did not reject many of its values. The slogan of a banner stretched across the back of the hall at the 1896 congress of the Social Democratic Party – 'Socialism is the Bearer of all Culture' – must be seen in the light of such ideas.

The early and rapid political successes of the social democratic movement seemed only to confirm their optimistic beliefs. The united German Socialist Workers' Party had secured almost immediate success at the polls. At the 1877 Reichstag election the SPD increased its popular support by almost one-third and secured the election of thirteen deputies. Its further advance was, however, stymied by the virtual outlawing of the party under Bismarck's anti-socialist legislation of 1878. Elections and electoral propaganda apart, the SPD could not organise meetings or educate its members, except illegally, camouflaging groups as choral societies or reading circles. Only after the repeal of the punitive legislation did the SPD develop into a party able to appeal to the masses.[21]

At the first parliamentary election after the repeal of the anti-socialist laws in 1890 the SPD almost doubled its vote, compared with four years earlier. By 1912 its share of the vote had reached 34 per cent.[22] The 1890s and the first decade of the twentieth century also saw the rise of a whole host of ancillary organisations to the SPD, most of them in the field of cultural and recreational activities. This institutional network with which the SPD surrounded itself was in part an answer to the social isolation and the iron curtain of hostility within which the socialist working class found itself confined. Rather than practise gymnastics under the auspices of the nationalist Deutsche Turnerschaft (German Gymnastics Association) or sing together with members of the bourgeoisie and with the master artisans, the workers established their own clubs and societies.[23]

The culture which workers and working-class organisations were thus expected to strive for was essentially the German high culture described earlier. Workers were to be encouraged to become acquainted with

the works of the great thinkers and with the masterpieces of literature and the arts, and above all with those which reflected the workers' struggle.

Initially, the acquisition of knowledge and familiarity with the arts could proceed only on the basis of individual effort, either via the spoken word of the public lecture or via the printed word of newspapers and books, the latter generally obtained through workers' libraries, which were in turn founded and maintained mostly by the trade unions.[24]

The actual use made of these libraries demonstrates the difficulties of transmitting knowledge and culture to ordinary workers, and the difficulties for the latter in learning and understanding them unaided. The leadership had hoped that readers would borrow books for serious study or select from the great works of literature. The daily practice of working-class life, with its long hours of heavy physical work and crowded living conditions, meant that the demand was for lighter and more recreational reading. Librarians might praise the literary and ideological merits of Schiller's *The Robbers* (*Die Räuber*); the loans made actually show a much greater interest in Gerstäcker's adventure stories.[25]

On the other hand the borrowing records indicate a relatively high interest in the sciences, and, above all, in popular literature on the theory of evolution.[26] This reading would lend strength to the belief in social progress and in the perfectability of men and women. Such evolutionist beliefs were at the root of most socialist philosophies. In Germany they came partly from the Utopian Socialists and from the Lassallean identification of progress with the rise of the state. For many German socialists the underlying motivation for their belief in progress and for the eventual 'social revolution' derived from the natural not from the social sciences; they lacked a detailed understanding of the mechanism of the capitalist economic system and of its inevitable collapse. There was thus a widespread acceptance of the basic tenets of Marxism by a large number of workers who had never read the 'sacred' texts.

In 1891 the SPD could thus accept a Marxist political programme, the so-called Erfurt Programme, and adherents of Marxism held power in the SPD for most of the next decades.[27] This famous declaration concentrated almost entirely on economic and political issues; it had little to say about the role of culture in general and the imparting of knowledge and of the cultivation of the arts for the working class in particular.[28] The underlying belief of the Programme was that the development of society, and with it social thinking, would follow the

inevitable and almost automatic evolution of the economic system towards a classless society. In spite of widespread popular ignorance, the Programme proclaimed it as an incontrovertible truth that 'only through the transformation of capitalist private ownership . . . into social ownership and through the transformation of the commodity mode of production into socialist production, can we ensure that labour will . . . cease to be a source of misery and oppression . . . and will become the basis of the highest level of well-being and of universal harmonious improvement'.[29]

Despite the assertive tone of the Erfurt Programme, it was now widely believed that the collapse of the capitalist system might come about through the weight of political action and the ballot box. Even Friedrich Engels thought so towards the end of his life. He wrote in 1895, shortly before his death, that 'the SPD used the franchise as a weapon which repaid its use a thousandfold. Its new-found legality had not killed the socialist movement. On the contrary this legality gives us firm muscles and rosy cheeks and we look like life eternal'.[30]

To mobilise maximum support and to utilise its political power, the party would need an ever better trained and generally well-educated proletariat. Initially the education of party members was largely concerned with the teaching of the skills needed to run the party organisation and train the officials of the fast-growing trade union organisations for their new administrative, legal and other public duties.[31] The content of the education and training was largely of a pragmatic character but in the larger local branches of the SPD some more theoretical and more academic types of instruction were provided, either by local talent or through a new group of peripatetic lecturers.

At the same time the interest in a wider education and in the arts grew with the rise of workers' recreational and cultural societies. Consequently, the wider issues of more general cultural and artistic activities for the working class became the subject of more general public discussion. This was especially so after the publication of the *Guidelines on Popular Education and Social Democracy* (*Leitsätze zum Thema Sozialdemokratie und Volkserziehung*), which were submitted to the 1906 party conference. Written by Klara Zetkin and Heinrich Schulz on behalf of the Executive, this document made proposals for a new policy in respect of both national and party education.

The document stressed the importance which the SPD attached to knowledge and education; it also affirmed its adherence to Marxism and stressed its importance in the educational process. Hence in order to raise the standard of education in the SPD, the party had to create

its own institutions. It could not rely just on bourgeois knowledge and bourgeois science, which was one-sided, if not perverted and hostile to the proletariat. The SPD sought to develop the 'highest scientific and artistic standards of our time, but contrary to bourgeois ideology of Science and Arts'. Bearing in mind its historic mission, 'it can not simply take over the spiritual culture of the bourgeoisie. It has to evaluate it for its needs and according to its ideology'.[32]

This would have meant that only convinced Marxists could give lectures to party audiences. This view was rejected by a majority of the party's intellectuals from whom instructors were drawn. Many of the latter also belonged to the revisionist, i.e. non-Marxist, wing of the party. They believed that there was a body of knowledge, especially in the sciences, which was independent of ideology or social background. There was even stronger opposition to the view that the value and significance of works of art could be judged according to their social background or political commitment. The *Guidelines* had been critical of bourgeois art and of its value for a working-class audience.

Revisionist critics rejected this view and argued that true art was timeless and classless.[33] If we conceive art in terms of the aesthetic effect of colour, line and space then, they argued, one could not speak of bourgeois or proletarian art. What was more, it was not the purpose of art to educate or to commit. Art should help workers emotionally, and it was already now possible for art to give them a strong zest for life and victory (*Lebens- und Siegesgefühl*).[34]

Up to the outbreak of war discussions of the content, function and role of culture in the life of the working class occurred only irregularly. With the general argument about the relevance of workers' culture accepted, attention now tended to focus on the content of the culture, and, in particular, what kind of art and literature would be suitable for the socialist workers. Not only should it relate to the workers' experiences in life and work, it should also take account of their limited elementary education. Last but not least, the cultural experience offered should strengthen their commitment to the political struggle and their skill in conducting it.

It was hoped that the result of the widespread absorption of culture would be seen in the general development of a mature and sensitive personality, which would flow from the workers' partaking of the rich nourishment of the arts. Once they tasted these fruits, workers would seek an even wider experience, and that, in turn, would strengthen their resolve to fight for the emancipation of their class.[35]

Literary critic Franz Mehring and others, as well as social democratic publicists, generally agreed that there could not be a socialist

culture under capitalism. In any case, the paucity of relevant literature and the primacy of the political struggle meant that there was not enough talent to produce such art and literature. What was being offered in this respect was inevitably tendentious and of lower artistic quality. Art and literature for the working class should be good art irrespective of the social background or politics of its creator. Conversely, bad poets remained bad poets even if they were workers and socialists.

Prominent among the few voices advocating a different course of action was the Dutch playwright Hans Heijermanns (pseudonym Heinz Sperber). In a series of articles during 1910–12 in the social democratic daily *Vorwärts*, he pleaded for an art and literature which would appeal emotionally to working-class experience. He attacked the artistic policy of the Volksbühne with its conventional programme which, he argued, did not meet the interest of the workers. The Volksbühne, or people's stage, produced plays for its largely working-class members, selecting some works of social significance within a broader repertoire.

Sperber also criticised the fact that on aesthetic grounds, and because of their alleged tendentiousness, struggling socialist artists were rejected in favour of bourgeois artists. There was no literature without *Tendenz* (commitment), Sperber argued, so that it was only right that socialist 'tendentiousness' should also be accepted and assured of a place. A socialist art should be encouraged to arise today in anticipation of the future socialism. 'We must accept a literature with a socialist tendentiousness today so that we should have a socialist art tomorrow.'[36]

Sperber's view received almost universal condemnation. Differences among the critics centred on the assessment of bourgeois culture and, above all, on the evaluation of Naturalism, then at the height of its influence. It was held that Naturalism was the accepted art and literature of the proletariat, as it described its own life and shared common opponents. This view was strongly opposed by Mehring, who pointed out that, while Naturalism was largely correct in its description of contemporary society, it had no solution for the evils which it described and would depress working-class readers, rather than give them courage for the fight. Modern art, so Mehring argued – thinking obviously of Naturalism – was deeply pessimistic while every revolutionary class was optimistic and saw the future in a rosy light.[37]

Proposals that the party should deliberately foster a proletarian culture, help with the publication and the circulation of writings by workers – for example *Arbeiter-Dichtung* or workers' poetry – and

give the working-class audience greater influence over the selection of plays in the Volksbühne, were rejected by most experts and intellectuals in the SPD as an *Aesthetik der schwieligen Faust* – aesthetics of the horny hand of toil. The kind of culture to be offered to working-class audiences should show sympathy with the cause of the proletariat, but it must also be of high artistic quality. Hence Mehring argued strongly in favour of classical German literature and in particular the great dramas which dealt with the emancipatory struggle of the bourgeoisie to free itself from the shackles of feudalism and absolutism. It would provide a lesson for the workers' own fight. For Karl Kautsky, editor of the SPD's *Neue Zeit* (New Age) journal, the workers were the rightful inheritors of 'the glorious achievement of the arts of which the ruling class had hitherto had a monopoly'.[38]

Such was the belief in the persuasive power of culture, and in human perfectability, that it was widely assumed that the individual worker could advance culturally and that the cultural institutions of the Labour Movement could help further such an advance. With this the general level of culture throughout society would rise and the institutions charged with the dissemination of culture were expected to work in this direction. Speaking concretely, the cultural committee of the Berlin SPD, which annually published a book with proposals for cultural events, condemned the many events which made no claim on the intellectual and emotional involvement of the individual. The committee endeavoured to 'lead [the worker] upwards to the appreciation of more serious art and to the understanding of more difficult works'.[39]

During the last years before the war the scope of cultural and recreational activities in the local social democratic parties expanded. The events on offer ranged from 'variety' entertainment to concerts and from poetry recitals to the performance of serious plays, such as those regularly given by the Berlin Volksbühne. The Volksbühne, which had come into being in 1890, soon had a membership of tens of thousands and just before the war had completed the building of its own theatre, a structure of conventional design which could seat two thousand.[40]

Many programmes still contained events and performances of low cultural level, which were entertaining rather than seriously artistic or intellectual events. But there were also performances of difficult music or lectures on serious themes. Local 'education committees' of the SPD aimed at high standards. Indeed, some members of the party thought that here and there a high level of cultural sophistication had already been reached. Proof of that was that in some large local parties

it had become customary on special occasions to stage a performance of Beethoven's Ninth Symphony. Kurt Eisner argued in 1906 that this showed the maturity of the proletariat 'which everywhere seeks to attain the highest and is reaching out to the stars'.[41]

Before the First World War workers' cultural associations were comparatively little involved in political discussion, let alone in political activities. The motives which had led to their formation were as much social as political, and their characters would change only slowly, especially as their activities had to endure police surveillance and chicanery.[42] An open discussion of political issues could easily bring about a prosecution.

After 1918 it was no longer necessary for workers' cultural movements to preserve their political neutrality. The social democratic organisations nevertheless preferred to do so, at least in terms of party political issues. This was to prevent arguments with members who identified with the Communist Party, which in turn sought to bring the 'common front' policy, a joint front which the SPD rejected, into the discussion.[43]

The field of workers' culture underwent some changes with the expansion and sophistication which occurred after the war and the revolution. The Social Democratic Party divested itself of responsibility for the general liberal education of workers, leaving this to the growing adult education movement.[44]

After 1918 the Labour Movement, and the SPD in particular, occupied a relatively powerful position in the state, sharing power in the Reich, the *Länder* (states) and municipalities. One result was a decline in the social isolation which workers had experienced before 1914. They could now join non-working-class recreational organisations more easily, and some did so. Nevertheless, the *Arbeiterkulturbewegung* achieved during the Weimar period a state of cohesion which generally made the organisations strong enough to withstand competition or penetration.

At the height of the movement's success some 2.2 million people were members of the various workers' leisure-time organisations. They ranged from athletes and gymnasts to chess players and 'worker-samaritans' (who provided first aid at demonstrations and public meetings), who numbered only a few thousands. In addition there were, apart from the social democratic trade unions, other ancillary organisations like the Arbeiter-Wohlfahrt (Workers' Welfare) and the Retail Co-operatives with their large membership which together helped to strengthen the solidarity of the working-class community.

There is substance in the claim that in the wide-ranging network of workers' cultural and other organisations the SPD had created a

'state within the state'. Its various institutions accompanied workers
and their families almost literally from the cradle to the grave, as the
party executive reported to the 1925 conference. The Socialist League
of Culture (Sozialistische Kulturbund) now encompassed organisations
to meet the needs of all sections of the working class, from children's
holiday camps to assistance with funerals. Among social democratic
freethinkers were atheists who helped members to bear the cost of
cremation, conducted alternative marriage ceremonies and so on.[45]

A large proportion of workers who wished to take part in recre-
ational pursuits, whether actively in sport or in singing or more pas-
sively by attending plays or concerts, continued even in the more
liberal atmosphere of the Weimar years to do so within the long-
established working-class organisations. Yet the expansion of workers'
cultural interests, following patterns set by the bourgeoisie, and the
drive for ever higher standards of performance, for example in music
and the theatre, must have caused some cultural 'embourgeoisement'
of the workers' lifestyle. To achieve its goals of attaining a high quality
of high culture the leadership was in some cases willing, even eager, to
co-operate with bourgeois cultural organisations or with local or cent-
ral government if these could offer material or intellectual support.[46]

Equally important for the raising of the level of workers' culture
was the fact that bourgeois artists were now ready to accept engage-
ments for events held under the auspices of organisations of the
Labour Movement. Discounting the effects of such deliberate steps
towards integration in the wider sociey, the successful development
of the aims of social democratic workers' culture was seen as proof
that the working class was now becoming readily integrated in the
new state.[47] For the secretary of the education council of the SPD,
the party's cultural activities contributed to the respected position
which the working class now occupied in state and society and would
in turn contribute to its emancipation as a class.[48]

The protagonists of the emancipatory role of the workers' cul-
tural activities believed that the contents and form of that culture
were largely identical with those of the bourgeoisie. This view was not
shared by all sections of the Labour Movement. It was opposed by the
Communists, who rejected bourgeois culture, but it was also opposed
by sections of the SPD. Within that party we have, during the years
of the Weimar Republic, a more specific and subject-based discussion
on the kind of culture which the various leisure-time organisations
should foster and transmit to their members. What was at issue here
was to what extent the very substance of the subjects which brought
people together should reflect the specific experience of the proletariat

and foster socialist ideals. Underlying it was the more general question about the relevance of the established, bourgeois culture for working-class men and women who sought to acquire for themselves the experience and the knowledge which a largely class-based society had for so long withheld from them.

For the proponents of a culture *sui generis*, the value of a rich and vigorous working-class culture lay also in its communal and communitarian character. Some leading social democrats held that this was best realised in the *Festkultur*, the 'Mass Festival' consisting of a type of multimedia performance involving choir and orchestra, dance and *Sprechchor* – a chorus of massed voices, declaiming in unison. The whole event was staged at night, using lights, torches and projectors as an additional and powerful means of communication. Using mostly original texts, the party, jointly with the trade unions and other organisations, staged and perfected such oratoria during the 1920s. The organisers believed that they were here actually anticipating a piece of practical socialism ahead of the socialist society. Altogether, cultural activities assumed such an importance in sections of the socialist movement that one spoke of a 'third pillar of the movement' no less important than the political and the economic. A motion before the 1920 party conference, which though defeated attracted considerable support, spoke of the SPD being a *Kulturpartei* (a party of culture) whose goal was the establishment of a 'Cultural Socialism for which the economic socialism is (only) a pre-condition'.[49]

Yet seen from the angle of a Marxist working class, the uncritical adoption of a bourgeois cultural tradition was a barrier to the earliest achievement of socialism. A statement by the SPD's Leipzig district, an influential group which stood on the left of the party, emphasised the need for the ideological commitment of workers' culture. 'All cultural endeavours which are not focused on the historic development of the working masses are an obstacle to its development and are therefore reactionary in character', it proclaimed in 1924.

In that view, contemporary culture and knowledge were willingly or unwillingly tied to the bourgeoisie and therefore an element in the class struggle. 'The workers' cultural movement has to select and foster from bourgeois culture such elements of scientific and artistic value which were important for them; its main task, however, is to create elements of a new culture and of new forms.'[50]

Overall the expansion of the German Labour Movement proceeded on a number of parallel tracks. Next to the political and the industrial, the cultural wing of the movement was to grow in size and importance. So was the thinking within the movement about the importance

of cultural activities in the emancipatory process of the working class and of the way in which socialist ideology might have a bearing on this. The beginnings of this discussion go back to the early days of the German Labour Movement, but it accelerated during the Weimar years. It was during that short and culturally fertile period that a growing link developed between workers' politics and the visual arts. This was particularly strong in the revolutionary period, when sections of the artistic avant-garde identified with the aims and aspirations of the Left. They expressed their convictions in works of art and helped the social democratic parties with which they identified, through the creation of *engagé* art for agitation and propaganda.

This study is not concerned only with art in its political role but with general links between the German working class and the visual arts (in the context of the emancipation of their class), and with the attitude of workers to works of art and the development of their artistic taste. The book is therefore as much concerned with those institutions and movements which sought to give workers full access to intellectual, spiritual and artistic achievements as with the more popular imagery of leaflet, poster, placard or graffiti which were seen regularly by the masses. The contents of the culture which was to be transmitted to the working class were to a significant degree those of the national culture, but they were to be transmitted to the masses of class-conscious worker, through their own organisations and under the ideological umbrella of the workers' political and industrial movements whose aim was the emancipation of their class.

NOTES

1 See O. Greiner, 'Die Bildende Kunst und ihre Bedeutung für das Proletariat', *Sozialistische Bildung* (1929), pp. 142–7.
2 W. L. Guttsman witnessed the last flickering of German avant-garde art, including its political manifestations, when a boy in Berlin. The more immediate antecedents of this book can be found in the exhibition 'Icon and Revolution – Political and Social Themes in German Art 1918–1933', Sainsbury Centre for Visual Arts, University of East Anglia, Norwich, which the writer curated in 1986. On the wider issue of German workers' culture see the author's *German Workers' Culture* (Oxford, 1990).
3 For an assessment of the work of four major German painters (Beckmann, Dix, Grosz and Schlemmer) which largely denies the influence of politics on their work, see Mathias Eberle's *World War Two and the Weimar Artists* (transl. from the German) (London, 1985).
4 See among others L. Niethammer, 'Wie wohnte der Arbeiter im Kaiserreich', *Archiv für Sozialgeschichte*, 16 (1979), pp. 61–134.
5 Kaiserliches Statistisches Amt, *Erhebung von Wirtschaftsrechnungen von minderbemittelten Familien* (1908). See also Deutscher Metallarbeiter Verband, *320*

Haushaltsrechnungen von Metallarbeitern (no place, 1908); J. Heiden, 'Was wendet der Arbeiter für Bildungszwecke auf', *Neue Gesellschaft*, 5, 4 (1907).

6 See M. Scharfe, 'Wandbilder in Arbeiterwohnungen', *Zeitschrift für Volkskunde* (1981), pp. 17–37 passim.

7 For a more detailed description of prints for the home see W. Brückner, *Die Bilderfabrik* (Frankfurt, 1973); Brückner, *Elfenreigen und Hochzeitstraum* (Frankfurt, 1973); C. Pieske, 'Wandschmuck im bürgerlichen Heim' in L. Niethammer (ed.) *Wohnen im Wandel* (Wuppertal, 1979), p. 262.

8 See H. Schilling, *Wandschmuck unterer Sozialschichten* (Frankfurt, 1971); H. Schomerus, *Die Arbeiter der Maschinenfabrik Esslingen* (Stuttgart, 1977).

9 See Scharfe, 'Wandbilder'. For home decorations in the Weimar period in general no figures exist but it has been suggested that overall there was a shift from household expenditure on basic items such as food. L. Preller, *Sozialpolitik* (Kronberg, 1949), suggests a decline from 52 per cent in 1907 to 45 per cent in 1929.

10 See H. Bausinger, 'Verbürgerlichung – Folgen eines Interpretaments' in D. Langewiesche and K. Schönhoven (eds), *Arbeiter in Deutschland* (1981), pp. 88–117 at p. 108.

11 See *Kunsterziehung, Ergebnisse und Anregungen* (Leipzig, 1902) (Report of a conference on art education in Dresden in September 1901), p. 150.

12 *Ibid.*

13 E. Mai, *Kunstpolitik und Kunstförderung im Kaiserreich* (Berlin, 1982).

14 For a methodological discussion on the distinction made between workers' culture and workers' movement culture see the special issue of the *Journal of Contemporary History*, 13 (1978), and, especially, Gerhard A. Ritter's essay which deals with the basic issue and claims the validity of the distinction.

15 The partial revival of folk art which took place in Germany during the Weimar years had few links with the Labour Movement or with socialist thought. There were more connections between socialism and the various reform movements. For a wider discussion see Chapter 7.

16 For a general discussion see G. Selle, *Kultur der Sinne* (Cologne, 1981).

17 See Lassalle's *Arbeiterprogramm*, quoted by B. Emig, *Veredlung des Arbeiters: Die Sozial Demokratie als Kulturbewegung* (Frankfurt, 1980), pp. 60–1.

18 Liebknecht's pamphlet is partially reprinted in A. van Rüden and W. Koszyk, *Beiträge zur Kulturgeschichte der Deutschen Arbeiterbewegung, 1848–1918* (Frankfurt, 1973).

19 Liebknecht was buried in the Friedrichsfelde Cemetery in Berlin, where many leaders of the German Labour Movement were buried.

20 Liebknecht, affectionately known in the party as 'Der Alte' (the old one), also constituted a living link with Marx and Engels in London, where he had lived during the years of his exile.

21 The rate of expansion is the more astounding in that the party, fearful of further prohibition, worked with a minimum of organisation and vested properties, ownership of newspapers and other possessions in individual members.

22 Figures on the circulation of the press are given in Chapter 5.

23 On workers', among others, sport see H. Ueberhorst, *Frisch, Frei, Stark und Treu: Die Arbeitersportbewegung in Deutschland, 1893–1933* (Düsseldorf, 1973).

24 For a detailed survey of membership and readership of workers' libraries see D. Langewiesche and K. Schönhoven, 'Arbeiterbibliotheken im Wilhelminischen Deutschland', *Archiv für Sozialgeschichte*, (1976), pp. 135–204.

25 See H. J. Steinberg, 'Workers' Libraries in Germany before 1914', *History Workshop Journal*, 1, 1, pp. 186–200.

26 See Steinberg, pp. 176–7.

27 The character of the SPD leadership changed with the widening of the social and educational background of the party. Many of the intellectuals who joined the party after 1900 tended towards reformism.

28 For a recent translation of the Erfurt Programme see S. Miller and H. Potthoff, *A History of German Social Democracy* (Leamington Spa, 1983).

29 The principal author of the programme was Karl Kautsky, the editor of the *Neue Zeit*, the party's theoretical organ. He also wrote a commentary of the Erfurt Programme, *Das Erfurter Programm in seinem grundsätzlichen Teil* (Stuttgart, 1892).

30 Friedrich Engels, Preface to 1895 edition of Marx's *Class Struggle in France, Marx and Engels Selected Works* (London and Moscow, various dates), I, p. 125. For Bebel's statement see his letter to Engels of 7 December 1885 (*Briefwechsel Bebel–Engels* (The Hague, 1965), p. 34).

31 Trade union education became even more demanding after 1918 when they became more involved in the enterprise policy through a system of works councils and through their statutory position in the health and social insurance system.

32 From the *Leitsätze* in SPD Parteitag 1906, pp. 122–3.

33 The 'revisionist' point of view is best represented in articles by Maurenbrecher, Göhre, David and others in the monthly periodical *Die Neue Gesellschaft*, 1903–7.

34 L. Berg, 'Die Feste des Proletariats', *Neue Gesellschaft* (1906), p. 81.

35 Franz Mehring, *Neue Zeit* (August 1893).

36 Heinz Sperber, 'Tendenziöse Kunst', *Vorwärts* (4 September 1910).

37 Franz Mehring, 'Die Kunst und das Proletariat', *Neue Zeit*, 15, 1, p. 129.

38 See K. Kautsky, *Materialistische Geschichtsauffassung* (Berlin, 1927), 2, p. 279.

39 See SPD Berlin, *Bildungsausschuss, Leitfaden für die Bildungsarbeit* (1914).

40 The only progressive aspect of the seating in the Volksbühne theatres was the allocation of seats by lot.

41 K. Eisner, 'Die Heimat der Neunten', *Neue Gesellschaft* (1906), p. 10.

42 For the practice of workers' cultural associations see D. Dowe, 'The Workers' Choral Movement before the First World War', *Journal of Contemporary History*, 13, 2 (1978), pp. 269–96.

43 Cf. H. Wunderer, *Arbeitervereine und Arbeiterparteien: Kultur und Massen-organisationen in der Arbeiterbewegung, 1890–1933* (Frankfurt, 1980).

44 See H. Feidel-Merz, *Zur Ideologie der Arbeiterbildung*, 2nd ed. (Frankfurt, 1972).

45 From the Report of the 1925 party conference of the SPD.

46 The involvemnt of professionals, such as conductors, in planning programmes of the workers' choirs was not always undisputed. Their choices of music tended to favour the classical and traditional while the more politically minded sections of the membership rejected the Christian oratorios and looked for works with a socialist content even at the cost of inferior music.

47 Examples can be found in the Sunday Concerts which formed part of the *Sozialistische Feierstunden*, a kind of secular religious service, which was held regularly in one of Berlin's largest theatres as well as in other cities.

48 R. Weimann, 'Sozialismus als Kulturbewegung', *Unser Weg* (Journal of the Berlin SPD), 2 (1928), p. 35.

49 SPD Parteitag, 1920, p. 316.

50 See 'Richtlinien für die Bildungsarbeit in Sachsen', *Kulturwille* (1924), p. 153.

Art, illustration and the proletariat, c. 1848–1914

Political and ideologically committed art in Germany is generally associated with the period of the Weimar Republic. Those years saw the widespread use of paintings, sculpture and, above all, of the graphic arts to express a critique of society, convey political ideas and influence political action. At one end of the scale are examples of pure art, created under the impact of the events of the period – war and revolution, unemployment and the threat from militarism and fascism. At the other end of the spectrum the contemporary observer would find in the press, on hoardings, on billboards and in leaflets, broadsheets and wall-newspapers a great range of images used for political propaganda and party political agitation. Such pictures and images – usually short-lived – were the work of amateurs or more often of graphic artists employed by the media or by the political parties.

This more ephemeral art and the visual agitation created by the German Left, and at times widely disseminated throughout the German working class, has generally been looked at in the context of contemporary art. It is linked to the traditions of the radical and innovatory art movement of Expressionism and to the avant-garde in general. Little attention has until recently been paid to political and other committed art and to the links between art and the German workers. This chapter will look at the radical and politically oriented art of the Wilhelmine period, going back where appropriate to the beginning of the German Labour Movement in the middle of the nineteenth century and to the effects of the revolutionary struggles of 1848.[1]

The events of 1848 found their expression in the political actions linked to the Frankfurt Nationalversammlung and the Parliament which had assembled in the city's Paulskirche and sought to elaborate a constitution for a united German state on democratic foundations. They also influenced local politics and local public opinion and, with this, some artists who in turn created works of art which reflected such general ideas.

One of the areas of the country where we can observe the artistic effects of the political movements was the Rhineland, at the time the most highly industrialised region of Germany. Its middle class tended towards liberalism, and even the ideas of Marx and of the *Bund der Kommunisten* had a relatively sympathetic reception. More specifically Moses Hess and radical poet Ferdinand Freiligrath, who represented the *Wahre Sozialismus* (true socialism) and the extreme radical position within the German bourgeoisie, had contacts among the group of artists of the Düsseldorf Art Academy. Some of the local artists were also active in the *Bürgerwehr* (voluntary militia). In Düsseldorf this was more than a group of local worthies, bent on the maintenance of law and order. It was also concerned with civil rights and pressed for the implementation of the constitutional demands of the bourgeois revolution – the creation of a democratic, parliamentary state.[2]

Originally the Düsseldorf artists, members and pupils of the famous Academy, painted relatively academic works such as historical and religious paintings, as well as portraits and landscapes which show the influence of the Dutch School. Under the impact of the political events and of the expressed aspirations of the middle class, some artists turned to more political and at times provocative subjects. Thus Adolph Schroedter, originally active as a graphic artist and portrait painter, turned to painting scenes from the lives of ordinary folk. He also produced a print in memory of the 1830 revolution in France, entitled *Das grosse Jahr* (the 'Annus Mirabilis'), and another entitled *Die Grundrechte des deutschen Volkes* (The Basic Rights of the German People).[3]

Most of these were genre paintings, or what later became known as *Elendsmalerei* (pictures of misery), which did not fundamentally criticise the existing social order even though they portrayed working people and sought to arouse pity and induce compassion. However, the works created by Düsseldorf artists in the 1840s include a few which pose more fundamental questions. One of these was Karl Wilhelm Hübner's *Die Schlesischen Weber* (Silesian Handloom Weavers), which illustrated the cruel nature of the capitalist process of exchange (Plate 2). It shows weavers in Silesia handing over bales of linen to the manufacturer. The artist contrasts the mostly deferential mien and gesture of the craftsmen with the haughty behaviour of the capitalist, painted as if he were a princely ruler, who has obviously just rejected a bale of cloth which he has dropped to the ground, while holding it gingerly, if not disdainfully, between two fingers. His action has aroused fear, but also hostility, among the weavers. A

woman is swooning, other workers display emotions ranging from deep anxiety about the verdict on their wares, to barely concealed aggression at their treatment at the hands of the rich manufacturer, whose sumptuous living quarters can be seen in the background.[4]

The *Kölnische Zeitung* called the painting 'socialist, and in consequence, appropriate for our times'. It demonstrated 'the desire of our time to remove the most drastic differences between the estates'.[5] That the reference is to 'estates' rather than classes is surely significant. It suggests a hoped-for return to a more traditional relationship between employer and workers, based on custom and mutually agreed fairness in respect of price and treatment; a contract which the entrepreneur had now wilfully broken.[6] Seen in this light, it would be wrong to argue that the painting pointed to the fact that social suffering was due to the exploitation of man by man, or agree with a contemporary assessment of Hübner as 'the first painter of the German proletariat'. Friedrich Engels saw in the painting evidence of the intensifying of the class conflict and thought that it would more effectively advocate socialism than a hundred leaflets.[7]

Other paintings by Hübner also point to the injustices of contemporary society. His *Jagdrecht* (Hunting Rights) points to the dominant position of the landowner who, without let or hindrance, can ride or hunt across his tenant's fields, flattening his corn, yet who can prohibit the tenant shooting any game which may damage his crops. In addition, the landowner has the right to judge and punish a poaching peasant or shoot at him, when, as in the picture, he has killed a wild boar who has devastated his ripening corn. Pursued by the gamekeeper or forester, the two 'poachers', one of whom has been shot at, seek refuge in a shed. To a reviewer the scene points to the existing conflict between natural human rights and the existing laws which reinforce the acquired rights of a protected and favoured estate.[8]

It is interesting to note that in this picture, and elsewhere in paintings by Hübner or by his contemporaries, the criticism is of a declining rural and feudal society, rather than of the emerging industrial society, based on factory, foundry and mine. A work which takes this new urban society as its theme is therefore politically all the more significant. Such a painting is Johann Peter Hasenclever's famous *Arbeiter vor dem Magistrat* (Workers in front of the City Council) painted in 1848 (Plate 3). It shows a meeting of the Düsseldorf City Council in which a deputation of workers confront the city fathers to demand work. The actual event followed a demonstration of five thousand Düsseldorf workers in October 1848 organised by the *Volksbund*, whose leaders included Lassalle and Freiligrath. On the

next day many workers assembled outside the Town Hall, and their representatives, backed by an agitated mass of workers (seen in the picture through the open window), forced their entry into the Council Chamber. It is the clamour of the demonstrators, the firm stand taken by the deputation and the amazement of the city fathers at this intrusion into their affairs which give the painting a clearly radical message.[9]

It is not only the conflict between workers and the representatives of the bourgeoisie, who controlled public life, which is important in this scene, it is also a fact that workers appear here as a united group. In the context of the representation of the class-conscious worker in the visual arts, the portrayal of united workers is more significant than the emphasis on the individual labourer, or on a loose group of the proletariat shown only in its oppressed state or in its general misery. It is still relatively rare for the arts to deal with such collective action in this period.

The *Düsseldorfer Monatshefte* (1848–55), which in its satires combined a radical bourgeois outlook with a high artistic standard, illustrated comparatively few workers. When it did so, the monthly paper

2 Karl Wilhelm Hübner, *Silesian Handloom Weavers in front of the Cloth-Merchant*, oil (1844)

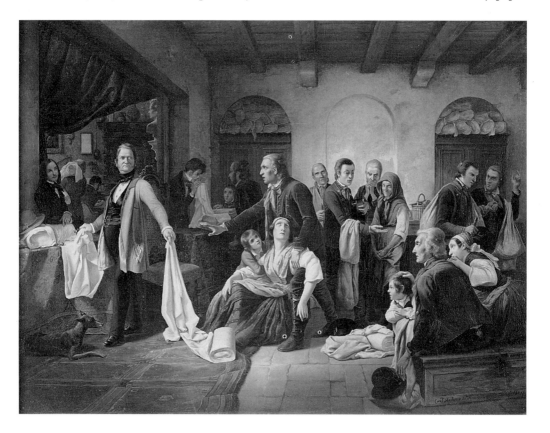

tended to show the proletarian in a critical light. Thus in one of
its first (1848) illustrations of a group of workers we are faced in
effect with the closed ranks of a workers' demonstration. The text,
however, strikes another note. The drawing is captioned 'A petition
of the working classes to the city council', but the list of demands –
including umbrellas for rainy days and a 'play day' on Wednesday
afternoons – ridicules the claimants and makes them sound like a
group of idle and slothful workers, and not, as the drawing suggests, a
delegation akin to one from the organised and class-conscious workers
of a later period.

The picture of the worker in the extensive visual documentation
of the revolutionary struggle of 1848 is equally ambiguous. In the
bourgeois revolution of that year representatives of the politically com-
mitted workers played an active part. In the relevant contemporary
prints and drawings there is, however, relatively little evidence of the
part played by workers in the demonstrations and on the barricades.
Judged by style and quality of dress, the behatted and jacketed figures
on these makeshift hurdles to the progress of army or police greatly
outnumbered the bare-headed workers in their shirt sleeves.

3 J. P. Hasenclever,
*Arbeiter vor dem
Magistrat* (Workers in
front of the City
Council), oil (1848)

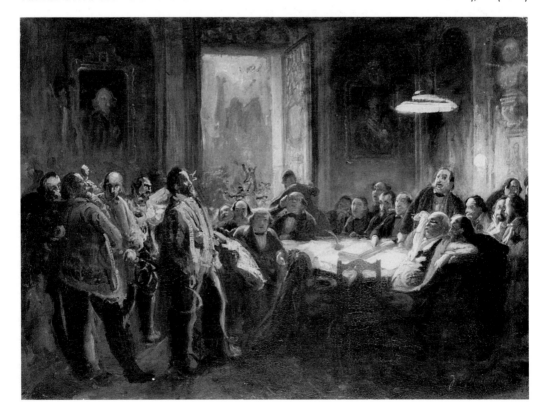

This is in contrast to reality. We know that in the fighting in Berlin between the revolutionaries and the troops in March 1848, 303 people were killed or died from their wounds. The majority of them were artisans or skilled workers. At their lying in state, representatives of all sections of the community paid their respects and this event was seen as an act of reconciliation of the classes. Adolf Menzel painted the scene, but his *Aufbahrung der Märzgefallenen* (The Lying in State of Those who Died in March) is a less than fulsome acknowledgement of the contribution which the working class had made to the struggle (Plate 4). Against the background of rows of black coffins stacked on the steps of the New Church, the masses of mourners in the middle of the scene are divided between agitated workers and solemn bourgeois in black. Prominently placed in the centre of the foreground is an elegantly dressed gentleman. With one hand he salutes a passing coffin, but his other hand remains in his pocket, surely a less than wholehearted acknowledgement of the unity of the revolutionary force which the ceremony sought to symbolise.[10]

With the failure of the revolution, such limited attempts to give a pictorial expression to certain political issues or to paint scenes which

4 Adolf Menzel, *Lying in State of Those who Died in the March Revolution*, oil (1848)

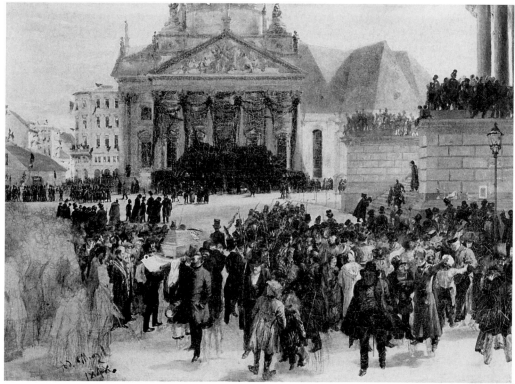

reflected basic social problems came to an end. Even the painters of the Düsseldorf school went back to painting traditional subjects: landscapes and portraits and, not least, social genre paintings. Superficially, the latter resembled works like Hübner's *Silesian Weavers* or Hasenclever's *Workers' Protest*, but they were generally devoid of critical intention. The *Genrebild* (genre painting) was the counterfeit of a social scene, painted in the most naturalistic manner with no detail left out. Yet it neither highlighted nor condemned, but created a world of appearances. 'With them [the painter] distances himself from the contemporary world, conjuring up elegance, sweetness and beauty.'[11]

Stylisticaly, the genre painters frequently borrowed from their Dutch predecessors, but their subjects, even more than those of the Dutch, tend to be be found in rural society and in the life of the peasantry. The new urban world of the city with its crowds of people did not come into their purview; their paintings were not intended to distract or distress. They dealt with themes like *A Village Sermon*, *A Funeral*, *Cardsharpers*, *A Proposal of Marriage*, *The Poors' Pew*, *The Jealous Girl* and *The Bailiff Comes*. Only the last deals with economic issues and social problems, but in the painting the subject of attention is not a poor family but the relatively comfortable home of a solid and dignified artisan.[12]

The defeat of the revolution and the reaction that set in nearly everywhere killed the young political organisations of the proletariat. When the German Labour Movement awoke from its 'Sleeping Beauty' slumbers in the early part of the 1860s, new trends in the visual arts were beginning to show themselves. In contrast to the realism which we found in the school of genre painters, a looser and more interpretative style developed. The new trend favoured landscapes and figure painting, but it also extended into social art. After 1860 the pace of industrialisation in Germany quickened. Work and the new industrial environment of the factory were becoming appropriate subjects for artists working in pencil and paint.

Such a trend can be observed throughout the industrialising nations; indeed, it loomed larger in countries like Britain where not only had industrialisation started earlier but the new factory-based proletariat had slowly become partially accepted into the civic community. In Belgium, where heavy industry had sprung up in the nineteenth century, Constantin Meunier (1831–1906?) had early in his artistic career concentrated on sculpting miners and other manual workers and, although his work has affinity with classical sculpture, there is also more than a hint of the hardship and the suffering experienced by the industrial proletariat.[13]

In Germany Adolf Menzel was one of the first major painters to take as a theme the industrial scene and the workers engaged in it. In 1875 he embarked on the painting of *The Rolling Mill* (*Das Eisenwalzwerk*), a large canvas of a modern ironworks, one of the Königshütte complex of enterprises, which at that time employed three thousand workers to make rails for the railways (Plate 5). The painting occupied Menzel over a number of years. It shows the complex production process and it gives vivid and clear evidence of the hot and heavy work in which puddlers and others were engaged. It also touches on other aspects of the work process; the fact that the shift is about to change, with some workers washing themselves in the workshop, where others are eating a meal brought to them by a young girl.

There is no hint of any condemnation or criticism at this. Menzel reports these practices factually, and although the workers, who are clearly recognisable as individuals, are at the centre of the painting, it appears to us today as a document celebrating the triumph of technology rather than as an apotheosis of the skilled worker. Menzel's painting is also a document of the rise of the large industrial enterprise which took place in the Germany of the *Gründerzeit*, the period which followed the foundation of the German Reich after the successful war against France in 1870.[14]

5 Adolf Menzel, *The Rolling Mill*, oil (1875)

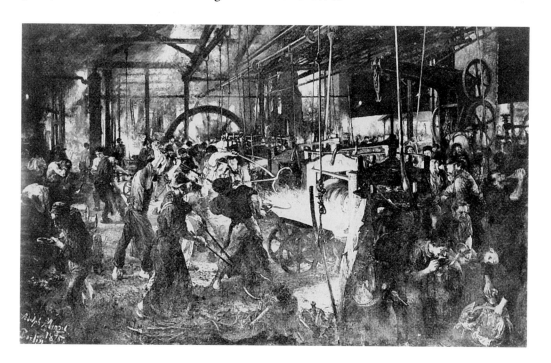

It was above all in the growing number of such large enterprises that the struggle between factory owners and the social democratic Labour Movement was being carried out. The large machine shop was, in the words of political scientist Roberto Michels, 'the exemplary breeding ground of solidarity'.[15] It was a fight not only for pay but also about working conditions. The emphasis on piecework and the long working day – extending frequently to ten or twelve hours – coupled with a six-day working week sapped the physical strength of the industrial worker and added to the feeling of exploitation. For many industrial workers the relentless pace of the machine meant that they had to quit before the end of their expected working life.[16]

A more positive view of the significance of Menzel's painting came surprisingly from a social democratic viewpoint. A writer in *Neue Zeit*, the party's principal theoretical organ, referred to it as a celebration of work, its beauty and dignity. Menzel, wrote the anonymous author of an article on the representation of work in the visual arts, had created his painting 'from within, influenced only by the spirit of the times'. In *The Rolling Mill* and elsewhere he had painted 'an artistic apotheosis [*Verwertung*] of work'. Contrasted with Menzel, later German painters working under the influence of French Impressionism, men like Liebermann and Skarbina, had merely created idyllic scenes.[17]

For a more all-embracing, and a more socially oriented representation of the life of the proletariat, we must look at the work of a later generation of artists – above all to Käthe Kollwitz and Hans Baluschek, born in 1867 and 1870 respectively. Both were steered towards socialism by their background or upbringing. Kollwitz grew up in Königsberg in a democratic, if not social democratic, home and Baluschek came under the influence of a social democratic teacher when at school in Stralsund. Moreover, they belong to the first generation of artists whose entry into the profession coincided with the period when the social democratic movement, freed from the shackles of the anti-socialist legislation, could develop into a mass organisation.

Yet whatever their ideological commitments during the early years of their careers, or later in their maturity, their artistic work, its subjects and their treatment, was determined as much or even more by emotional and artistic considerations as by political affinities. Kollwitz's work has always been linked to the portrayal of women, who are shown in their suffering and their tribulations so that we would often identify them with the oppressed class, even if the titles did not direct us to this fact. Yet, as Kollwitz herself reports, her selection of women and workers as themes for her work was initially not linked

to ideological considerations. Her first attraction to the proletarian and the manual worker as the prime subject of her art was aesthetic.

The views of her father and of her brother, as well as her early reading, had predisposed her towards socialism, but she chose to illustrate the life of the workers because:

The motives which came out of that sphere gave me . . . that which I regarded as beautiful. Beautiful for me was the Königsberg porter . . . beautiful the generosity of his movement . . . beautiful the movements and gestures of the common people. People from the bourgeois camp, on the other hand, held no attraction for me. The whole of the bourgeois life seemed to me pedantic, but the proletariat had grandeur.

On another occasion she wrote of her early artistic work that the type of manual worker whom she observed carrying heavy loads in the wharfs and storehouses of her native Königsberg attracted her strongly.[18]

Later on, after studies in Munich and her marriage to socialist doctor Karl Kollwitz, who practised in a Berlin working-class district, her attitude changed. 'I set out quite deliberately to portray the life of the workers in its most characteristic situations.'[19] 'I got to know the hardships and the tragedy of the proletarian existence to their very depths. Unresolved problems like prostitution and unemployment upset me and worried me greatly and tied me down even more to the portrayal of the common people.'[20]

Kollwitz's identification with the fate of the oppressed and suffering proletariat is already apparent in her early work, a cycle of etchings and lithographs on the 1844 uprising of the Silesian hand-loom weavers (Plate 6). She had been stimulated by Gerhard Hauptmann's drama *Die Weber* (The Weavers), which she had seen in Berlin at its first performance in 1898. The showing of this sequence of prints in 1898 brought the artist instant recognition and a proposal by several major artists that she should be awarded the Little Gold Medal. This was vetoed in the strongest terms by the Emperor but it had already been rejected by the Prussian Ministry of Education and Science.[21]

Kollwitz's early work is, however, not concerned only with poverty and suffering but also with workers' protest and revolt. Plate 5 of the *Weavers' Revolt* depicts the attempt to break down the gates of an exploitative cloth-merchant, with the women picking up paving-stones from the roadway to use as missiles. Her *Bauernkrieg* (The Peasants' Revolt), created some ten years later, has even more pictures of violence. The famous etching *Losbruch* (Outbreak) of 1903 portrays the embodiment of blind fury in the ancient shape of a

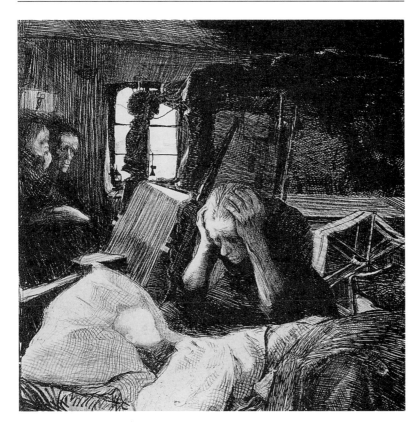

6 Käthe Kollwitz, *Not*
(Suffering), etching
(1893–4)

woman. Historically the figure is based on that of the *Schwarze Anna*
(Black Anna), whose deeds in extolling the peasants to fight had been
described by Wilhelm Zimmermann in his popular history of the
Peasants' War.[22] The print reproduced here (Plate 7) is very similar
to that in the *Peasants' War* cycle.

 If Kollwitz's illustrations for the *Weavers* cycle and for the *Peas-
ants' War* were symbolic representations of the sufferings of all the
oppressed and of their need to struggle to free themselves, most of
her work dealt more concretely with the proletariat at the beginning
of the twentieth century. In 1909 she worked on a series of drawings
for the illustrated magazine *Simplicissimus*, which included some
drawings with the title *Elend* (Misery) showing mostly women, includ-
ing an outworker, exhausted from their labours. One print, *At the
Doctor*, showed a pregnant woman knocking at the door of the sur-
gery. With these prints, as with her posters, such as that for the 1906
'Heimarbeit' exhibition which showed a pale and exhausted woman,
Kollwitz reached a wider public than she did with her more import-
ant cycles of prints.[23]

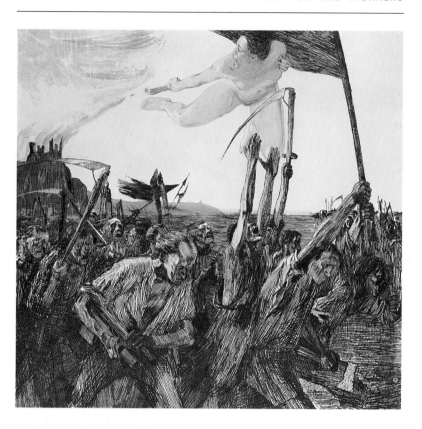

7 Käthe Kollwitz,
Aufruhr (Uprising),
etching (1899)

Compared with Kollwitz's sombre work, the drawings and paint-
ings of the proletarian milieu and of the Berlin working-class districts
which Hans Baluschek (1870–1935) created at the same time are
both more intimate and less ideological in content and intention. In
his own assessment of his art Baluschek spoke of the sympathy with
which he painted his workers, petty bourgeois, philistines, whores and
pimps whom he portrayed with the hope of a new life for them. He
claimed – to my mind wrongly – that he was not a sentimentalist
and that he did not like gentle protests: 'My weapons, brush, char-
coal, pencil and pen, should bite and hit.'[24]
Strong feelings of hatred and of deep disgust, which so frequently
seem to have moved Kollwitz, are less evident in Baluschek's work.
His illustrations display a gentle irony, as in a drawing of the May
Day celebrations in Berlin (Plate 8), which he published in 1898 in
the new satirical magazine *Das Narrenschiff* (The Ship of Fools).[25]
Unlike Kollwitz's motivation, too, is his concern with the social milieu
and with the portrayal of masses of workers, their wives and their
families. 'He who looks closely behind the almost amusing façades
will perceive the accusing inhumanity of mass housing, the dullness

and the stupor of tired people, exhausted from work as well as the heart-aching idyll which you will find in some corner.'[26]

Apart from the occasional publication in contemporary satirical magazines, such as the fortnightly *Wahre Jakob* (Honest Jacob), the art of these two radical artists at first reached only regular visitors to exhibitions. (The original title of the journal was *Der Wahre Jakob*, but the later spelling is used here throughout for the sake of simplicity.) Only after the revolution did it and other similar work reach a larger audience through reproductions, posters and the periodical press. The restricted availability before 1914 lay probably not only in the more restricted character of the working-class press. It was possibly also linked to the nature of their art. The very realistic character of their work might have militated against it being widely reproduced in the socialist satirical magazines of the period. A debate on the magazine *Neue Welt* (New World) at the 1896 conference of the SPD brought out the widespread and strong popular resistance on the part of many delegates to the 'excessively' naturalistic character of the fiction printed in the magazine, which was the widely read illustrated Sunday entertainment supplement of socialist newspapers.

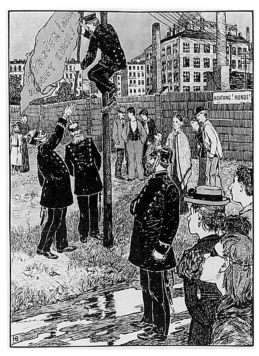

8 Hans Baluschek, *The Red Flag on 1 May, Der Wahre Jakob* (1891)

Many delegates argued that, given their hard and exhausting work and the severity of their daily struggle, the proletarian readers sought uplifting, not depressing reading in their Sunday magazine. Coarseness of behaviour or of language should not appear in a family magazine. Edgar Steiger, the editor of *Neue Welt*, might ridicule the idea of presenting 'workers in evening dress' but the respectable and moralist workers sought heroism rather than weakness in their fictional characters.[27] In this set of attitudes among workers, radicalism in political and economic thinking goes hand in hand with conservative aesthetics. It seems likely that the assessment of works of visual art would not have come out very differently, but we cannot prove this.

There was at that time little discussion of the visual arts, although there was repeated criticism of the poor quality of the illustrations in the magazine. We certainly have little evidence of a positive attitude to modern, 'expressive' and somewhat pessimistic art, such as

that created by Kollwitz. As one of the earliest accounts of her art pointed out, 'her work expresses a strongly and deeply felt sense of indignation but it does not evidence a conviction of the certainty of the eventual victory of socialism'.[28]

If the portrayal of misery and suffering was for many too depressing, the scenes of violence and the calls to arms conveyed in *Riot*, Kollwitz's etching of weavers about to attack the house of the cloth-merchant, or her *Outbreak*, would have been too dangerous to print in a socialist magazine. Even after 1890 the German Social Democratic Party feared new attacks on its liberties and on the freedom of association and industrial action of the growing trade union movement. Although the SPD had in 1891 adopted a quasi-revolutionary programme, the party was most anxious to dispel the belief that such a social revolution would demand recourse to violence. In any case, the publication of prints such as these in the social democratic press would almost certainly have led to prosecution and confiscation.[29]

To trace the influence of the visual arts, and especially the impact of the visual imagery which deals with the life of the proletariat and with the political ideas of the German Labour Movement, we must examine the socialist press, in particular the social democratic satirical magazines like the *Süddeutsche Postillon* (1882–1910) and *Der Wahre Jakob* (1881–1933; 1924–7 as *Lachen Links* (Laughter on the Left)). In addition *Neue Welt*, just discussed, which reached a circulation of over half a million by 1914, also published some traditional and usually very sentimental illustrations to accompany its stories. The satirical magazines sought to achieve a higher artistic standard and generally succeeded. At the same time they aimed to include illustrations which would appeal to a working-class audience and could be easily comprehended by the relatively unsophisticated. Above all, they aimed at the political education of the working class. Their large readership – *Der Wahre Jakob* had a circulation of over 100,000 in 1890 and 366,000 in 1914 – suggests that the images conveyed in them reached a sizeable section of the committed socialist working class.

The word 'satire' is an inadequate description of the contents and the style of these magazines. Illustrations conveying humour and sarcasm formed only part of their content. Together with the generally gentle irony with which the bourgeoisie and ruling class are shown, the magazines included many illustrations which depicted scenes from the daily life of the proletariat and which present the workers in an admiring, if not a heroic, light (Plate 9).

More specifically political illustrations – images which showed the workers' power and depicted their hopes for a better future – were

found regularly in the illustrations published in connection with the celebration of 1 May, the 'World Holiday of the Proletariat'. Such programmatic drawings and allegories often appeared on the title-pages of the two magazines. Above all, they appeared annually in the so-called *Mai Zeitungen* (May magazines) which the SPD published regularly from 1891.

These were broadsheets of normally eight pages, often with a special double-page spread, conceived as a *Schmuckblatt* for workers to pin up in their homes. The party printed – and sold at a nominal price – some hundreds of thousands of these publications. They reflected socialist ideology in a pictorial and often symbolic way, and they were also an indication of the party's attitude to contemporary art. This body of May Day art, which extends over a forty-year period from 1891 to 1932, permits a relatively systematic analysis of socialist – and later also of Communist – popular art and of its iconography.

9 E. G. Lau, 'Der Wahre Jakob' has Arrived, drawing (1893)

The publication and distribution of these broadsheets was clearly a major undertaking, and we would undoubtedly understand the celebration of May Day better if we knew more about the editorial and artistic direction of the broadsheets and about their reception by the organised workers. We know that the *Mai Zeitungen* were issued by the Vorwärts Verlag, the SPD's principal publishing house, which also published the party's official newspaper of that name.

The printing was done by commercial publishers but control and editorial direction lay with the central party organisation and in particular with Richard Fischer, who was in charge of the administration. He admitted, in answer to criticism of the illustrations in the 1902 broadsheet, that they had encountered technical difficulties, but he also stated that it was not always easy to find suitable contributors – promises of contributions were often not kept. Moreover, the number of painters and illustrators who could be used was very limited. These difficulties were probably ideological rather than financial. The party seems to have paid quite reasonable honoraria; we know that the *Wahre Jakob* paid over 8,000 Marks for illustrations in one year.[30]

The remainder of this chapter will discuss the May Day art for the period before 1914. The May Day illustrations of the Weimar period will form one of the subjects of Chapter 9.

In a formal sense 1 May was initially conceived only as an international demonstration in favour of the eight-hour working day, but it soon became more than that. It was widely regarded as the most sacred day in the calendar of the socialist working class, an expression of international working-class solidarity, the World Festival of Labour. The institution of May Day was decided on in 1889 at the international Socialist and Trade Union Congress, the forerunner of the Socialist and Labour International, which assembled in Paris in July of the same year. The date of the Congress was chosen for its symbolic significance as a centenary celebration of the French Revolution and in some way the spiritual tradition of May Day thus goes back to the first revolution with a socialist flavour.[31]

The event proved popular from the beginning, and the first May Day celebration brought hundreds of thousands of workers out into the streets and to meetings and demonstrations. After the 1890 meeting in London's Hyde Park, Friedrich Engels wrote to Laura Lafargue, Marx's second daughter, that he must have looked a couple of inches taller when he got down from the old wagon that served as a platform, 'having heard again for the first time in 40 years, that is since the days of the Chartists, the unmistakable voice of the English proletariat'.[32]

Observers in other countries, too, referred to the great tendency of that first demonstration to produce solidarity. For Victor Adler, the veteran Austrian socialist leader, it had been 'like the ploughing up of virgin soil. Where neither programmes nor oratory had any effect, there the May Day celebrations had struck roots so deep that they could never be taken out.'[33]

The vigour of Germany's May Day demonstrations is evident from the large body of visual material which was produced from the beginning. This took the form of drawings, prints, posters, leaflets, special postcards, flags, banners and even medals. Thus, to commemorate the first May Day, the SPD had a medal struck. On one side was a relief of the Statue of Liberty with the text 'in Memory of May 1 1890' and on the other the head of Marx surrounded by the words 'Proletarians of the World Unite'. At the same time a watch manufacturer advertised a pocket-watch the design of which reflected current May Day ideals. The cover showed a miner and an ironworker shaking hands in front of the Goddess of Liberty, who wore a laurel wreath in place of the more common Phrygian cap. An inscription along the rim read 'Workers of the World unite for the defence of your liberties', and engraved on the rim of the watch-face were the words 'We want to work for eight hours, rest for eight hours and educate ourselves for eight hours'.[34]

It is the quaint and the fantastic, but above all the emotional and
the emotive, the allusive and the allegorical in these illustrations which
should attract our attention. May Day art was true mass art: it prob-
ably reached a large section of the politically and industrially organ-
ised working class and transmitted to them aesthetic values and images
of themselves and their world and ideals.

May Day illustrations not only reflect the ideological content of
the event, they also mirror the ritual itself. The celebrations had a
highly visual character. There were marches and demonstrations with
banners and flags, as well as popular fêtes with musical offerings,
recitations, dancing and games. The event thus nearly always had a
dual character. It was both an assertion of the strength of the working
class and an occasion for partying by the proletarian family. All this
is vividly pictured in the 1891 *Mai Zeitung* in an obviously highly
idealised form. The print (Plate 10) shows the cessation of work and
the demonstration, led by top-hatted workers marching behind a
banner with the inscription 'Liberty, Equality, Fraternity'. The assem-
bled crowd is being addressed by a speaker, a group of children are
at play and, finally, a very bourgeois-looking group is stretched out
in the forest in the fashion of the *Déjeuner sur l'herbe*.[35]

In line with the dual function of the May Festival, the contem-
porary illustrations were not only a reflection of the underlying ideals,
they also constituted a kind of pictorial record of the conduct of the
celebrations. One of the major issues of the First of May in Germany
was the choice of the actual date for the event. Conceived solely as
a popular festival, many May Day celebrations in Germany, as in
other countries, were held on the first Sunday in May. But many sec-
tions of the SPD and the unions also believed that an international

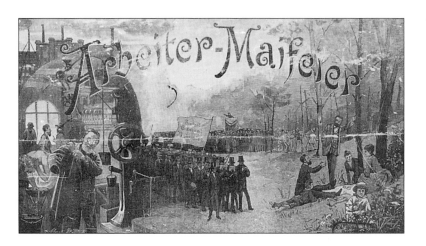

10 *Arbeiter Maifeier,
Mai Zeitung* (1891)

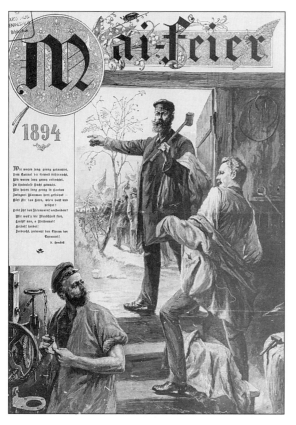

11 Title-page, *Mai Zeitung* (1894)

demonstration in favour of an eight-hour working day should be a show of primitive solidarity with the force of a strike and that May Day should be celebrated on the actual date. Then workers would absent themselves from work, losing wages, but lending added conviction to the demonstrations.

The choice of date for the celebration of May Day formed a central issue in the contemporary discussion within the SPD and in the trade union movement. The leadership of the latter demanded that workers who were locked out after having been absent on May Day should be compensated for loss of wages, while the party leadership urged holding the major demonstrations on Sunday. The issue and the character of the conflict are reflected in a number of contemporary illustrations, as in the cover of the 1894 broadsheet, which shows one worker leaving for the demonstration, while another stays at his machine (Plate 11).

The festive character of May Day as well as the problematic issue of whether to stop work is brought out in a later drawing (1907), which is almost like a triptych. In the centre we see through the window of a workshop a procession led by the figure of Liberty, who carries the May Day banner. On the right wing a mother and her children, dressed in their Sunday best, are preparing to join the celebrations. Everyone seems to join in; only the home worker, shown in the left wing, is tied to her work. The whole tableau is surrounded by a spring garland which, in the words of the commentary, reminds the reader that May Day was also a festival of nature.[36]

These two illustrations are unusual in May Day art because they portray aspects of working-class life in a realistic way. Even this representation of aspects of home and work is subtly sanitised and idealised. At a time when bourgeois artists painted men and women at work, and when bourgeois sympathisers with the German Social Democratic Party, like Kollwitz and Baluschek, showed the living conditions and suffering of the proletariat in their work, the social democratic May Day illustrations tended to neglect 'social art'.[37]

A May Day appeal of the SPD addressed itself 'to the oppressed and the burdened' and urged them 'to leave their hovels and their cellars, quit workshops and factories' and celebrate May Day. Yet the everyday life of the proletariat, the oppressive workshop and the often dismal and generally overcrowded working-class home, is barely reflected in May Day art. The men and women in these illustrations are nearly all tall and well-built, their eyes are clear, their gaze is steady. There is no obvious evidence of life near the poverty line or of the deformities of the body as the result of hard and unhygienic work.

It would be easy to ascribe such apparently biased visual reportage to ignorant or romanticising misrepresentation on the part of bourgeois, and perhaps non-socialist, graphic artists. The truth is probably more complex. In whatever way such illustrations came to be commissioned or executed, they were probably received by working-class readers as a welcome pictorial idealisation, a deliberate overcoming of reality in the special circumstances of this first-ever working-class holiday.

On the face of it it is less obvious why, seen collectively, the portrayal of workers in the 1 May broadsheets should so frequently present an antiquated picture of the social character of the working class. Following Germany's late industrialisation, the labour force was moving away from handicraft to factory-based production and from small workshops to medium-sized and large enterprises. The May Day illustrations reproduced predominantly craftsmen and artisans and representatives of older traditional trades. Thus an allegorical drawing in praise of Labour in *Der Wahre Jakob* in 1892 shows children and youths, who clearly represent the future, carrying aloft the symbols of the various crafts, as if Germany was still operating a guild system.

The *Mai Zeitung* of 1892 published a souvenir print by Heinrich Scheu, the London printer and engraver who in the previous year had engraved Walter Crane's large tableau *The Triumph of Labour*. The print (Plate 12) is dedicated to the German workers, but the group, which pays homage to the Goddess Liberty, is hardly representative of the addressee. It comprises a miner, a blacksmith, a farm worker and a ledger clerk. Only the figure laying a wreath at the foot of the plinth may represent the unskilled labourer. The plinth is inscribed 'All men are born equal and they are of noble descent'. The restricted view of the working class in such allegorical drawings reflects more accurately the character of the actual membership of the SPD and of the trade unions than that of the whole class. The early unions recruited their members largely from the ranks of the skilled workers,

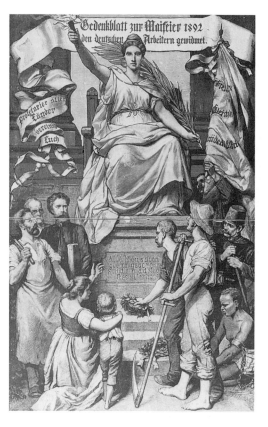

12 H. Scheu,
*Gedenkblatt zur
Maifeier, Mai Zeitung*
(1892)

and the party included many artisans still working in small workshops as well as small independent tradesmen, publicans and white-collar workers.

I am not trying to suggest that the readers of the *Mai Zeitungen* saw in such illustrations a sociologically correct portraiture of their own situation. What the emphasis on crafts, skills and traditions may well have done is to confirm in the German worker the value of virtues often associated with artisans, namely honesty, sobriety, pride in workmanship and the pursuit of knowledge. It is likely that many of the bourgeois graphic artists who drew for the socialist press and who worked largely in the tradition of genre painting or *Historienmalerei* saw the organised working class in that light.

Images of May Day often blend older, non-socialist and, indeed, non-political traditions with the pictorial message of the workers' celebrations. The month itself links the tradition to spring and to the renewal of nature; older festive traditions became incorporated. Socialists all over the world celebrated May Day, and the Austrian socialist party sought to link the celebrations of the working-class struggle to older folk customs.[38]

In Germany, and especially in the larger urban centres, where the strength of the SPD was concentrated, there was less scope for such expansion of May Day customs, but they nevertheless incorporated some of the imagery and we can trace their pictorial roots in some of the illustrations. A drawing of 1894 refers us back to older traditions of religious processions, with banners and swirling flags, and to customs connected with the celebration of spring and to the *Mai Spaziergang*, the tradition of townsfolk walking out of the city into the countryside (Plate 13). At the same time, however, the drawing alludes to the Rights of Man with a larger-than-life figure of Liberty who is holding a flag which carries the words 'Liberty, Equality and Fraternity'. She indicates the lateness of the hour by pointing to 'the clock of socialism' which stands at five minutes to twelve. The revolutionary slogan is repeated in the banner, which also shows the naked figure of Liberty. The cap of Liberty, carried aloft on a pole, completes the symbolism.[39]

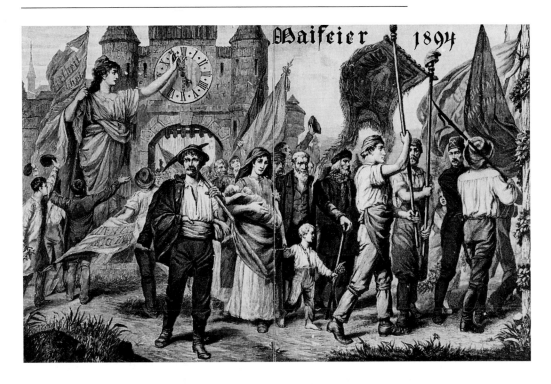

Maifeier 1894

13 *Maifeier, illustration in Mai Zeitung* (1894)

The figure of Liberty was, especially during the early years, at the heart of many of the 1 May allegories. She is often shown bare-breasted and, as in this drawing, carrying or waving a flag. She nearly always wears the Phrygian cap of the revolutionaries, well known from Delacroix's seminal painting of 1830 *Liberty Leading the People on to the Barricades*. Delacroix's tableau clearly legitimises the violent struggle; his Liberty is very much a fighter, modelled most likely on the figure of Marie Deschamp, the legendary fighter of that revolution.[40] In the social democratic canon of illustrations, on the other hand, Liberty is generally half goddess and half genius, sometimes associated with learning as well as with the workers. Only later does she become a model fighter. With all her attributes she may be seen as the personification of social democracy, and she is occasionally referred to as such in May Day illustrations.

This emasculation of a strong symbol is not surprising. The SPD's rejection of violence as a weapon in the political struggle was not dictated solely by the tactical considerations already referred to. The SPD admitted that it sought a complete change in the economic and social order but asserted that this would not be achieved by insurrectionist means. It would follow on the inevitable breakdown of the existing economic order. The inability of the bourgeoisie to steer the ship of state out of the political shoals would then bring the representatives

of the broad masses of the population to power. The Social Democratic Party, in the words of Karl Kautsky, its foremost theoretician, was 'a revolutionary, but not a revolution-making party'.[41]

The allegorical drawings which can be found in many May broadsheets tended to allude to the idea of a peaceful advance of the working class, to the mobilisation of strength in the fight for the cause and for the advance of the socialist ideas rather than to violence, let alone to an armed struggle. An 1897 drawing by Peter Bauer is full of allegorical references to the social advance which socialism would bring (Plate 14). It shows Liberty as the personification of progress. Her foot rests on the writings of Lassalle, Marx and Darwin. With one hand she holds the red flag, with the other she hands over the *Geistesschwert* (the 'sword of the spirit') to the clamouring masses. Its pommel is inscribed 'Knowledge is Power'. In the foreground a Clio-like figure discards the bourgeois policies of social reform, literally into the dustbin of history.[42]

The frieze surrounding the drawing shows scenes from the May Festival. Equally interesting are the allusions to the renewal of nature in the blossoms on the as yet almost bare fruit trees. Trees in bud or in blossom are frequently used symbolically for freedom or renewal

14 P. Bauer, *Das Geistesschwert, Mai Zeitung* (1897)

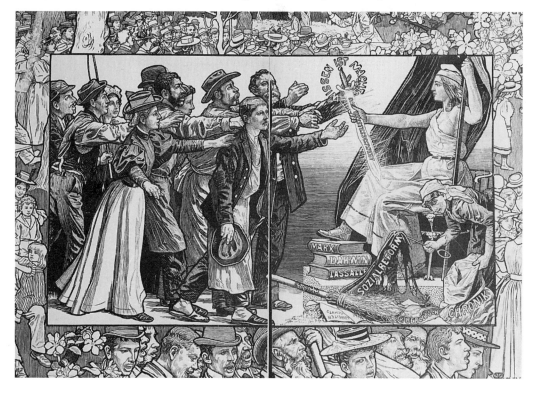

and for the awakening of the proletariat and its growing strength. The texts of the May Day broadsheets, and especially their poetry, are full of allusions to spring and to the joys of nature. The proletarian May Day celebrations were a manifestation of the 'upward thrusting young world, which in springtime hears the clarion call of a new era'.[43]

Other attributes of Liberty in her goddess-like role are the palm leaves (peace) and the torch, which obviously stands for progress and enlightenment which comes from the spread of socialist ideas. The conflict of light and darkness, with the sun symbolising the ultimate goal of the New Society, also figures frequently in May Day illustrations. Thus a double-page drawing, with the caption 'The morning arises, the night sinks below, the great May Day awakens', shows the torch-carrying, Liberty-like female figure of the New Day beckoning a male figure who struggles to free himself from the clutches of Night (Plate 15). Night herself, half alluring woman, half beast with claws, represents the baser instincts, but she is also a symbol of the old world, which socialism seeks to overcome. A shattered cannon and a broken sword, symbols of socialism's fight against the dangers of war, complete the allegory.[44]

More positive and more obvious in its use of cosmic or spring symbolism is a drawing by Stassen for the 1904 *Mai Zeitung*, entitled *The New Day*. Here the naked – that is pure – figure of a youth, wearing the cap of Liberty and carrying a red flag, greets the Promethean charioteer whose head also represents the sun. The whole image mixes

DER MORGEN STEIGT. ES SINKT DIE NACHT. DER GROSSE MAIENTAG ERWACHT.

15 O. Galle, *Der Morgen steigt, Mai Zeitung* (1898)

Greek mythology, revolutionary symbols and signs of seasonal renewal following the rising sun. As a symbol of light, rationality and progress, the sun has a central place in socialist imagery. Its rising glow can be linked to the red of the workers' flag and the Red Dawn is equated with hope. The 1919 May Day postcard here reproduced (Plate 16) uses a design originally published in 1911. Here, too, the rising sun is a central symbol. Pointing to the dawn rays and to the single file already on the march, a worker seeks to waken his comrades and to join what looks more like a procession than a demonstration.[45]

16 USPD May Day Celebrations Nürnberg, postcard (1919)

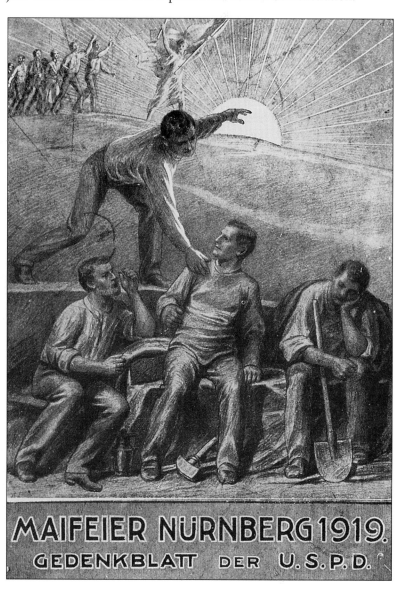

MAIFEIER NÜRNBERG 1919.
GEDENKBLATT DER U.S.P.D.

The Goddess of Liberty and the rising sun are ethereal symbols. They stand for the hope for a better future, even the certainty of progress. Such allegories continued to be used in the official art of the German Labour Movement throughout this period and beyond. Moving specifically into the new century, the themes and style of May Day illustrations underwent a subtle change. There are more images relating to the political struggle, to the breaking of the chains which fetter the workers and to their forging the weapons for the struggle or planting the red flag firmly in the ground.

The figure of Liberty is taken down from her pedestal to become a standard bearer at the head of the proletarian army. In 1912, after the SPD's truly amazing victory at the polls, a double-page illustration shows her half-naked and barefoot carrying the red banner at the head of a vast throng (Plate 17). Possibly more than any other May Day illustration of that period, this print expresses what Rosa Luxemburg called 'the belief in the massive pressure exercised through the linking of arms'. This solidarity, she went on, had led to the institution of the May Day demonstration which 'increasingly governs the struggle of the international proletariat'.[46]

17 M. (?) Fabian, illustration in *Mai Zeitung* (1912)

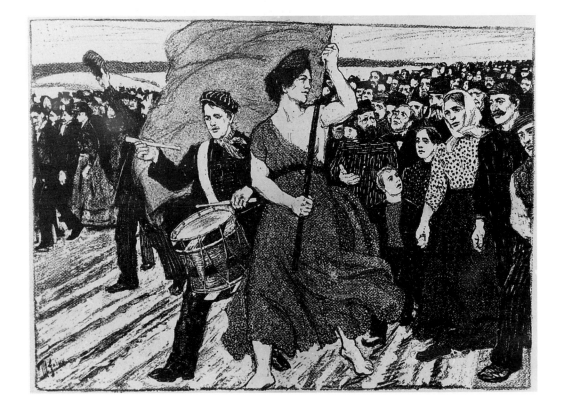

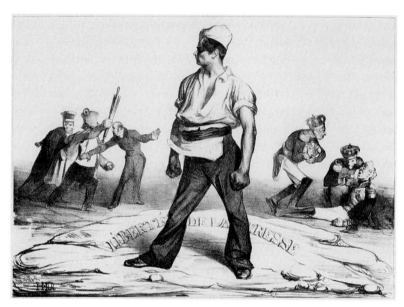

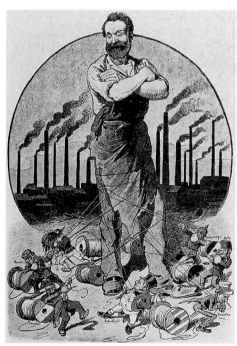

The mood of assertiveness and combativeness in these illustrations comes out even more clearly in designs based on the model of the 'giant proletariat', the figure of the larger-than-life worker of great strength, which is a major motif in the corpus of socialist emblems. We can trace this allegorical figure back to Daumier's print *The Freedom of the Press*, which was published in 1834 (Plate 18). The printer shakes his fist at the king and his clique with the words 'ne vous y frottez pas' – 'do not meddle'. The strength of the proletariat is also conveyed by a half-length portrait of a muscular worker, his arms akimbo, shown against an industrial background, as on the title-page of the 1907 *Mai Zeitung*. Or, taking a cue from the figure of Gulliver among the Lilliputians, it is shown in a drawing in *Der Wahre Jakob* in 1902, depicting the representative of the international proletariat towering unperturbed above the representatives of the national interests who have failed to fetter him (Plate 19).[47]

Why the twentieth century saw such subtle change in the character of May Day illustrations is difficult to establish now, and we cannot say to what extent the change in the imagery was due to deliberate decisions on the part of the

leadership of the SPD. But the movement from the heavily allegor-
ical to the more realistic chimes in with the changes in the charac-
ter of the party and with the new way in which it sought to mobilise
the masses.

In the years after 1900 the SPD formally organised itself on the
basis of fully self-governing local party units. Its membership was now
nearly four hundred thousand, and it reached over one million by
the outbreak of war.[48] Hence the meetings and the demonstrations
organised by the Labour Movement were now attended by thousands,
and the informal and spontaneous events such as the May Day cele-
brations assumed a more formal and organised character.

Evidence of the power of the social democratic organisation can
be seen after 1908 in the series of protest actions against the iniquit-
ous *Dreiklassenwahlrecht*, the electoral system based on income which
governed election for many *Länder* parliaments and for local coun-
cils. Especially in Prussia and Saxony this virtually precluded workers
from being represented in proportion to their numbers. Tens of thou-
sands of workers, men, women and children, took part in these
demonstrations. Although these protests were deliberately organised
on an informal basis as so-called *Wahlrechts-Spaziergänge* (franchise pro-
test walks), the 'fortuitous' coming together at central points gave the
whole enterprise the character of a mighty demonstration. The gener-
ally caption-less illustrations in the broadsheets conveyed the picture
of the masses demonstrating their solidarity. By giving women a pro-
minent place in these drawings, they also showed the importance
which the SPD now attached to women's political activity.[49]

The demonstrating masses, which are the theme of many drawings
in the broadsheets of the years before the war, might be seen as much
as documentation of events as the artistic expressions of an ideal. They
are thus contributing to the legitimation of a practice which the auth-
orities had long regarded as illegal. Before the age of photo-journalism
these contemporary illustrations were also, in an indirect way, a record
of actual events such as the mass protest of tens of thousands held
in 1910 on the large expanse of meadowland in Berlin-Treptow. An
observer wrote that 'the giant's body of the proletariat is spread out
before me, its mighty will and its resolve to do battle stands bodily
in front of me'.[50]

The demonstrations were thus in themselves image-producing
events for the spectator as well as for the participants. To heighten
this, a contemporary observer suggested that artificial elevations should
be erected on the route of the demonstration so that the marchers
could look out over the long train of the demonstration. The reader

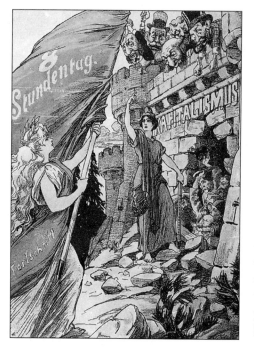

20 Otto Marcus, A New Year Present for which the Workers Hope, Der Wahre Jakob (1895)

of the *Mai Zeitungen*, looking at a drawing of only a small section of a march, would likewise be able to sense the larger procession. 'Even if we can not see it, we sense it. Thousands march ahead, hundreds of thousands are following behind. It is the large and never-ending column of the socialist army'.[51]

German May Day art concentrated on images of the celebrating and the congregating aspect of the proletariat. Political controversy, suffering workers and the industrial struggle are largely absent from the illustrations. The large strikes by miners, dock workers and others, which characterised the first decade of the twentieth century, find no echo in the broadsheets, nor does the extensive and heated discussion about the use of the mass strike as a political weapon, which agitated the SPD during the decade before 1914.

We find more relevant presentation of the everyday life of the proletariat in the two socialist satirical magazines, but even here the treatment of the working class or of its capitalist opponent is often allegorical. Thus a 1895 drawing by Otto Marcus, one of the earliest illustrators of the working-class press and one who actually supported the SPD, shows Liberty, armed with a cudgel inscribed 'Social Democracy', breaching the wall of the fortress of Capitalism. She is welcomed by the future in the shape of a young child, while pygmy-sized capitalists are forced to look on powerlessly from the battlements (Plate 20). An ideologically more realistic image is a drawing of 1904, occasioned by the brutally suppressed strike of the textile workers in Crimmitschau with the caption 'In the service of Moloch – as in Babel so in Crimmitschau' (Plate 21).

Realistic illustrations of working-class life are often found in pictures which contrast the fate of the poor with that of the rich. In a 1912 drawing Willibald Krain shows the social and economic gulf between the classes in the form of an apartment block. On the first floor the Banker Meier's one-child family occupies a six-roomed apartment, while cobbler Müller's six-child family lives in a one-roomed cellar.[52] A similar contrast is brutally brought out in a drawing in the 1894 New Year's Eve issue of the *Süddeutsche Postillon*. Captioned 'In the sweat of thy brow thou shalt eat thy bread', it shows the rich drunkenly celebrating the advent of the New Year while in a

drawing beneath it the factories, working at night, symbolise the hard life of the industrial worker.[53]

The contrasts drawn in these illustrations refer generally to aspects of the daily life of the bourgeoisie or of the proletariat. But occasionally the magazines illustrate more fundamental social conflicts, like the battle at the industrial front. As late as 1899 the government sought to restrict the freedom of the trade union organisation by trying to protect the Right to Work, in other words the right of a blackleg to break a strike, by threatening pickets with prison. An interesting drawing in the *Wahre Jakob* of 1904 combines the symbol of the 'giant proletariat' with the juxtaposition of opposites. Rata Lange, that is Gabriele Galantara, shows how the unorganised worker must kow-tow before the mighty capitalist. In a second drawing the picture is reversed and the capitalist is put in the position of the supplicant, once the worker has become organised (Plate 22).[54]

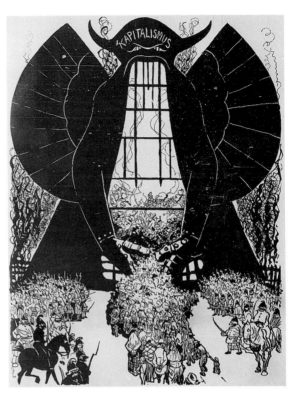

21 *In the service of Moloch – as in Babel so in Crimmitschau, Der Wahre Jakob* (1904)

Such double-take drawings and cartoons were to be used frequently in the political art of the German Left, and the relationship between political dialectic and visual art will be discussed later. They naturally fit best into the context of the political satire which was the mainstay of these magazines. But the *Wahre Jakob*, especially, would from time to time publish more straightforward portrayals of the life of the proletariat. More 'pure' art can also be found in the magazine and in other publications which would come to the notice of the German workers.

Stylistically the drawings which we find in the May Day broadsheets or in the satirical magazines do not differ from illustrations in bourgeois publications and, given the fact that most of the illustrators had no specific links with the Labour Movement, this is not surprising. What is more, there are similarities in the symbolism of the different kinds of art. Neither the landscapes nor the rural scenes nor the decorative borders with their echoes of *Jugendstil* (as in Plates 14 and 15) which are used in the workers' press are very different from

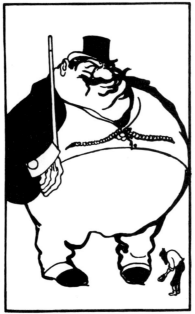

22 Rata Lange
(pseudonym for
Gabriele Galantara),
*Capital and Labour,
Der Wahre Jakob* (26
January 1904)

those found in similar bourgeois publications. Indeed some of the
allegories in the May Day art invite comparison with the drawings
and the paintings of the historical school. The early art of the Labour
Movement used some symbols which we also find in the all-pervading
and generally pompous 'public art' of the *Gründerzeit*.[55]

The years between the founding of the German Empire and its
defeat in the First World War saw the erection of a whole series of
monuments, many commemorating individuals or events important
in national history. The figure of Germania crowning the Niederwald-
Denkmal to commemorate the victory over France is only one but
highly elaborate example (Plate 23). Some designs of 'Liberty' present
her likewise in monumental form, though with emblematic representa-
tions, as in the May *Schmuckblatt* of 1892, reproduced in Plate 15.

Similar female figures, personifying cities or symbolising virtu-
ous attributes such as invention or industry, were published in the
Wilhelmine period. They were issued for public or private anniversaries
or jubilees, reproduced on medals, on posters of exhibitions, diplomas
or other public or commercial documents. They must have been seen
by many workers and received by those who had successfully completed
their apprenticeship or acquired a master diploma or other testimonial.
We cannot establish how workers reacted to such visual imagery which
affirmed the existing political and social order almost everywhere. They
will mostly have been aware of the partial congruence of socialist and

nationalist symbols, and this must have led to some confusion in the interpretation of images, some of which rejected and others of which affirmed the existing order.

The committed political art of the period reached a substantial section of the German working class before 1914, but it was not always the only art. With this hypothesis in mind we shall be in a better position to discuss the wider question of the relationship of contemporary art and working-class consciousness and aesthetics. We shall also be able to consider to what extent the images presented to the socialist workers were unique or how far they formed part of a wider imagery, used in other political contexts.[56]

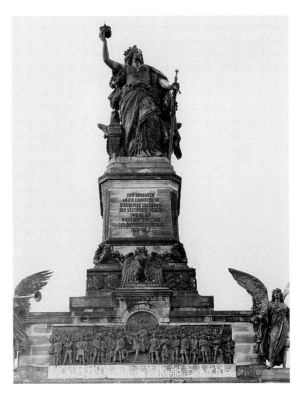

23 Niederwald-Denkmal showing Germania (c. 1900)

NOTES

1 For the early German Labour Movement see E. Schraepler, *Handwerker-bünde und Arbeiterpolitik, 1830–1853* (Berlin, 1962); W. Schmierer, *Von der Arbeiterbildung zur Arbeiterpolitik: Anfänge der Arbeiterbewegung in Württemberg* (Hannover, 1970); F. Balser, *Sozial Demokratie: Die erste deutsche Arbeiterorganisation, 1848/9–1863* (Stuttgart, 1962).

2 H. Gagel, 'Die Düsseldorfer Malerschule in der politischen Situation des Vormärz und 1848' in Düsseldorf, Kunstmuseum, *Die Düsseldorfer Malerschule* (n.d.); W. Hütt, *Die Düsseldorfer Malerschule* (Leipzig, 1964), pp. 107–10.

3 Hütt, pp. 58–9.

4 Hütt, pp. 102–3; Gagel pp. 75–6.

5 Hütt, p. 103.

6 On the general issue see E. P. Thompson, 'The Moral Economy of the English Crowd in the 18th Century', *Past and Present*, 50 (1971), pp. 76–138.

7 F. Engels, 'Rascher Fortschritt des Kommunismus in Deutschland', *Marx Engels Werke* (Berlin, 1958–), 2, p. 510; Hütt, *Düsseldorfer Malerschule*, p. 103.

8 *Düsseldorfer Zeitung*, 211 (1845), quoted in Hütt *Düsseldorfer Malerschule*, p. 76.

9 Hasenclever's painting was taken by Ferdinand Freiligrath to London. It was shown there in 1851, in Manchester in 1852 and finally in New York in 1853 (Hütt, *Düsseldorfer Malerschule*, note 2).

10 See P. Paret, *Art as History* (Princeton, 1988), pp. 97–120. Menzel's ambiguous attitude to the painting is suggested by the fact that he kept it in his studio and did not finish it. The Neue Kirche was later re-named Deutscher Dom (German cathedral) in distinction to the Französischer Dom (French cathedral) at the other end of the square.

11 See Ute Ricke-Immel, 'Die Düsseldorfer Genremalerei' in Hütt *Düsseldorfer Malerschule*, pp. 149–64.

12 The titles of the paintings are taken from the *Düsseldorfer Malerschule*, note 2. On social aspects of Victorian painting see J. Treuherz, *Hard Times: Social Realism in Victorian Art* (London, 1987).

13 On Meunier see Berlin, Neue Gesellschaft für Bildende Kunst, *Constantine Meunier*, exhibition catalogue (Berlin, n.d.); W. Gensel, *Constantine Meunier* (Bielefeld and Leipzig, 1905).

14 See M. Kaiser, *Das Eisenwalzwerk* (Berlin, 1953).

15 R. Michels, 'Die Psychologie der anti-kapitalistischen Massenbewegungen', *Grundriss der Sozialökonomik* (1926), pp. 241–359 at p. 267.

16 On the social and psychological aspects of the life of the industrial labour force in Germany at the beginning of the twentieth century see the reports of an enquiry undertaken by the Verein für Sozialpolitik under the title *Auslese und Anpassung der Arbeiterschaft in der geschlossenen Grossindustrie* and published in a number of volumes around 1910.

17 See F. P., 'Die Arbeit in der Bildenden Kunst', *Neue Zeit*, 22, 2 (1903–4), pp. 22–9.

18 K. Kollwitz, *Die Tagebücher*, ed. J. Bohnke-Kollwitz (Berlin, 1989). These quotations are taken from a series of autobiographical essays written by the artist between 1923 and 1943 and reprinted in this volume on pp. 715–47. On Kollwitz in general see Elizabeth Prellinger, *Käthe Kollwitz* (Washington and London, 1992).

19 *Ibid.*, p. 729.

20 *Ibid.*, p. 741.

21 She received a gold medal in Dresden one year later in 1899. Cf. Prellinger, p. 100; P. Paret, *The Berlin Sezession* (Cambridge, Mass., 1980), pp. 212–14.

22 For other versions of this etching and of drawings connected with the *Peasants War* cycle but not incorporated in it see Prellinger, pp. 31–9.

23 With her poster for the 'Heimarbeit Ausstellung' (Homework Exhibition) of 1906, which shows the head of a desperately tired outworker, Kollwitz came again into conflict with authority, this time in the shape of the Empress. Prellinger, pp. 106–8.

24 H. Baluschek, 'Im Kampf um meine Kunst', in Berlin, Staatliche Kunsthalle, *Hans Baluschek, 1870–1935* (exhibition catalogue) (Berlin, 1991), pp. 72–8 at p. 75.

25 M. Brohan, *Hans Baluschek* (Berlin, 1985), p. 51.

26 *Ibid.*, p. 44.

27 In his speech at the conclusion of the debate August Bebel attempted to reconcile the two factions. He agreed that there were many people in the party 'who held radical views on political and economic matters but were very conservative when it came to literature and the arts'. On the other hand, he added, 'a party such as ours, which is reformist in all areas, cannot in literature and the arts take a stance which is widely regarded as old-fashioned'. See Georg Fülberth, *Proletarische Partei und bürgerliche Literatur* (Berlin and Neuwied, 1972), esp. pp. 94–100.

28 Review by Hugo Heller of Max Lehr, *Käthe Kollwitz* (Vienna, 1902) in *Neue Zeit*, 2 (1902/3), pp. 50–60.

29 The *Süddeutsche Postillon* was at times censored or prohibited.

30 See SPD Parteitag, 1902 for Fischer's statement on pp. 270–1.

31 The choice of 1 May was due to the American practice of 'Moving Day', the day when rental contracts were renewed or changed and when hiring fairs were held.

32 Friedrich Engels, *Paul & Laura Lafargue, Correspondance, 1868–1895* (Paris, 1956–59), 2, p. 396.

33 Cf. J. Braunthal, *Geschichte der Internationale*, 3 vols (Hannover, 1961–71), 1, p. 255 cited from V. Adler, *Aufsätze* (Vienna, 1929), vol. 1, p. 73 and vol. 6, p. 191.

34 See *Arbeiterkultur um 1900* (Berlin, 1984), p. 57. Similar watches, made in Italy, are reproduced in *Memory of May Day* (Fondazione Giancomo Brodolino, Venice, 1989), pp. 326–7.

35 Many of the illustrations in the *Mai Zeitungen* appeared anonymously. For a list of illustrators who could be identified see Appendix 1.

36 See 'Der Erste Mai und die Kunst', *Mai Zeitung* (1907). The *Mai Zeitungen* for the period 1891–1914 are reprinted in a volume introduced by B. Achten under the title *Zum Lichte empor* (Bonn, 1990).

37 In the *Mai Zeitungen* 'there was little by way of social art' – critical drawings of comparatively minor aspects of life – such as as we find in the politically liberal *Simplicissimus Der Wahre Jakob*, 385 (1901).

38 In Austria the social democrats made special efforts to incorporate older rural and folk customs into the May Day ceremonies. See H. Troch, *Rebellensonntag: Der Erste Mai zwischen Politik, Arbeiterkultur und Volksfest in Oesterreich, 1890–1914* (Vienna, 1991), pp. 109–34.

39 The position of the hands of the clock translates the belief, relatively widely held at the time, that the end of the capitalist system was close and might indeed come overnight. Bebel relates that he went to bed every night with the thought that the end of the capitalist system might come on the very next day.

40 Delacroix's famous picture was painted during the revolution of 1830. It was bought by the state and exhibited but removed into storage on the restoration, to be brought out only during the Second Republic. Only one print was made of the original, and the popularity of the painting in terms of later copies, illustrations and the 'borrowing' of the allegory of Liberty is intriguing and, as far as I knows, as yet unexplored.

41 See also Kautsky's article '1784–1848–1905' in the *Mai Zeitung* (1908), referring to the much greater likelihood of revolutions in Europe as the result of the Russian Revolution.

42 The reference to the *Geistesschwert* is not only allegorical. It also alludes to a line in the 'Arbeiter-Marseillaise', one of the earliest and most popular socialist songs. The words were by Jacob Audorf and it was sung to the tune of the 'Marseillaise'. The relevant verse runs as follows: 'Der Feind den wir am tiefsten hassen / der uns umlagert schwarz und dicht / das ist der Unverstand der Massen / den nur des Geistes Schwert durchbricht' (The enemy we hate the most, / the one around us, black and thick, / Is the ignorance of the masses, / crushed by the sword of the spirit).

43 See 'Festefeiern', *Mai Zeitung* (1894), p. 3.

44 For the interpretation of the drawing see 'Der Völker Maienmorgen' on p. 8 of the same *Mai Zeitung*.

45 See *Ein Hauch von Maienblüten* (Berlin, 1898), p. 100.

46 Rosa Luxemburg, 'Die Maifeier' in her *Gesammelte Werke*, 5 vols (Berlin, 1972–9), vol. 3, pp. 435–45 at p. 438.

47 The use of pygmy-like figures to depict capitalists etc. is not uncommon in socialist cartoons.

48 The membership of the social democratic trade unions grew fairly rapidly after 1890. From about 300,000 at the beginning of the 1890s it grew to 1,052,000 in 1904 and to 2.5 million in 1914.

49 For the suffrage protest movement of the SPD see *Als die Deutschen demonstrieren lernten* (Ludwig-Uhland Institut für empirische Kulturforschung, University of Tübingen, 1986).

50 See B. J. Warneken, 'Massentritt' in P. Assion (ed.), *Transformationen der Arbeiterkultur* (Marburg, 1986), pp. 64–79 at p. 65. See also an illustration from *Der Wahre Jakob* of 24 May 1910 reproduced in *ibid.*, p. 77.

51 Stephen Grossman in *Der Kampf*, 1 May 1980; 'Unsere Bilder', *Mai Zeitung* (1901).

52 *Der Wahre Jakob*, 674 (1912).

53 *Süddeutsche Postilion*, 36 (1894).

54 *Der Wahre Jakob*, 246 (January 1904).

55 On the historical school in German nineteenth-century art see *Historismus und Bildende Kunst* (Munich, 1969); R. Scholz, *Volk, Nation, Geschichte: Deutsche Historische Kunst im 19. Jahrhundert* (Rosenheim, [1969]).

56 H. Tittel, *Das Niederwald-Denkmal* (Hildesheim, 1979), plate 19; Hamburg, Museum für Kunst und Gewerbe, *Historismus in Hamburg* (exhibition catalogue) (Hamburg, 1977), especially Section VII: Künstlerische Dokumente.

The November revolution and the visual arts

A ny account of the interplay between the visual arts and the political ideals and practices of the German working class during the period of the Weimar Republic must start with the November revolution of 1918. The view that there had to be radical changes in society was already held before the war. The SPD had long prophesied the coming of the social revolution as a certainty, but the party had no blueprint for such an event. The need for social and political change was, however, widely felt, especially among the intelligentsia and the artistic avant-garde. The brutal and destructive force of the First World War lent further urgency to the debate on the sort of society which should follow. Many of the younger artists were affected by the horrors of the fighting. Some artists were killed, some escaped abroad, others feigned illness to avoid the draft. Among those who fought, several suffered breakdowns.

The latter included Max Beckmann, who served as a medical orderly during the early part of the war and mused about the future and about the prospect for a new and better social order. Before the war, the haste and the hankering after success had touched everybody. Beckmann now asked whether it was too much to 'hope for a lessening of business acumen ... [or] for a more vigorous pursuit of communist principles, which would lead to a growing love of things for themselves'.[1]

Beckmann was discharged in 1915 and he gradually returned to his art, especially etchings and lithographs. In a portfolio of ten lithographs with the title *Die Hölle* (Hell) he gives us a stark portrait of the violence, the permanent scars of the war and of the political radicalism of Berlin in the early months of 1919. The drawings show in intricate detail the private sorrow and the public political struggle of the revolution. Beckmann does not take sides, nor does he hide things. He draws a gathering of amputees around a barrel-organ, the last of the revolutionaries shooting from their attic and, in a print entitled *Martyrdom*, depicts what is probably the murder of Rosa Luxemburg by soldiers of the right-wing Freikorps (Plate 24).

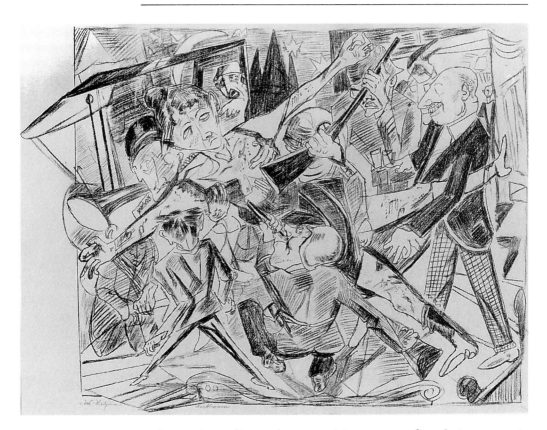

24 Max Beckmann, *Das Martyrium* (Martyrdom), from *Die Hölle*, lithograph (1919)

25 Jakob Hirsch, *Karl Liebknecht in a halo*, from *Die Aktion*, woodcut (1919)

A more immediate and more positive account of revolutionary sentiment comes to us from Karl Jakob Hirsch, another artist, who spoke of

the hour of Liberation when we were inwardly prepared to throw everything overboard, the old and the ballast. What did form mean to us; it was a question of content. And that was given. Liberty, Equality, Fraternity. Ours was not the task to paint the flagstaff well, all we had to do was to show the conviction of the fluttering flag. Long pent-up forces were released and pushed forward into the masses. And the masses were receptive, ... in a thrice proletarian exhibitions and theatres sprang up.[2]

With so positive an attitude towards the revolution it is not surprising that, following the murders of Liebknecht and Luxemburg, Hirsch should produce for the cover of the left-wing journal *Die Aktion* (Action) a memorial woodcut showing Liebknecht with a halo (Plate 25).

The German revolution, unlike its counterpart in Russia in the autumn of the previous year, did not lead to radical economic and social changes. This should not blind us to the fact that the November revolution produced major changes in German political institutions and

in the formal distribution of power. These in turn had a significant and beneficial impact on the visual arts and on access to them.

At least at first, a new and more liberal spirit was abroad, which stimulated the arts and encouraged the avant-garde.[3] The public purse was slightly more open in supporting the arts. The working day was by and large reduced to eight hours and the working class, hitherto so disadvantaged, now had more leisure time, more power and more encouragement to enjoy the arts.

But Germany's belated and improvised revolution suffered painful traumas at its birth which were to affect the political life of the state created by the revolution which was to cause its brutal extinction fourteen years later. The formal change of power which took place in 1918 was not due to mass pressure from below, it was engineered from above. By the autumn of 1918, after four years of war, it had become clear that the army had been beaten, rather than stabbed in the back as it was later alleged. The Western Front had crumbled and thousands of ordinary soldiers had protested with their feet at the continuing slaughter and had simply walked home. Anxious to prevent what they saw as the danger of descent into anarchy, the leaders of the army, above all General Wilhelm Groener, the Chief of the General Staff, thought that only a radical change of government could prevent chaos.

The military recognised that the Social Democratic Party represented the only force in Germany capable of containing a threatened popular revolt, and vested the power of government in its representatives. The leaders of the Social Democrats, above all party chairman Friedrich Ebert, were moved by a mixture of patriotism and triumph at the death of the old order and were prepared to accept this role.

Military defeat achieved at last what fifty years of pressure from below had failed to bring about, namely Germany's bourgeois revolution. The constitution approved by the National Assembly which met in Weimar in 1919 introduced a parliamentary system of government which most other industrialised countries had already achieved during the nineteenth century.[4]

The new government had constituted itself as the *Rat der Volksbeauftragten*, the Council of People's Representatives. It consisted of three members each of the SPD and of the USPD, the Independent Socialists, who had split from the majority in 1917. The first, in particular, were cautious men and the second group soon left the government. Entrenched in party bureaucracy, and mindful of the real danger of chaos and anarchy, the SPD representatives were above all concerned with the establishment of order. They saw it as their

principal task to return as quickly as possible to normal conditions, ensure adequate food supplies and to re-start industry.

The introduction of economic stability and the return to 'normality' was thus one of the government's primary concerns, but its members were equally anxious to see the revolutionary emergency ended and the government legitimised. With this in mind, they resolved to call a National Assembly so that legal government could be established and a new and democratic constitution could be prepared. The date for the election was fixed for 19 January 1919, little more than two months after the revolution. There was apprehension and opposition to the early date, but the proposal was accepted by a majority of delegates at the Berlin National Congress of Soldiers' and Workers' Councils. The election to the National Assembly saw the SPD emerge as the largest party, but it failed to gain a majority of seats.

The Weimar Constitution had introduced universal adult suffrage and established an electoral system based on proportional representation. This gave even political minorities a chance to mobilise support and gain seats but it made it difficult to establish a strong and stable party system.

On the positive side was the fact that the new constitution was based on liberal and democratic principles and that it incorporated elementary political rights and individual freedoms which should have laid the foundation for an open and tolerant society. The Weimar Constitution proclaimed that 'the liberty of the person is inviolable, it can only be diminished by legislation'. Freedom of expression was also enshrined in the constitution, which declared that it was 'a right which took precedence over others, especially material possessions, provided that the ideas are propagated only through their expression in intellectual form'. The constitution also gave greater freedom to independent associations and institutions and laid down that the practice and propagation of the arts and sciences should proceed unhindered within the limits of the conventions established by artists and scientists.[5]

In spite of the general upheaval and at times the violent conflict, the reforms ushered in a period of optimism, intellectual speculation and open-mindedness in Germany. With this came a more vigorous debate on political and cultural matters which found expression in a range of new journals and magazines and in new associations of artists and intellectuals. Many of these propagated the ideas of the artistic avant-garde and sought to disseminate these among the masses. Not all endeavours, however, were in full support of the new state and

many individuals and political groups wished to carry the revolution further. Other members of the avant-garde were politically neutral or even identified with the political Right. Yet throughout most of this period the intellectual forces of the Left had a significant influence on cultural and artistic life. What the political Right condemned as the 'System of Weimar' was a fertile breeding ground for artistic experimentation and innovation.[6]

In the arts, and in particular in the visual arts, the strangeness of many of the new experiments and their often distorted forms and the frequent flouting of artistic tradition prompted opposition from more conservative sections of the population, including many members of the middle class and the professions who had lost out from war and inflation. This cultural opposition merged with the political opposition from nationalist forces who referred to the new trends as 'cultural Bolshevism', thus bringing them into the arena of party political discussion.

Opposition from the Left to the cautious, if not conservative, policies of the government came from the ranks of the Independent Social Democrats (Unabhängige Sozial Demokratische Partei Deutschlands, USPD) and was even more pronounced in the Spartacus League, the forerunner of the German Communist Party, which had itself emerged from the left wing of the USPD. The Spartacists, led by Liebknecht and Luxemburg, claimed to be the real revolutionaries. Liebknecht stated this view as early as 9 November 1918, when he proclaimed the socialist republic from the balcony of the Royal Palace, almost at the same time as Philip Scheidemann, the joint leader of the SPD, declared the foundation of the democratic republic from the steps of the Reichstag.

The Communists wished to drive the revolution further and were willing to use force for that purpose. They challenged the government in Berlin through an uprising. Fighting began in January 1919 and continued in the capital and elsewhere throughout the winter. The Communist Party (Kommunistische Partei Deutschlands, KPD) was at that stage still a small band of political activists but it had the sympathy of sections of the Independent Socialists and it could exploit widespread disillusionment at the limited gains which the revolution had produced so far.[7]

Independent Social Democrats and Communists pursued their opposition mainly through the Räte, the Workers' and Soldiers' Councils. Modelled on the Russian Soviets, they sought to control the administration at the local level. In the aftermath of the revolution, *de facto* political power over large stretches of the country was

indeed in the hands of these local *Räte*. In many cities they virtually controlled such matters as the supply of food and fuel, which needed urgent attention and firm executive action.

But these new vehicles of political control generally had little time for less urgent issues, like culture and the arts. Only in Bremen and in Munich did this movement, the *Rätebewegung*, go further and establish short-lived Soviet-style governments in the form of Räte Republiken, which sought to introduce changes, including founding new institutions in the arts and education and encouraging discussions of cultural matters.[8]

This was notably so in Munich, where a number of writers and artists such as Kurt Eisner, Gustav Landauer and Erich Mühsam played a leading role in the council government and where the arts received correspondingly extensive attention. Under Landauer's influence a wider circle of artists and intellectuals were mobilised in the Aktionsausschuss Revolutionärer Künstler (Special Executive of Revolutionary Artists). This body claimed 'to represent all Munich and indeed all Bavarian artists [and] declares its support for the principles of Communism. It sees in the Dictatorship of the Proletariat the only true way for the realisation of a proletarian Council Republic and of Communism.'[9]

The Aktionsausschuss aimed to deal with all the visual arts, and its Committee comprised representatives of all branches of art, including Hans Richter for paintings, Alois Wach for graphics and Georg Schrimpf for crafts.[10] Most artists are said to have declared themselves in favour of Expressionism, which for them represented the revolutionary spirit on the pictorial plane. In their view this extended to drawings in the contemporary press where form should express the same spirit as content, so the reader could 'take in the revolutionary spirit also through the illustrations'. Such illustrations, mostly original woodcuts, were for a time during the life of the Soviet Republic a regular feature of the papers. One of these was Alois Wach's woodcut showing the liberated world after the revolution (Plate 26). If revolutionary artists made very high claims for the power of the arts this was because 'Art is bread. The oppressed and suffering creature hungers for truth and for beauty.'[11]

Gustav Landauer, Munich's Commissioner for Education, Art and Science, sought to extend the revolutionary policies of the new government to the arts and to art education, but during the short life of the Räte Republik he could not achieve practical results.[12]

Speaking concretely, Landauer envisaged changes in all institutions in the field of the visual arts. He said arts schools and academies

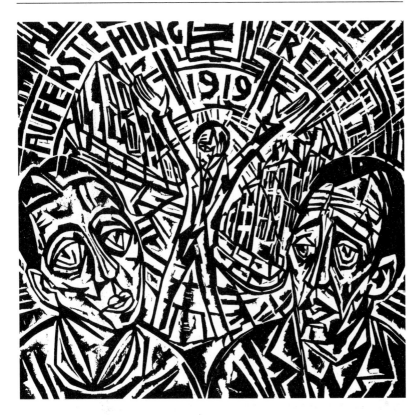

26 Alois Wach,
Der Weg (The Way),
title-page,
Süddeutsche Freiheit
(6 January 1919)

should be places of work. Artists should at first be treated like ordinary workers but be freed from daily tasks when their work had reached a certain level of maturity. Instead of pictures hanging in museums they should be on show in buildings freely accessible to the public and, above all, they should circulate in travelling exhibitions. Landauer envisaged the close co-operation of artists and architects in all new buildings.[13]

The radical policies proposed in Munich died with their advocates after right-wing loyalist forces occupied the city, removed the Soviet and brutally murdered its leaders in May 1919. The council-based institutions were short-lived and the movement itself generally declined or was forced out of existence with the reassertion of normal central or local government. Alternatively, as in the Ruhr, they were forced out by the violent intervention of central government.

However, the model of the Räte also encouraged intellectuals and artists to establish their own 'councils' in order to harness culture and the arts to the service of the revolution and the new state. Such bodies generally had no strong roots in the working class, but they aimed to make culture and the arts more popular. Thus the Rat

geistiger Arbeiter (Council of Intellectuals), established in Berlin almost at the time of the revolution, was a rather elitist gathering of intellectuals under the leadership of Kurt Hiller who, under the same linguistic umbrella, offered spiritual leadership independent of the *Rätebewegung*.[14]

A similar body, the Kunst und Kulturrat (Art and Culture Council) in Baden, had some links with the regional Workers' and Soldiers' Councils, but did not achieve a popular membership. Its members were mostly established liberal academics and artists. According to the local paper, the *Karlsruher Zeitung*, they accepted the aims of the new *Soziale Volksstaat*, the Social People's State, and they wished to assist in the creation of a *Volkskultur*, a common or people's culture, and to raise the cultural understanding and interests of the workers so that they could readily participate in the enjoyment of culture.[15]

The Kulturrat opposed all art which was merely an expression of luxury and educational privileges and it wished to make the institutions which furthered the arts, such as theatres, academies and museums, more genuinely popular and representative. Artists should be free from the 'creativity-destroying' dependence on the market. They should be given a secure economic existence so they could devote themselves solely to the creation of art for the public. The role of the museums was likewise expected to change, and they should become 'People's Houses of Art' instead of mere repositories of objects. The Kulturrat genuinely sought to make the arts more popular and avoid everything that was merely fashionable and exclusive, but its members did not wish to subject the arts to any sort of control, nor did they seek to build links with the political working-class movement. Indeed, of the people connected with the organisation, only one or two are known to have had links with the SPD.

Here was a highly idealised programme, advocated by a group of liberal-minded members of the bourgeoisie, who wished to raise the cultural level of the masses without subjecting existing culture to critical judgement. Elsewhere, under the harsh postwar material conditions, neither the government of the *Reich* nor the administrations of the *Länder*, which had had their own revolutionary upheavals to cope with, paid much attention to the visual arts. Yet in spite of all the problems, there was a great demand in the period for education, for cultural activities, for music and for the theatre and other forms of entertainment. 'It was hardly possible to find enough halls and enough lecturers to satisfy the demand.'[16]

The SPD registered similar sentiments when, at its party conference in 1919, it passed a resolution, proposed jointly by the Executive,

the Party Council and the Parliamentary Party, which said 'it is one of the most urgent tasks of the party . . . to initiate a comprehensive and purposeful system of cultural activities'.[17]

Visual art in its institutional and educational aspect, like all cultural and educational matters, was in Germany the responsibility of the *Länder*, who took charge of the administration of museums and were responsible for art schools and academies. In contemporary discussion these two institutions came in for critical scrutiny. The new radical artists' organisations wanted to reform art education, urging that training should be less academic and that artists themselves should have greater influence on the selection of teachers.[18]

They also demanded that museums should be more concerned with the education of the broad masses. In the new intellectual climate after 1918 the Museumsbund, an association of museums and galleries and their staff, called for action to make museums more popular, saying they should become more relevant and more responsive to the needs and interests of the broad masses, who traditionally never set foot in them. The association regretted that four-fifths of the population were virtually excluded from the enjoyment which can be derived from art. The fact that, throughout the greater part of the nineteenth century, education in art had been restricted to members of the bourgeoisie was in part responsible for the present prevalence of cultural mediocrity. Fortunately there were new stirrings, especially among the young 'who are hungry for beauty and seek exaltation'. They were eager to understand art and 'they show great modesty when faced with great art'.[19]

By contrast, the authorities themselves pursued a fairly careful policy. In a debate in the Prussian Landtag, Social Democratic deputies accepted the revolutionary claims of expressionist art, but even they wished it to be depoliticised. There was criticism of inadequate financial support of artists, many of whom were very poor, and of the great contrast between the living conditions of members of academies and experimental painters. Konrad Haenisch, the very right-wing socialist minister, promised to bring the working class 'into active and closest contact with popular artistic endeavours'.[20]

The parties of the Left were concerned with formulating ideas and policies for the arts. The SPD had from its earliest days thought it important for workers to attain a high level of education. They also sought to propagate a lively interest in culture. During the war all this had been largely left in abeyance. After the war, the position of the SPD shifted towards emphasis on cultural and artistic as against educational activities, leaving the latter mainly to the newly established

and politically neutral *Volkshochschulen* – the adult education colleges – which grew in numbers and importance during the 1920s. This shift in policy evidenced in part the strong position which the party now held in local government, so that it felt safe to entrust the colleges with educating its members. The shift also constituted an admission by the SPD that it could no longer singlehandedly satisfy the growing demand for education by workers who had now more leisure time for such pursuits.[21]

Compared with the increasingly reformist ideology and policies of the SPD we might expect a more radical attitude to culture from the German Communist Party, with its revolutionary programme. Initially this was not so. As the SPD had done nearly two decades earlier, the KPD published in 1921 a set of *Leitsätze zur Bildungsarbeit* (Guidelines on Educational Policy).

These were of a rather general nature. For Communists the struggle for working-class emancipation was also a struggle 'for the liberation of proletarian thinking and feeling from the superseded forms of bourgeois ideology and lifestyles as well as for the creation of a new culture'. The party stressed that it would make no concession to bourgeois institutions and that its educational and cultural activities were to be inextricably linked to the class struggle. In practice the party in its early years did not invest much effort in such activities and its members found an outlet for their cultural interests and for the enjoyment of their leisure almost exclusively in social democratic organisations.

Two years later, the Communist leadership planned local uprisings, which took place in Hamburg, Saxony and in the Ruhr, in the hope that this would lead to a nationwide revolution. In preparation for this event the party ordered the drawing up of a *Kulturpolitisches Notprogramm*, an emergency cultural programme.[22]

In this programme we find more concrete proposals about the future role of art and artists and greater claims for the visual arts than the SPD made at that time. The authors – Hermann Duncker, Gertrud Alexander and Karl August Wittfogel – envisaged that the arts should permeate the whole of public life. Pictures and posters should be used as visual propaganda, the streets should be decorated, workers' clubs should exhibit works of art and the training of artists should be improved. The programme proposed that all art education should be vested in the state and linked to technical training. Although there was no reference to the style and content of the art to be shown, the programme itself urged the removal of 'reactionary symbols, books and pictures' from museums and other public places.

Museums were to become 'generously funded institutions to show the material and intellectual social history of mankind'.[23]

The Communist Party, however, did little to translate its ambitious cultural programme into practice. If we look for attempts at the practical application of radical thinking about the arts in the proletarian milieu, we find it at the extremes of the political spectrum. We must go to those artists and intellectuals who held anarchist or syndicalist views or to groups like the oppositional Communists, the Kommunistische Arbeiterpartei Deutschlands (KAPD, Communist Workers' Party), who for a short time after 1918 attracted a fair measure of popular support. For such groups, the new 'proletarian' culture would be a culture not only for the proletariat but one in the creation of which workers would be actively involved. They held the view that a proletarian class-consciousness would not emerge just out of the daily economic struggle; it had to be nurtured and fostered and it needed institutions through which the arts could be brought directly to the proletariat. Bringing arts to the worker could not be done just from outside the working class; it needed the involvement of workers not only in the formal organisation but also through their participation in the actual production of art.

Thus the KAPD wrote in its 1920 programme that 'a decisive factor in hastening the social revolution is revolutionising the proletariat's entire mental view of the world. With this in mind, the party supports all revolutionary tendencies in science and in the arts.'[24]

According to such thinking, the development of class-consciousness and its mobilisation for the proletarian struggle could not rely solely on the actual experience of the worker in the industrial situation and in the class struggle to which this gave rise. It needed stimulation through cultural and artistic activities.

Such views received an impetus from the writings of Alexander Bogdanov, the father of the *Proletkult* movement in post-revolutionary Russia. *Proletkult* ideas stimulated some German intellectuals and artists who in the autumn of 1919 established the Bund für Proletarische Kultur (League for Proletarian Culture). In explaining its name the Bund referred back to the Russian origins of the term 'proletarian culture'. It 'seeks to respond to the clamour for a new culture and a revolution of the spirit'. In its first pronouncement the *Bund* reminded the public that the nationalist and militaristic bourgeois culture was still about and very active, and to counteract this the Bund wished to 'lay the foundations for a new proletarian culture'.[25]

The Bund was successful in as far as it managed to attract members from some groups of workers, shop stewards and other representatives

of the workforce of some Berlin factories. Claiming to write in the name of the revolutionary workers and artists, the leaders of the Bund, artists and intellectuals themselves, declared that they sought to wipe out the last traces of the culture of the contemporary class society from the consciousness of the proletariat 'as they had torn it out of their own hearts'.[26] In the past the workers had in any case been fobbed off with a 'pseudo-culture', and its disappearance would be no loss. In its place a new proletarian culture would arise, drawing on the rich and marvellous culture which slumbered within the depth of the working masses.

In practice, the Bund für Proletarische Kultur could during its short life hardly awaken such cultural forces. Of its many projected activities – lectures, concerts, exhibitions and the 'Proletarian Theatre' – only the latter was realised, but even this could not bridge the gulf between actors and their audience. In any case, the 'Proletarian Theatre' of the League was closed by the police after only six months because of the radical plays it put on.[27] It was only with its successor theatre, the Proletarische Theater under the direction of Erwin Piscator and Hermann Schüller, that a change took place. Piscator set out to demistify the theatre. He staged his plays in rooms attached to taverns and turned the theatre into a vehicle for instruction and propaganda. This affected the choice of contemporary plays and gave a tendentious slant to the productions of classical drama. He also tried, although with limited success, to use ordinary workers in some productions. Producers encouraged informal and unscripted discussion between actors and their audiences.[28]

The theatre, music and the literary arts had early on struck roots in the German working class. The visual arts were less avidly cultivated, but this began to change after 1918. Attempts were now made to improve workers' visual imagination and to develop their aesthetic judgement. The approach to this was educational as well as purely visual, for example through exhibitions which addressed themselves especially to the working class. Here, as in other cultural fields, the impetus for improvement and change came from ideologically committed individuals who were often socially outside the working class.

Working-class organisations were generally sympathetic to such efforts. Thus in Mannheim, the Bund zur Einbürgerung der Bildenden Kunst (Association for the Promotion of Visual Art) had already before the war received the support of the local Social Democratic Party. After the war the more radical sections of the party, now organised in the USPD, expressed some doubt about such co-operation. They feared that diversionary tactics would blunt the resolve of the workers to

engage in the political struggle, but they were willing to put their trust in the *Bund*, as long as it was directed by a man 'so full of love for mankind as Fritz Wiechert', the director of the Mannheim Kunsthalle.[29]

Similar motivation prompted some groups of artists and some local authorities to arrange art exhibitions which, they hoped, would appeal not just to those already interested in art but also to the broad masses of the population. A note in the *Rätezeitung*, the newspaper of the Berlin Workers' and Soldiers' Council, commented favourably on the interest in the arts which was now shown in spite of all the political excitement. But the paper also reported criticism by working-class visitors to an exhibition who thought that the art on show was not sufficiently popular. It expressed the hope that in future more inexpensive prints – lithographs and etchings – would be available and it suggested that 'Sunday painters' among workers, especially among the unemployed, should be encouraged to show their work.[30]

A number of associations of artists which emerged in several cities after the revolution generally sympathised with the revolution and with the policies of the Left and wished to give the arts a new and more central role in the new state. Some of these used *Räte* in their title, but their links with the Council Movement were rather tenuous.[31]

The best known and most influential of these groups were the two organisations founded in Berlin in 1919, the Novembergruppe (November Group) and the Arbeitsrat für Kunst (Workers' Council for Art). The organisations were generally started by individual artists with more decisive political views and in some cases with links to the working class. One of the artists involved was Max Pechstein, a member of the *Brücke* (literally, 'Bridge') group of artists, who became a founder of the Novembergruppe. He was born into a working-class family and had originally been trained as a painter and decorator. Pechstein had sympathised with the socialist cause before the war and recalled that after the revolution 'I resolved to put myself at the disposal of the government, creating posters and drawings for magazines'. Walter Gropius, whose Bauhaus experiment is described below, reacted in a similar mood. He 'came to Berlin . . . to take part in the great transformation'. He found in the Arbeitsrat 'a fruitful, radical mood . . . which was truly refreshing. People have set to work.' Gropius was sure that they would 'soon advance more important ideas' but they all had to pull together.[32]

The members of the Novembergruppe saw themselves as 'revolutionaries of the spirit'. They claimed to stand squarely 'on the fertile ground of the Revolution' but they abjured all party political connections. They said they represented neither class nor party and only

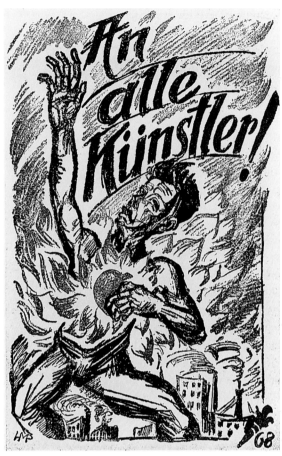

27 Max Pechstein, *An alle Künstler!*, cover illustration (1919)

wished to ensure that all available artistic talent was used for the well-being of the whole community.[33] The artist on the cover illustration of *An alle Künstler!*, a collection of essays published in 1919, is shown as a muscular worker who holds his red heart like a palette (Plate 27). The Arbeitsrat, likewise, gave only a general ideological commitment to the democratic state. Its first circular expressed the conviction that the political system should be used to liberate art from age-old tutelage. With this in mind a circle of like-minded artists had been formed with the aim 'to unite all the arts under the wings of great architectural projects'. Such a common enterprise would serve a clear social purpose. Moreover, it would be a communitarian enterprise, and the feeling of brotherhood which this would engender would 'create in the souls of men what we all desire, namely the true socialist spirit'.[34]

The Arbeitsrat was to devote much of its energies to propagating architectural designs, mostly through exhibitions. The first of these, 'For the Unknown Architect', showed mainly sketches, based on a utopian concept, and they did not constitute realistic designs. But the Arbeitsrat also looked forward to the time when construction would start again and their second architectural exhibition, 'Neues Bauen' (New Building), was devoted to this theme. In general, however, the theoretical and programmatic were more important to men like Gropius, Adolf Behne and Bruno Taut, the leading spirits of the Arbeitsrat, than practical building development. They hoped, however, that a new and fruitful period of building would commence soon and that architects would do their best to meet society's needs, while at the same time create structures of great beauty.[35]

The Arbeitsrat also attempted to involve the workers in its work, for example when it mounted a special exhibition in a working-class district of Berlin. Alongside work by established artists, it put children's drawings and art by working-class amateurs on display in an effort to encourage workers' interest in the visual arts.[36]

The identification of the Arbeitsrat with some of the ideals of the Revolution, or the commitment of some artists to socialism – a theme we shall return to – did not imply any organisational or political links with the Labour Movement. Nor did the organisations of the Labour Movement take much notice of these developments, let alone welcome artists or make use of their talents. These efforts did, however, involve attempts to bring the visual arts nearer to the working masses. Thus members of the Dresden branch of the Novembergruppe arranged some introductory lectures on art in the hope of encouraging workers to be creative. When their endeavours failed to attract an audience, 'there was great disappointment at the fact that the untutored masses of the people, on whom they had set their hopes, failed them'. It was really tragic that with few exceptions the rising working class was only anxious to take possession of the spiritual and artistic heritage of the bourgeoisie, while the latter accepted the revolutionary art which one would have expected them to reject.[37]

In the general discussion on the arts which was stimulated by the political and social upheaval, the role and function of architecture played a major role. In the aftermath of war there were no opportunities for actual building, but radically inclined architects stressed the social commitment of their work. They urged that future buildings should be regarded not as a commercial but primarily as a social activity and that the edifices which would be built should reflect the spirit of the age. Paintings and sculpture should be incorporated in the new buildings and all talents and skills would be as closely integrated in the new buildings as they had been in the cathedrals of the Middle Ages.

One of the few institutions brought to life by the revolution in which such utopian thinking as well as novel educational theories were successfully realised was the Bauhaus in Weimar. The Bauhaus arose from an amalgamation of two Weimar educational institutions, the Hochschule für Bildende Kunst (Academy of Art) and the Kunstgewerbeschule, the local College for Arts and Crafts. It was a revolutionary act to unite two institutions which had hitherto symbolised the division of art and craft teaching.[38] Gropius, one of Germany's leading modern architects, was appointed in 1919 as head of the new institution. He was determined to fuse the two subjects and to bridge the social gulf which had hitherto existed between artists and artisans.

In the *Bauhaus Manifesto* he demanded that 'architects, sculptors, painters return to the craft'. The Bauhaus curriculum combined teaching of the various crafts with training in design and art which would

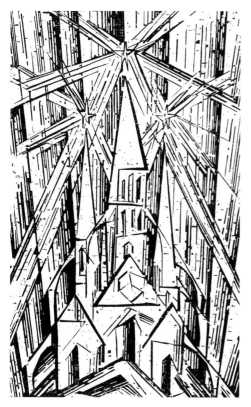

stimulate creativity. Through this, and through a system of apprentices, journeymen and masters, Gropius hoped to eliminate class distinction and class snobbery and break down the barrier between craftsmen and artists.[39]

The *Bauhaus Manifesto* spoke of the new buildings of the future which would bring together arts and crafts and 'rise skywards as a crystalline symbol of a future faith'. Such utopian sentiment and the reference to a new egalitarian society, and to the new building as the *Gesamtkunstwerk* – a work of art incorporating architecture, sculpture and painting – found its symbolic expression in Lionel Feininger's design for the cover of the *Bauhaus Manifest*, which became known as 'The Cathedral of Socialism' (Plate 28).[40]

NOTES

28 Lionel Feininger, *The Cathedral of Socialism*, title illustration, *Bauhaus Manifesto*, woodcut (1919)

1 From Max Beckmann, 'Bekenntnis', reprinted in D. Schmidt, *Manifeste, Manifeste* (Dresden, 1965), pp. 139–42.

2 Karl Jakob Hirsch, 'Novembergedanken' in 'Zehn Jahre Novembergruppe', *Kunst der Zeit (Sonderheft)* (1928), pp. 18–19.

3 On Weimar culture in general see P. Gay, *Weimar Culture* (London, 1974).

4 See S. Miller, *Die Bürde der Macht: Die deutsche Sozialdemokratie, 1918–1920* (Düsseldorf, 1978). It was paradoxical that this 'bourgeois' revolution had to be carried out by the leaders of a party which originally had put the slogan of the 'Social Revolution' on its banner.

5 For a study of the Weimar constitution see W. Apelt, *Geschichte der Weimarer Verfassung* (Munich, 1964).

6 Sections of the avant-garde consisted of refugees from Eastern Europe, above all political émigrés from Hungary, who fled when the Bela Kun regime collapsed. On the influence and interconnectedness see Klaus Känder *et al.* (eds), *Berliner Begegnungen: Ausländische Künstler in Berlin, 1918 bis 1933* (Berlin, 1987).

7 The KPD became a major political party only in 1920 when it united with the left wing of the USPD.

8 The essential difference between local council rule and the *Räte* Republics lay in the fact that the former operated alongside the existing elected local municipal councils and carried out technical and administrative functions whereas the *Räte* Republics took over all functions of government.

9 Quoted from the *Mitteilungen des Vollzugsrates der Betriebs- und Soldatenräte* of 17 April 1919 in B. Schrader and J. Schebera, *Die 'Goldenen' Zwanziger Jahre* (Berlin, 1987), pp. 22–3.

10 See Berlin, Archiv der Parteien und Massenorganisationen der ehemaligen DDR, *Eisner Papers*, Folder 123.

11 D. Halfbrodt and W. Kehr (eds), *München 1919: Bildende Kunst/Fotografie der Revolutionszeit* (Munich, 1979), p. 23.

12 On the Munich *Räte Republik* in general see A. Mitchell, *Revolution in Bavaria* (Princeton, 1965); W. Bischoff, *Artists, Intellectuals and Revolution* (Cambridge, Mass., 1982).

13 See U. Linse, *Gustav Landauer und die Revolutionszeit* (Berlin (West), 1974).

14 On the *Rat geistiger Arbeiter* see I. B. Whyte, *Bruno Taut and the Architecture of Activism* (Cambridge, Mass., 1985).

15 The appeal of the *Kunst und Kulturrat* is reprinted in P. Brandt and R. Rürup, *Arbeiter und Soldatenräte in Baden*, 3 vols (Düsseldorf, 1980), 1, pp. 340–6 (from *Karlsruher Zeitung*, 21 December 1918).

16 Quoted by H. Feidel-Merz in *Zur Ideologie der Arbeiterbildung*, 2nd ed. (Frankfurt, 1972), p. 119.

17 See SPD Parteitag 1919, p. 26 and the list of Resolutions.

18 See N. Pevsner, *Academies of Art* (Cambridge, 1940).

19 Deutscher Museumsbund, *Die Kunstmuseen und das Deutsche Volk* (Berlin, 1919), especially G. Pauli's essay 'Die Kunstmuseen der Zukunft' (quotation on p. 11).

20 See Prussia, Landtag, *Sitzungsberichte der Verfassungsgebenden Landesversammlung*, vol. 6, Sitzungsbericht of 4 December 1919, p. 16.

21 The introduction of the eight-hour day, so long fought for by the German Labour Movement, was the outcome of negotiations between the unions and the employers. It has become known as the Legien–Stinnes accord from the name of the heads of the two organisations. With time the agreement was increasingly broken.

22 For a draft of the programme see the archives of the KPD in the Archiv der Parteien und Massenorganisationen der DDR, Berlin under *ZPA, 2/707/f.5/*. See also article in *Beiträge zur Geschichte der Arbeiterbewegung* (1981), p. 702.

23 *Ibid.*

24 See programme of the KAPD of May 1920, cited from H. M. Bock, *Syndikalism and Linkskommunismus, 1918–1923* (Meisenheim, 1969) and W. Faehnders and M. Rector, *Literatur im Klassenkampf* (Munich, 1971). See also the same authors', *Linksradikalismus und Literatur*, 2 vols (Reinbeck, 1974), I, p. 132.

25 From the 'Aufruf zu einem Bund für proletarische Kultur' in Faehnders and Rector, *Literatur*, pp. 155–7. For the membership of the League see *ibid.*, p. 222.

26 From the 'Grundsätze und Programm' of the Bund: see *ibid.*, p. 160.

27 There is no history of the *Bund*, but see footnotes to the reprinted documents in Faehnders and Rector, *Linksradikalismus*.

28 See E. Piscator, *Das Politische Theater* (Berlin, 1929; 1963); English edition, New York, 1978; J. Willett, *The Theatre of Erwin Piscator* (London, 1978).

29 See J. E. Howoldt, *Der Freie Bund zur Einbürgerung der Kunst in Mannheim* (Frankfurt, 1982). See also Fritz Wiechert, 'Die Bildende Kunst und der soziale Staat' in *Zentrale für Heimatsdienst* (Der Geist der neuen Volksgemeinschaft, Berlin, 1919).

30 *Rätezeitung*, 17 and 21 July 1919.

31 For a survey of associations of artists see Peter W. Guenther, 'A Survey of Artists' Groups' in S. Barron (ed.), *German Expressionism, 1915–1925* (Los Angeles, 1988), pp. 99–115.

32 See Max Pechstein, *Erinnerungen*, ed. L. Reidemeister (Wiesbaden, 1960), Gropius, writing to Karl Osthaus on 23 December 1918 and on 6 January 1919. See R. Isaacs, *Walter Gropius*, 2 vols (Berlin, 1985), I, pp. 194–5. The Arbeitsrat für Kunst is often wrongly translated as 'Workers' Council' instead of 'Working Council for Art'.

33 From the 'Manifest der Novembristen' and other early pronouncements of the Novembergruppe. See H. Kliemann, *Die Novembergruppe* (Berlin, 1969).

34 See Berlin (West), Akademie der Künste, *Arbeitsrat für Kunst* (exhibition cata-
 logue) (Berlin, 1980), p. 87.

35 See leaflet for the exhibition for unknown architects in *Arbeitsrat für Kunst* (exhibi-
 tion catalogue), p. 90.

36 The 1920 *Arbeiterkunstausstellung* is discussed more fully in Chapter 6.

37 Will Grohmann in '10 Jahr Novembergruppe', *Sonderheft* of *Kunst der Zeit*
 (1928), p. 4.

38 The previous director of the Weimar Academy of Art, the pioneering Belgian
 architect Henry van de Velde, had already taken some steps to link the teach-
 ing of arts and crafts.

39 *Bauhaus Manifesto*, various printings. The best English version is in H. Bayer
 and W. Gropius, *The Weimar Bauhaus, 1919–1925* (London, 1975).

40 The ascription 'Cathedral of Socialism' does not seem to appear in print at that
 time.

Artistic utopianism versus committed art 4

Before the war a belief in a more just and more democratic and liberal society had already spread into some sections of the middle class: the comparatively few individuals involved were motivated largely by political and social ideas. The November revolution was the result of such views and these were in turn shaped by it.

Some of the new ideas can be traced to the revolution in art itself. This had begun in the last years of the nineteenth century and was connected, above all, with the movement known as Expressionism. Expressionist artists were in the vanguard of the artists' groups which sprang up after 1918. Their views had been shaped not only by their artistic background, but, under the impact of war and revolution, also by their response to the contemporary political and social situation.

But, as we shall see, the artists in this movement were unsure whether they could or should translate into concrete action the obvious sympathy many of their works demonstrated for the proletarian cause. Many of them saw art as an object to be respected, whether or not it depicted images relevant to the class struggle, and were reluctant to get too closely involved in the revolutionary movement.

The anti-establishment Dada movement, on the other hand, was only too keen to criticise society and existing social values. Some of its followers questioned whether the art of the present and the past was sacred and whether an artist could ever become a full member of the working class.

In one of the earlier books on the expressionist movement Eckhardt von Sydow wrote that before the war 'an inner-directed socialist belief was alive in only a few artists. But the war spread such views into widening circles. Three factors contributed to this, a feeling of aversion to the bourgeoisie, the resistance to the coercion by the military and the wish to get closer to the proletariat.'[1]

Expressionist ideas about art and about the nature and basis of artistic creativity helped to give the ideas and ideals advanced by individuals, or by the new organisations of artists described earlier, their utopian character. This new and radical movement in the arts

manifested itself not only in paintings, sculpture and the graphic arts but also in the cinema, in literature and even in music. Here we must concentrate on the visual arts, but we must look not only at art itself but also reflect on what artists said about their work and the basic philosophy which influenced it.[2]

The most significant artistic principle of the new trend was that the painter or sculptor should enter the spirit of the subject and that this work should seek to probe beyond the outer world of appearances and give expression to what was thought to be the essential, basic and spiritual aspects of reality. The expressionist artist worked by interposing person and emotions between the object and its representation.

The catalogue of the 1911 exhibition of the Neue Sezession (New Secession) – the organisation which at the time represented the most modern and least traditional group of German artists and which had split from the Berliner Sezession, founded in 1898 – said of the artists who worked in the new style that 'they no longer attempt to portray nature in all its passing moods, but to bring out its essence. The complete work does not aim to express nature, but to express the sensitivities of the artist, reflecting the most characteristic expression of the object.'[3]

In a similar vein Herwarth Walden, editor of *Sturm* magazine and the proprietor of the Sturm Gallery which regularly showed expressionist art, wrote in 1919 that expressionist paintings 'expressed a vision, made a revelation apparent and gave shape to a feeling through the medium of painting, colour and form. The feeling is expressed directly, not indirectly.'[4]

The underlying aesthetic principles of Expressionism and the new way of looking at reality filled many of those who followed with a feeling of freedom and pioneering spirit. The programme of the Dresden artists' group Die Brücke, established in 1905, gave expression to almost revolutionary sentiments. They wrote: 'We who as youth carry the future [in us] appeal to all youth. We seek to create for ourselves a physical and spiritual freedom. Everyone who is opposed to the values of the comfortably established older generation and who directly and truthfully reproduces that which causes him to be creative belongs to us.'[5] Karl Schmidt-Rottluff, one of its founders, wrote to his colleague Emil Nolde that Die Brücke 'seeks to attract all revolutionary and restless elements'.[6]

Such sentiments encouraged some expressionists to embrace utopian ideas about changes and improvements in society. They exposed the artificial and the sham in their art, and this influenced their choice of subjects and treatment.

Among the targets of such critical unmasking were the German bourgeoisie, its philistinism, its false morality and its materialism.[7] Hence it is not surprising that the immoral and the socially deviant – prostitutes and perverts, night clubs and sleazy bars – should be frequent subjects of expressionist paintings. Admittedly, the social criticism is often implied rather than explicit, as in a drawing by Otto Dix of a bare-breasted hag and a war veteran with part of his face shot away (Plate 29). It was reproduced in the Communist satirical magazine *Die Pleite* (Bankruptcy) in 1923 with the caption 'Whore and War-Cripple – two victims of capitalism'.[8]

In the same year, the Malik Verlag published a devastating criticism of bourgeois society in the form of George Grosz's *Ecce Homo*. This was a collection of drawings which needed no captions to convey the searing criticism of society and its politics.[9] *Ecce Homo* is an indictment of bourgeois mores, including an indulgent attitude towards the pleasures of the flesh, so often bought by the rich.

29 Otto Dix, *Hure und Kriegs-Krüppel* (Whore and War-Cripple), etching (1923)

Expressionist artists also represented the sexual in a more positive way, as in the very explicit presentation of female nudes in some of the paintings and prints of the Brücke artists. They imply a criticism of a society whose taboos prevented the frank expression of a creative sexuality and of a freer life for which the sexual energies might have acted as a driving force.[10]

These socio-aesthetic reflections and criticisms of the philistinism and the atmosphere of the big city, which were felt to be destructive of social ties, found some concrete expression in a number of generally short-lived artists' colonies. They were largely residential in character, as was Worpswede, in the Lüneburg Heath, a windswept area of northern Germany. The Brücke artists also did some things collectively, sharing holidays and studios. Such new forms of living were, however, not restricted to artists. We can see them as part of a widely based *Lebensreform* movement which was prominent in Weimar Germany. Its aims were to reform people's diet, dress and overall

lifestyle. Societies active in this field sometimes had some ties with the Labour Movement and there was generally some sympathy in the Labour Movement's ranks for ideas and movements concerned with lifestyle reform.

At the same time the social ills depicted in some paintings and more often in prints were also linked to the growth of urban society, the big city in particular. Some artists were infatuated with urban life, with its violence and with the speed of life in the metropolis. Yet they also castigated the city in their art, highlighting its destructiveness and the excesses of city life. The city was a symbol of the destruction of organic social ties and a portent of an imminent, wider catastrophe.

The critic Kurt Hiller stressed the importance of city life as a proper subject of art. He argued that Potsdamer Platz – a square in the centre of Berlin regarded by many as the hub of the city – 'should fill us with the same degree of inner longing [*Innerlichkeit*] as the small hamlet of the novelist Hermann Hesse'. At the same time, he reminded us that this square was also the location of E. L. Kirchner's street scenes with its parading prostitutes.[11] If the philistines expressed their hostility to such immorality, they were equally upset at the expression of nudity, as in Kirchner's painting *Das Paar vor den Menschen* (The Couple in front of the Crowd) (Plate 30).

The painter Ludwig Meidner was one of the first to recognise the visual as well as the symbolic significance of the urban scene. He urged his fellow artists to take the city as their subject. 'We really must begin to paint our home patch, the city, which we love so fervently. Our groping hands should draw on huge canvases all the magnificent and the weird, the dramatic and the monstrous which we find in the avenues, railway stations, factories and towers of the city.'[12]

Meidner rejected impressionist techniques which treated urban landscapes as if they were rural backwaters, stressing tonal values and shimmering light. A street, he argued, could not simply be dissolved into colours; it bombarded the onlooker with shapes and movements. He was not suggesting filling canvases with purely ornamental, abstract designs, like Kandinsky or Mondrian, but 'with life in all its fullness: space, light and darkness, heaviness or lightness of movement. In short, to produce a deeper penetration of reality.'

Yet while the turbulence produced by city life was looked at aesthetically, the city was also seen as an expression of the machine age and hence a symbol of the new industrial society. 'We are the contemporaries of the engineers, we are sensitive to the beauty of straight lines, of geometrical shapes', he wrote.[13]

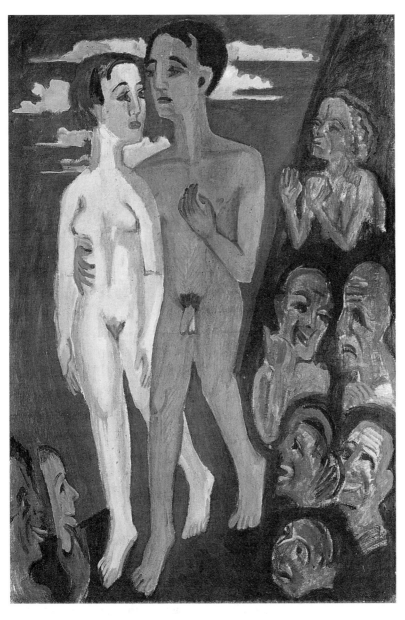

30 E. L. Kirchner, *Das Paar vor den Menschen* (The Couple in front of the Crowd), oil (1924)

It was not that the city as a social environment was always in danger of breakdown and collapse. Meidner, for one, gave expression to the horrors of this in a series of apocalyptic visions of destruction and revolution (Plate 31). These paintings, of the years immediately before the war, drew on the growing fear of violent conflict and war which then manifested itself everywhere. Meidner wrote later that 'the fear of the catastrophe of war haunted me at that time – a year and a half later the conflagration actually occurred'.[14]

31 Ludwig Meidner, *Armed Workers in a Civil War*, drawing (1913)

The war, in the words of playwright Bertolt Brecht 'that great practical demonstration how to see things in a new light', clearly affected expressionist artists greatly. When it came many artists were gripped by the widespread enthusiasm and sought to be part of it. Otto Dix volunteered, because he wished 'to experience everything. War was a ghastly thing, but it was also something enormous. I really did not wish to miss it. One must have experienced man in this unrestrained state in order to know man's nature.'[15]

However, as the grim battle continued, many artists who took part in it began to recoil from its horrors. At the same time the experience of war gave rise to new feelings of camaraderie which strengthened communitarian sentiments among artists and contributed to the establishment of artists' societies as we saw in the last chapter. Towards the end of the conflict Max Beckmann confessed that he now 'wished more than ever before to be in the city and among people'. He hoped that his work 'would in future show a deeper love for man and for nature, much as we find in a Grünewald, a Breughel or a Van Gogh'.[16]

The opposition to the war among artists was due not only to the suffering and the destruction which came in its train. War was also rejected as an example of an all-pervading materialist attitude which the radical painters generally condemned. In the programme of the Dresden journal *Menschen* (Humanity) (1919–22) Walter Rheimer, the editor, countered this materialism with principles of idealism. 'In

the world of art, this idealism was called "Expressionism". It was not a matter of technique or of form but a spiritual, that is ethical and meta-physical attitude. In politics this idealism was called anti-nationalist socialism.'[17]

The social ideas and ideals of expressionist artists were, however, more frequently based on more than feelings of revulsion against social evils, human selfishness, violence and an amoral society. For many there were also more fundamental, existential attitudes and feelings which, as a system of shared beliefs, permeated such expressionist groups as the Brücke and the Blaue Reiter.

The Brücke group saw its task as that of proselytisers of their art.[18] The travelling shows of their work were concerned with the education of the *Volk*, that is the entire nation. Not surprisingly their favourite medium was the woodcut. As a cheap art form it could reach a wide public, just as the *Bilderbogen*, broadsheets and leaflets of earlier periods had done, or indeed like the prints of the Middle Ages, whose Gothic style they often took as a model.[19] The woodcut, with its bold lines, offered scope for the presentation of stark con-trasts of black and white. It forced artists to make clear statements of their fundamental beliefs.[20]

In general, expressionist artists used strong colours and bold and aggressive lines in their paintings, drawings and prints. They im-pressed themselves on the public, even if the non-realistic and dis-torted treatment of subjects caused incomprehension and opposition. Prints, especially woodcuts, were felt to be the appropriate medium to express their feelings.

The immediate postwar period saw a flood of prints on the mar-ket, many in an expressionist vein. They were frequently issued in portfolios and they often had religious and even political themes.[21] The Dresden poet Felix Stiemer spoke of pictures as *Extrablätter des Geistes* which 'reflected the latest spiritual developments'. He urged his fellow artists 'to abandon exhibitions of art on the street. Sell the telegrams of the intellect in editions of millions of copies.'[22]

However, the ideas about art and life advanced by the Brücke artists were never presented systematically. Their significance lay more in their working together with a wider body of adherents and supporters. In any event the group lasted only a few years. It came to an end in 1913 when the members gradually moved to Berlin.

The Munich Blaue Reiter group, like Die Brücke, lasted only a relatively short time. Its *Almanach*, the major document of expres-sionist art theory, was published only in 1912 with a second edition planned for 1914, not long before war caused the breakup of the

group. Vassily Kandinsky, the principal theorist of the group, returned to Russia and Franz Marc marched to his death on the battlefield.[23]

For Kandinsky art was really concerned not with the representation of physical reality, even when it was filtered through personal experience and temperament, but with underlying metaphysical perception. Painting or sculpture was to express the absolute character of the object or the abstract idea. Kandinsky saw the duty of the artist as being 'to stimulate realisation and the understanding of the spiritual essence of all things'.[24] Hence art need not reproduce an object at all; it could make an impression on the viewer through colour and shape alone, independent of the object. Form was a secondary matter.[25]

In order to present their theories in visual form the Blaue Reiter artists painted increasingly non-representational pictures. (After 1911 Kandinsky's art became more and more abstract and spiritual.) They also hoped that the influence of the spiritual would express itself not only in the visual arts but also in music and literature, and the contributions to the *Almanach* reflected this. Moreover, they hoped that art would influence other areas of life. Kandinsky and Marc envisaged that humankind would enter a period of spiritual revolution compared with which the political revolution was action at a lower level. Abstract art would arouse people to the spiritual values needed to bring about a utopian epoch.

The emphasis on content and meaning of art implied that formal rules were an encumbrance when it came to the free expression of the spirit. This freedom of the artist led to the emphasis on freedom in general. The modern movement would seek 'the disintegration of the soulless materialistic life of the nineteenth century and the establishment of a psychic and spiritual life of the twentieth century'.[26] The Blaue Reiter artists held that this attitude should make people love all art, especially that which showed spontaneous creativity.

Examples of this could be found in the art of primitive peoples, and the unselfconscious creations of organic communities still found expression in peasant art. The *Almanach* reproduced examples of such art, and Marc, writing in it, stressed that many people had so far not established an intimacy with it. But this would come. In the past the spirituality of such spontaneous and unsophisticated art was acknowledged and accepted throughout society. In their own time such a universal understanding no longer existed, hence the isolation of the artist from society.[27]

Marc went on to argue that, since the nineteenth century, the belief in a universal style had broken down. Some individual artists had created serious art, but they had no link with the style and needs of

the masses. Instead there was a deep gulf between genuine art and the public. This was inevitable because the gifted artist was no longer rooted in the artistic instinct of the whole people. Marc saw the loss of such organic ties as proof that the world was again at a turning point between two epochs. 'The first signs of the coming new epoch are the smoke signals of those who search the way.'[28]

Like the Brücke artists, Kandinsky, Marc and their colleagues saw themselves as proselytisers and as prophets. In the first instance they addressed their fellow artists, who were expected to be the principal contributors to the *Almanach*. But there was also to be a place for the critics, in spite of the distorted way in which they viewed such art. The *Almanach* also stressed the international character of their approach. They did not seek to disregard national influences – these as much as the character of the individual were reflected in all great art. 'But art knows no frontiers or nations, it only knows humanity.'[29]

Such beliefs matched the views held by socialist educationalists, publicists and others interested in culture and the arts that the visual arts acted as a psychic force exerting a humanising influence throughout society. The ideas about the aesthetic influences found in primitive art, which could still be found in the countryside at this time (that is before 1914) and which Franz Marc put forward in the *Blaue Reiter Almanach*, were raised also by Valtin Hartig in discussing the popularisation of art in the columns of the socialist cultural magazine *Kulturwille*.[30]

We find a third strain of utopian thinking and its artistic representation in the theories and designs of some younger architects, especially Bruno Taut. They had generally started their professional careers in the immediate prewar period, and their work made innovative use of materials, as in Bruno Taut's pineapple-shaped Pavilion of Glass and Steel at the 1914 *Werkbund* Exhibition in Cologne. They experimented with pure new forms. Examples of such new structures can be found in Eric Mendelsohn's Einstein Tower in Potsdam (1919–21), which embodied natural forms, and in Hans Poelzig's remodelling of the interior of the Berlin Grosse Schauspielhaus, giving full scope for fantasy (1919). Both are examples of a three-dimensional Expressionism. They were buildings conceived not purely in utilitarian terms but as original shapes and in application of pure fantasy.[31]

Examples of utopian designs are also in evidence in Paul Scheerbarth's *Glass Architektur* (1914), which influenced Taut, and in the latter's *Alpine Architecture*, structures which were partly to envelop rocks and icy slopes. They would not only be beautiful and glitter in the sun by day or light up by night, but they would also demonstrate

what could be achieved in peacetime if, as in war, resources were harnessed to achieve one great aim. *Alpine Architecture* was created during the war but it was published only in 1919 (Plate 32).[32]

Designs such as these were publicised at a time when the ravages of war and the painful transition from war to a peacetime economy made actual building virtually impossible. The designs therefore had to be seen as an architectural expression of a belief in a new social order. Taut and others felt strongly that architecture would play an important part in the process of achieving such a society. In an appeal

32 Bruno Taut, *Alpine Architecture*, drawing (c. 1919)

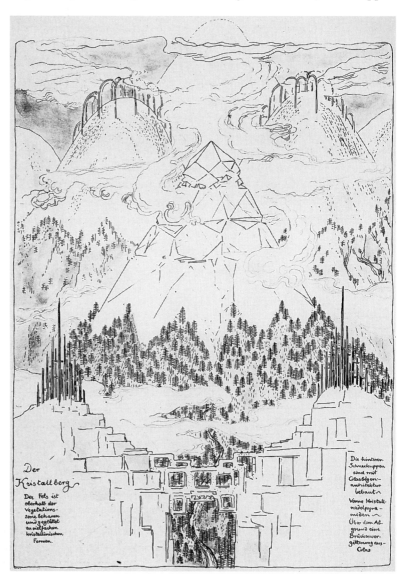

to the new socialist government, Taut claimed that 'architecture in its highest form was the expression of the all-embracing popular forces and feelings'.[33] Only a future faith could produce the non-utilitarian architecture which was to include contributions from all the other visual arts.[34] Similarly, Walter Gropius believed that architecture should become again what it had been in the past, 'an expression of the noblest thoughts of men, of their innermost fervour, their humanity and their religion'.[35]

Like Gropius, Taut had welcomed the Revolution. His architectural thinking and his designs were linked to his hopes for a new social order. He claimed for architecture in its highest state a role in shaping the all-embracing popular forces and sentiments. It should be a focal point for the other arts like painting and sculpture, which would come together under its wings. Under the influence of contemporary events, Taut saw himself, at least for a short time, as the servant of the revolutionary movement. He urged artists to live and act like workers. For himself he desired only shelter, food and clothing such as every worker had and he would work like all of them.[36]

In his essay on the *Stadtkrone*, the 'crowning edifice of the new city', Taut linked an idealised view of the past – the medieval town dominated physically and spiritually by the cathedral – to what he conceived to be the modern community's need for unifying symbols (Plate 33). Using words not unlike those in the *Bauhaus Manifesto*, he said that such 'pure art could make the desert bloom, it could create miraculous structures which would tower into the sky'.[37] The function of such central and dominating building would, however, be 'cultish' only in a very general way. It could be a theatre or a House of the People (*Volkshaus*) and its function was to be specific as well as symbolic and 'reflect the vision of the whole people, acting in common as a citizenry and as a religious community whose spiritual property it was'.[38]

Taut's concrete proposals about the new building were linked to his social views. He advocated building *Volkshäuser* which the people

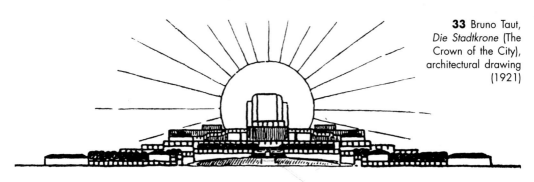

33 Bruno Taut, *Die Stadtkrone* (The Crown of the City), architectural drawing (1921)

could use for their leisure-time activities and for communal purposes. Surrounding these Taut envisaged a cultural precinct, with theatres and concert halls. At the same time he advocated the dispersal of cities. The big city was in his view decaying and new housing should be located on new estates and in new towns, conceived in their entirety by architects who, once appointed, should be given a completely free hand to realise their design. For Taut they were to be more like the garden city with terraced housing, such as he had designed for Falkenhausen near Berlin before the war.[39]

Taut's concept of the city of the future was based on a spatial representation of a formal view of society. This moved from the people (*Volk*) to the spirit (*Geist*) and to utopia (*Paradies*). This new Eden was to be realised through the activities and designs of the ideal architect, a view in which he followed Gustav Landauer's view of socialism.[40] Taut's social thinking, like Landauer's, was based not on an analysis of the working of society and of social institutions but on the 'simple human relationship between man and man'. This would bridge and overcome the deep gulf which existed between the warring classes and between nations. If anything could crown the city today it was first of all a realisation of such thought.[41]

Taut believed in the elevating and civilising function of beautiful form itself and of the play of light. Indeed, the crystalline building at the very heart of the *Stadtkrone* which was to crown the People's Houses was seen as a marvellous shape, a colourful structure of shimmering glass, metal and precious stones. Such a 'crystalline edifice would induce a cosmic feeling; it would be the basis of a new religious sentiment'. This structure was not to stand on its own. It would be surrounded and supported by important public buildings which would be separated from those housing more humdrum activities. Surrounding them would be the sea of colour of the housing areas which would symbolise the happiness of the new way of life.[42]

Taut's attitude to socialism and the artist's role in society was echoed in the replies of some other artists to the Arbeitsrat für Kunst in response to an inquiry about the role of the artist in the socialist state, and on the steps which should be taken to bring the aims and practices of artists into line with popular sentiment.

In general the respondents rejected the idea of identifying artists with particular policies or parties. Only Oswald Herzog suggested a formal link with the leaders of the USPD and the KPD. Max Taut, in a less structured argument, said only that the artist must make a clear decision in favour of socialism which would guarantee the basis for a simple existence. Many artists agreed with the proposition that

artists should co-operate and that they should be publicly supported. The view that, in return, they should work for the community was also widely shared, often with reference to a formal representation of artists and the disbursement of relevant funds, through an organisation of artists or even by the Arbeitsrat itself.[43]

The majority of artists, however progressive in a general sense, were not inclined towards formal participation in political organisations. They generally sympathised with the fate of the masses, but they were wary of the state and its institutions. Adolf Behne, a leading member of the Arbeitsrat and himself a trained architect, argued that the state was essentially hostile to the arts. Artists should roll back the power of the state so that the fundamental, simple and modest divine order of things could grow in scope.

Gropius wished to root out the spirit of commercialism so that 'the creative spirit of reconstruction should flourish among the people'. That, to him, was the task of the socialist state. Only the people were a vehicle to propagate art, and artists must unite with the people. Behne, more than most others, stressed the importance of co-operating with the working class, its institutions and organisations.[44]

The general ideas developed by expressionist artists discussed here have some common strands which go beyond artistic theory. However strong their emotional hostility to bourgeois society, their general attitude to mankind was positive and, after the establishment of peace and the new state, they looked with some hope into the future. Their art may have satirised and castigated certain institutions or individuals, but their basic attitude to their fellow human beings was one of sympathy, suffused at times with pity. They tended to believe in the perfectability of the human race and wished to raise – through their art and in general – the level of spirituality in society.[45]

As we have seen, their art and their thinking on art led some artists back to something resembling the community of the faithful of medieval society, and we find echoes of its art in theirs. They also hoped that the spirituality of their own art would contribute to the growth and spread of a similar belief in the here and now, based on a new non-denominational faith. Indeed, for some, art itself had a religious character, with the artists taking on a priestly role – or at least the role of a ministrant.[46]

However, the identification of artists with the revolution operated largely on the emotional level, and many critics and contemporary observers agreed with this. Thus Willi Wolfradt wrote in the leading progressive literary journal *Die Neue Rundschau* (The New Review) that, however sympathetic to the cause, artists should not identify with the

daily activities of furthering the revolution. 'As soon as the artist leaves the utopian plane and engages in practical politics, art dies.'[47]

Some artists, nevertheless, developed fairly concrete political views and sought to convince other artists of them. Thus Ludwig Meidner, whose sensitivity in political matters could already be seen in his pre-war paintings, urged his colleagues to support the workers' cause. He wrote in the artistically progressive but politically uncommitted *Kunst-blatt* (Art Journal) in favour of a just order in state and society:[48]

We artists and poets should be at the forefront of the struggle. There had to be an end to exploiters and exploited. No longer should it be possible for the great majority to live in the most miserable, undignified and deprived conditions while a tiny minority shovel in their food at overfull tables. We must decide in favour of the socialisation of the means of production so that everybody should have work, leisure, bread, a home and an intimation of higher goals. Socialism should be our new faith.[49]

Meidner suggested that painters and poets were bound to feel solidarity with the poor. They had been poor themselves and were as dependent on the whims of bourgeois collectors as the proletarians were dependent on employers. Moreover, the money with which the artist was paid, and sometimes very well paid, was itself gained through exploitation. There was a great danger that the bourgeoisie would again secure power in the state, and Meidner called on his contemporaries to 'throw in their lot with the workers'.

Meidner, a Jew who was at that time strongly influenced by Christian theology, appealed to 'the divine voice to lead us in these dark days to justice and love. With all our senses and with our hands we should help. Socialism is at stake and that means justice, liberty and love of our neighbour – God's order in the world.'[50]

Even Meidner's passionate appeal lacked any very clear indication of the way fellow artists should apply their sympathy and support for the proletariat and for its cause. We might have expected that the numerous artists' associations which came into existence during the revolution would have found ways to bridge the gap between a largely rhetorical political stance in favour of socialist ideals and day-to-day policies which would help the workers. This, however, was not to happen.

The fate of the Novembergruppe is a case in point. The group had identified strongly with the revolution and had claimed a place in the struggle that led to it. Yet this did not produce any practical results and the organisation soon began to concentrate on exhibiting its members' works. Some younger members, including Dix, Grosz,

Höch, Schlichter and Scholz accused the leadership, who were generally artists of an older generation and were now well established and successful, of perverting the original aims of the group. Not only were they turning the society into an organisation largely concerned with exhibitions, but they had forgotten their earlier support of solidarity with the workers and international understanding.

It had been that policy and their own revolutionary longing 'for a genuine association and collaboration with the working masses' that had attracted these younger artists to the Novembergruppe.[51] They sympathised with the proletariat and its aspirations. The opposition thought that the way to liberate humankind did not lie in the establishment of a revolutionary aesthetics but in the artist becoming an instrument for the struggle of the masses for a better and purer life. 'Our Love', they wrote, 'belongs to the proletariat because only the proletariat will, through Communism, bring about the equality of all mankind and of all work. By such means mankind would achieve freedom from slavery and exploitation.'[52]

The point of departure for criticising political utopianism did not lie in views about the spiritual and quasi-religious function of art and in an approach to politics which was based on such an aesthetically determined world view. Their policy was derived more from the historical course of events such as the outbreak of war in 1914 and the military collapse in 1918. The horror of war and revolution as well as the social conflict and bitter political struggle which developed in the immediate postwar period all contributed. In addition the fact that some members of such opposition groups identified with the Communist Party would have had some influence.

Equally significant is the connection between these artists, who were politically active, and the Dadaist movement in art. Taken as a whole, Dadaism was not politically committed, but its attack on bourgeois values and on the general pretentiousness of some art and its opposition to the emotion-soaked approach to art which often occurred in Expressionism inevitably encouraged a socially critical attitude. This found expression in a series of political slogans, which taken together amounted to some kind of political stance.

The slogans were prominently displayed at the first (and only) *Internationale Dada Messe* of 1920, which clearly reacted to war and defeat and to the economic and social collapse which followed it.[53] The exhibition illustrated the survival of aspects of Wilhelmine society. The art and the documentation also reflected the new lifestyles of the profiteers, the fraudsters and the easy-going, amusement-seeking parvenus. It took account of the influence of American-inspired new

leisure and entertainment practices, symbolised in the 'shimmy', the dance-bar, the nightclub, fast cars and gambling.[54]

Dada had condemned the hypocrisy and pretension of existing society, but it knew that Dadaists were themselves part of this society and were anti-bourgeois members of the bourgeoisie. Dada was 'against all aesthetic-ethical attitudes, against the bloodless abstractions of the expressionists, against world-improving theories of empty-headed literati'. It was in favour of Dadaist happenings and of the Dadaist manifesto, but to be against manifestos also meant to be a Dadaist.[55] Wieland Herzfelde, whose Malik Verlag published Dadaist magazines as well as the catalogue of the *Dada Messe*, saw Dada as 'a politically based opposition to art and especially to Expressionism'.[56] Herzfelde's brother Helmut was a graphic artist who changed his name to John Heartfield at the beginning of the war to demonstrate his opposition to the conflict.

Given the paradoxical nature of many of Dada's statements and its general iconoclastic attitude, coupled with the extreme individualism of the Dadaists, we must look sceptically at Dada's political declarations, some of which were displayed at the 1920 exhibition. One of them said 'Dada ist politisch', another proclaimed that Dada 'fought on the side of the revolutionary proletariat' while a third stated, 'Dada opposes all exploitation'. But, adding a symbol of total irreverence, the exhibition also contained a suspended figure of a German officer in uniform, and a pig's head. A notice below the officer stated that in order to understand the figure one should exercise for twelve hours with full pack. A notice around the pig's neck read 'Hanged by the revolution'.

The whole show, with its title alluding to commercialism in art, was more a send-up of art than a genuine exhibition, although it contained major paintings and sculpture by artists like Arp, Grosz, Dix and Picabia. It was not so much anti-art as an attempt to take art down from its pedestal by using material hitherto regarded as unartistic, like screws, wood, paper, glass and tin.[57] Here was an attempt at the demythologising of established 'great art'. The idea was allegedly to make art comprehensible, or, more realistically, to satirise it and thus rob it of its aura.[58] Grosz described it later as 'the organised use of insanity to express contempt for a bankrupt world'.[59]

To emphasise the 'art/anti-art' character of the *Dada Messe*, a photograph showed Grosz and Heartfield, as monteurs of an exhibit, holding a placard with the inscription 'Die Kunst ist tot – lang lebe die Maschinenkunst Tatlins' (Art is dead – long live Tatlin's Machine Art). This was not a provocative inscription. It rather showed the

underlying belief of artists like Grosz in an unemotional, purely object-
ive, art.[60] In Grosz's work we also find figures drawn as automata, in
the style of Di Chirico and of the Italian futurists, who had held an
exhibition in Berlin some years earlier (Plate 34).

Such an approach to art is, of course, related to politics. We are
concerned not only with the persuasive power of pen and brush, of
pencil and burin; but also with the artist's place in society and, above
all, the artist's relationship with the proletariat. The latter did not
respond readily. Nearly half a century later, Wieland Herzfelde wrote:
'The proletariat, as far as it was aware of the exhibition at all, did
not stand on the side of Dada, whatever the latter's protestations and

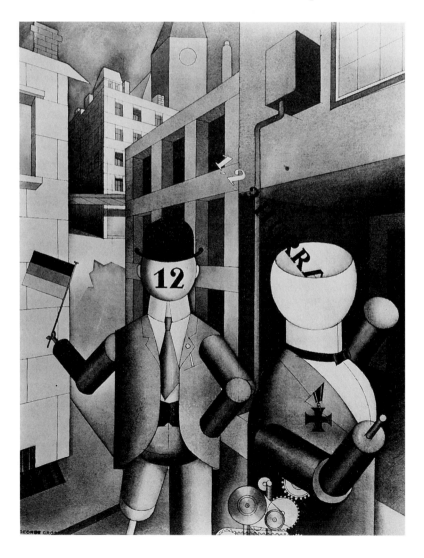

34 George Grosz,
*The Republican
Automaton*, drawing
(1920)

slogans professing its sympathy with the cause of the proletariat.' The
Rote Fahne (Red Flag), the official organ of the Communist Party,
condemned the *Dada Messe* as 'a collection of perversions. To call it
"culture", let alone artistic achievement, is more than a joke, it is
bloody cheek; Dadaists should not call themselves Communists.'[61]

Dada's attack on art was 'a reaction to the cloud-cuckoo-land
attitude of its practitioners', who 'regarded art as sacred and were
immersed in discussions about the Gothic and the Cube, while the
generals painted in blood'.[62] Yet for critics on the Left like Grosz,
Dadaism had not gone far enough. It sought to escape from the
confines of bourgeois society, but it had not as yet recognised that it
was the prevalent social system which supported this evil society. The
revolution, Grosz said, was to lead some artists to the point when
they saw it as their task to embark on the creation of a great new art
which would put itself in the service of the revolution.[63]

In Grosz's eyes the allegorical and symbolic prints and paintings by
artists who had suddenly discovered their sympathy for the workers
did not count in this respect. Art was not revolutionary if it painted
chiliastic visions or if it was full of religious themes and sentiments.
The needs of the workers, he argued, were immediate and material.
Art with a revolutionary content must respond to these needs and
must relate to the revolutionary ideals of working men and women.[64]

The creation of politically committed art was not expected to be
a straightforward process, as contemporary discussion reveals. Pro-
fessional artists were inevitably members of the bourgeoisie. Their
working practices were tied up with the commercial practices of that
class and their original ethos was that of the independent, creative
artist.[65] By identifying with the political aims of the proletariat,
politically committed artists isolated themselves from their own class
colleagues and their work practices. This, however, could be only a
gradual process and was much slower than the process of their polit-
ical conversion in which they were supported by time-honoured prac-
tices of political agitation. At the same time, their artistic adjustment
and its problems were not easily understood by the proletariat.[66]

Wieland Herzfelde wrote at the time that, unlike workers who are
firmly rooted in their class, artists must loosen their ties with their
class and with the traditional practices of their art. The needs of the
proletariat demanded that they must fully and unhesitatingly put all
their talents and skills as artists at the disposal of that class. An artist
could not become a member of it, he or she could be only 'a bour-
geois who has come to recognise the inevitable historical superfluity
of that class'.[67]

Such a view of the role of the politically committed artist echoes what George Grosz wrote about the style appropriate for such art, with its rejection of the emotional and the merely decorative:

It was no longer a question of conjuring up expressionist multi-coloured patterns of the soul on canvases. The realism and the precision of an engineering drawing is a better precept than the idle prattling about cabbala, metaphysics and the ecstasy of the saints.[68]

Grosz said his own work was like a 'training exercise, a work-out with the punch-ball' – a sport which he himself practised. 'Man should no longer be represented as if he was an individual with his own psychological sensitivity . . . but as a collectivist, almost mechanical concept' to which the artist would respond by a simple design which would be universally understood.[69]

The expressionist painters sought to reduce the social distance between artist and worker by stressing the skills needed for the arts while still maintaining a belief in their creative aspects. On the other hand Communist artists and radical critics denied the creativity of committed art. Grosz and Herzfelde stressed the common skills which artists and workers shared. Their art was related to the development of modern technology and the artist's work was akin to that of the engineer. They believed that artists who were also Communists had two choices: they could either 'become an architect, an engineer or a commercial artist in the service of industry and of the exploitation of the world, or he will, as narrator, critic or agitator, defend revolutionary ideas and join the ranks of the oppressed who are fighting for a better society'.[70]

The critical attitude to established art and the concept of *l'art pour l'art* went further than questions of creativity and commitment. Those who raised it questioned the meaning of art for politically conscious and active workers, questioning whether the political struggle and support for the institutions of the working class were of greater importance than any art of past centuries. Classical art in particular spoke a language alien to the working class. Its message tended to be quiet and conformist and its influence could easily 'sabotage the class consciousness of the proletariat and sap its will to secure power'.[71]

Such basic questions about the role of art were also raised in the *Kunstlump* (art scoundrel) debate between traditionalists and revolutionaries in the spring of 1920. This brilliant piece of art-historical polemic was provoked by a broadside from Oskar Kokoschka, then a newly appointed professor at the Dresden Academy of Art. He was dismayed by the fact that, in the course of some fighting in the city,

a bullet had penetrated the walls of the Zwinger Art Gallery and damaged Rubens's *Bathsheba at the Well*. Kokoschka urged the Dresden workers, who had defended the new Republic against the right-wing *Kapp Putsch*, to take their shooting to the heath outside the city, or better still, settle their disputes with a fight between the chief protagonists on the shooting ranges. This would avoid the recurrence of such an incident because, he argued, 'the German people would in the future judge that a painting, thus saved, would give them more happiness . . . than they could possibly derive from the views held today by the politicking Germans'.[72]

But the great majority of workers saw things differently. The concerted action by all sections of the German working class had succeeded in saving the Republic. Grosz and Heartfield, in the *Kunstlump* article, poured scorn on Kokoschka and his lack of concern for the fate of ordinary people for the sake of art.[73] It was fortunate, they argued, that the bullets penetrated galleries and palaces rather than the dwellings of the poor. More important, in our context, is the assessment of the value of art for the working class.

Grosz and Heartfield argued that the workers, so heavily involved in their daily struggle, had little interest in art, let alone in classical art whose language and symbols had little meaning for them. *Tendenzlose Kunst* – art without any commitment to the cause of the working class – had no place in workers' culture. Such art had always implied a flight from reality, an attempt to create the *schöne Schein*, the beautiful deception which 'would conjure up the false picture of a world of peace and order'. The religious art of the past had created a false consciousness by focusing on an other-worldly future, while secular art had sought to serve the interest of the bourgeoisie and its striving for possessions and display.

Grosz and Heartfield argued that Kokoschka acted only as a mouthpiece for the bourgeoisie by saying that the sacred inheritance of the past, the 'masterpieces' of painters like Rubens and Rembrandt, must be preserved for the benefit of the rich and of speculators in works of art.[74] The two artist-critics attacked those writers in the Labour Movement who praised bourgeois art. They did not fully detail what kind of art would be acceptable to the workers, but said bourgeois art should be replaced by art which the workers themselves would create, 'just as they had created the organisations for the class struggle by their own efforts'.[75]

A more balanced view of the value of established art was put forward by anarchist Cologne painter Franz Seiwert, who urged that a distinction should be made between the underlying spirit of art and

its actual expression in individual paintings or sculptures. The museums which Kokoschka wished to protect from disturbances were for Seiwert 'mortuaries of dead art; a bullet would not kill, rather wake them'. For centuries these galleries had displayed on their walls only huge voids in huge frames. To pay so much attention to the art of the past was a perversion of values; it was inimical to the development of present-day culture and art. 'It is for the sake of the art of today that the art of the past must be destroyed.' The spirit of creative genius was indeed immortal but the distinctive part of this art weighed heavily on the living and robbed them of the power to act. His slogan was: 'Away with the respect for all bourgeois art . . . destroy the old idols in the name of the future proletarian culture.'[76]

Such extreme views were not shared by many sections in the Labour Movement. There were doubts about them even within the Communist movement. In the columns of the *Rote Fahne* Gertrud Alexander (pseudonym GLL), the paper's literary and art critic, condemned the extreme attitude towards the art of the past which Grosz and Heartfield demonstrated in their attack on Kokoschka and, through him, on all classical art.[77] For her, the wholesale rejection of bourgeois art was nothing short of vandalism. She agreed with Grosz and the Herzfelde brothers in their assessment of Expressionism, which she called a 'bloodless and ascetic art', but she followed in the steps of her mentor, Franz Mehring, when she criticised the attack on the masterpieces of classical art and on the humanist values which many represented.

Alexander wrote that many of these works were indeed objects of great beauty which even workers would enjoy and value. It would be quite wrong to discard all art of the past because it was created in a capitalist and bourgeois society. This art was not only of historical interest. 'In spite of capitalism and exploitation there existed a culture in which immortal works were created. A new culture could not arise overnight. In the meantime workers should appreciate the great art of the past.'[78]

NOTES

1 E. von Sydow, *Der deutsche Expressionismus, Kultur und Materie* (Berlin, 1920), p. 33.
2 For the rise and interpretation of the word 'expressionism' see E. J. Gordon, 'On the Origin of the Word Expressionism', *Journal of the Warburg & Courtauld Institute* (1966), pp. 368–86.
3 Quoted by B. Schulz, 'Natursehnsucht und Grossstadtethik: Der deutsche Expressionismus zwischen "Brücke" und Berlin' in *Ich und die Stadt* (exhibition catalogue) (Berlinische Galerie, Berlin, 1987), pp. 15–34 at p. 23 (from the

preface to the catalogue of the spring 1911 exhibition of the Berlin *Neue Sezession*).

4 H. Walden, 'Zur Formulierung der neuen Kunst' in Walden (ed.), *Expressionismus: die Kunstwende* (Berlin, 1919), pp. 102–4 at p. 104.

5 See (for translation) V. H. Meisel, *Voices of German Expressionism* (Englewood Cliffs, N.J., 1970), p. 13.

6 Letter of 4 February 1906 in D. Schmidt (ed.), *Manifeste, Manifeste, 1905–1933* (Dresden, 1965), p. 40.

7 R. Hamann and J. Hermand, *Expressionismus* (Berlin, 1977), p. 77.

8 It is not clear whether the caption of the drawing was provided by the artist or the editors.

9 George Grosz, *Ecce Homo*, original ed. 1923, English ed., New York, 1976.

10 Hamann and Hermand, *Expressionismus*; P. H. Selz, *German Expressionist Paintings* (New York, 1957), p. 74.

11 For Kirchner see D. E. Gordon, *Ernst Ludwig Kirchner* (Cambridge, Mass., 1968). Kurt Hiller quoted in S. von Wiese, *Grafik des Expressionismus* (Stuttgart, 1976), p. 60.

12 L. Meidner, 'Anleitung zum Malen von Grossstadtbildern' in Schmidt, *Manifeste*, pp. 84–8.

13 *Ibid.*

14 In an inventory of the paintings and drawings in his studio taken in 1916, when Meidner was called up, he lists eight 'apocalypse' paintings out of a total of forty-four paintings. A modern exhibition of Meidner's apocalypse paintings and drawings showed thirty-seven and reproduced others in the catalogue. See *The Apocalyptic Landscapes of Ludwig Meidner* (exhibition catalogue) (Munich, 1989). The drawing here shown is from a reproduction in *Die Freie Welt*, the weekly magazine of the USPD.

15 For the quotation see M. Eberle, *Der Weltkrieg und die Künstler der Weimarer Republik* (Stuttgart, 1989), p. 31.

16 Max Beckmann, 'Bekenntnis', in Schmidt, *Manifeste*, pp. 139–42.

17 D. Schubert, *Otto Dix* (Reinbeck, 1980), p. 37. See also F. Loeffler and E. Bertonati, *Die Dresdner Sezession, 1919–1925* (Dresden, 1977).

18 From the *Brücke Manifesto*; see Meisel, *Voices*.

19 They also used to go together to paint out of doors in the Moritzburg Lakes and on the Baltic coast.

20 E. Barlach, *Briefe* (Munich, 1968), p. 569.

21 On expressionist graphic art in general see von Wiese, *Graphik*, and, on illustrations, L. Lang, *Expressionistische Buch-Illustrationen in Deutschland, 1907–1927* (Leipzig, 1975).

22 Felix Stiemer, *Die schöne Rarität* (June 1918), quoted in von Wiese, *Graphik*, p. 145.

23 All references to the *Blaue Reiter* are to the 1984 (Munich) reprint of the first (1912) edition of the *Almanach*. It is a documentary edition and it reprints in a separate section additional material, some of which Kandinsky and Marc might have included in a new edition.

24 Selz, *Expressionist Paintings*, p. 21.

25 H. W. Wingler, in the Introduction to W. Kandinsky and Franz Mark (eds), *Der Blaue Reiter: Zeichnungen und Graphik* (Feldafing, 1954).

26 W. Kandinsky, 'Ueber die Formfrage', *Der Blaue Reiter*, pp. 132–82. See also Franz Marc's essay 'Zwei Bilder', *ibid.*, pp. 33–8.

27 Marc, 'Zwei Bilder'. Chapter 7 will show how the importance of folk art was stressed by some social democratic writers in the 1920s.

28 Marc, p. 38.

29 Text signed 'Redaktion Kandinsky, Franz Marc'. From material collected for a proposed second edition of the *Blaue Reiter Almanach*. See 1984 ed., pp. 315–17 at p. 316.

30 *Kulturwille* was initially published by the Leipzig co-operative Bildungsinstitut run by the local SPD but with the support of the municipality itself under SPD control.

31 On expressionist architecture see W. Pehnt, *Expressionist Architecture* (London, 1971). For Taut see I. B. Whyte, *Bruno Taut, Master Builder for a New World* (Cambridge, Mass., 1982).

32 See the English edition of Taut's *Gläserne Kette, The Crystalline Chain*, ed. I. B. Whyte (New York, 1985).

33 B. Taut, 'An die sozialistische Regierung', *Sozialistische Monatshefte*, 51, 2 (1918), pp. 1050–2. See also Arbeitsrat für Kunst, *Bruno Taut* (exhibition catalogue) (Berlin, 1980), p. 90.

34 *Ibid.*, p. 91.

35 *Ibid.*, p. 90.

36 See B. Taut, 'Der Sozialismus des Kunstlers', *Sozialistische Monatshefte* (1919), p. 259.

37 Taut in the broadsheet issued by the Arbeitsrat für Kunst for their exhibition 'Für unbekannte Architekten' mounted in April 1919 and reprinted in the catalogue of the exhibition on the Arbeitsrat für Kunst, Akademie der Künste, Berlin (West), 1980, pp. 90–1.

38 B. Taut, *Die Stadtkrone* (Berlin, (1919), 1977), p. 59.

39 Taut, *Die Stadtkrone*.

40 See Gustav Landauer, *Aufruf zum Sozialismus* (no place, 1919).

41 Taut, *Die Stadtkrone*, pp. 59–60.

42 Freely translated from *Die Stadtkrone*, p. 69.

43 Arbeitsrat für Kunst, *Ja – Stimmen des Arbeitsrat für Kunst* (Berlin, 1919), reprinted in the exhibition catalogue *Der Arbeitsrat für Kunst* (note 37).

44 *Ibid.* These statements are taken from replies to a questionnaire drawn up by the leadership of the Arbeitsrat. They reflect widespread sympathy with the revolution. However, only 28 responded out of 100 polled.

45 See C. Hepp, *Avantgarde: Moderne Kunst, Kulturkritik und Reformbewegungen nach der Jahrhundertwende* (Munich, 1967).

46 From comments made by Hermann Finsterlin and Moritz Melzer in *Ja – Stimmen des Arbeitsrats für Kunst*.

47 Willi Wolfradt, 'Revolution und Kunst', *Die Neue Rundschau* (1919), pp. 745–55 at p. 753.

48 On Meidner in general see T. Grochowiak, *Ludwig Meidner* (Recklinghausen, 1986).

49 L. Meidner, 'An alle Künstler, Maler, Dichter' in *Das Kunstblatt*, 3 (1919), reprinted in U. M. Schneede (ed.), *Die Zwanziger Jahre* (Cologne, 1979), pp. 41–3 at p. 41 and Schmidt, *Manifeste*, pp. 245–7. Meidner wrote in a similar vein in *Die Freiheit*, the paper of the Independent Social Democrats, and his essay was reprinted in *An alle Künstler*, published by the Werbedienst (Berlin, 1919).

50 Meidner, 'An alle Künstler', p. 43.

51 From Otto Dix, George Grosz, Hannah Höch and others, 'Offener Brief an die Novembergruppe', *Der Gegner*, 2, 8–9 (1920–1). Reprinted in Schneede, *Zwanziger Jahre*, pp. 95–101.

52 *Ibid.*

53 This section looks at Dada largely in its political aspect. For the movement in general see W. Verkauf, *Dada* (London, 1975); D. Ades (ed.), *Dada and Surrealism Reviewed* (London, 1978).

54 See also *Dada in Europe, Werke und Dokumente*, 1978, p. 3/3.
55 From the *Dadaist Manifesto* in Schneede, *Zwanziger Jahre*, pp. 20–2; also in K. Riha and H. Bergius, *Dada Berlin* (Stuttgart, 1977), pp. 49–52 at p. 52.
56 Wieland Herzfelde, *Der Malik Verlag, 1916–1947* (Berlin, n.d.) (a history and a bibliography).
57 A list of works shown in the *Dada Messe* was printed on the back of the poster-cum-catalogue of the exhibition which is inserted in the Malik bibliography (note 56) but, significantly, names and titles were only partly legible, having been 'over-printed' by figures and photographs.
58 See H. Meier-Merz, *Expressionism – Dada – Agitprop* (Frankfurt, 1984), pp. 254–66 for a discussion of the *Dada Messe*.
59 Quoted by F. Klingender, 'Life and Work of George Grosz', *New Masses* (1946), no pagination.
60 Meier-Merz, *Expressionism*.
61 Gertrud Alexander in the *Rote Fahne*, cited in H. Bergius, 'Lederstrumpf zwischen Provinz und Metropole' in catalogue of the *Rudolf Schlichter* exhibition (Berlin, 1984), p. 44a.
62 G. Grosz, 'Zu meinen neuen Bildern', *Kunstblatt* (January 1921), pp. 11–14, 16.
63 G. Grosz and W. Herzfelde, 'Die Kunst ist in Gefahr' (Berlin, 1925) In Schneede, *Zwanziger Jahre*, pp. 126–37.
64 *Ibid.*
65 There were a few artists who had started as manual workers but it was only in the later years of the Weimar period that the KPD encouraged the development of drawing skills among members so that they could help with agitation and propaganda work.
66 See W. Herzfelde, *Gesellschaft, Künstler, Kommunismus* (Berlin, 1921), reprinted in W. Faehnders and M. Rector (eds), *Literatur im Klassenkampf* (Munich, 1971), pp. 124–49.
67 *Ibid.*
68 G. Grosz, 'Zu meinen neuen Bildern', p. 14.
69 *Ibid.* The fact that Grosz did not follow his precepts should not blind us to the theoretical significance of this approach. Nor was his analysis a temporary view; he made similar observations in 1924. See his essay in *Situation 1924: Künstlerische und kulturelle Manifestationen* (Ulm, 1924), pp. 22–4. At the same time the Cologne artist and political anarchist Franz Seiwert drew workers as well as capitalists or soldiers in an almost stereotype form.
70 Grosz and Herzfelde, 'Die Kunst ist in Gefahr'. A similar view was put forward by Franz Seiwert. See his 'Der Aufbau der proletarischen Kultur', *Die Aktion*, 51–2 (1920), cols 719–24.
71 This and the following quotations are taken from George Grosz and John Heartfield, 'Der Kunstlump', *Der Gegner*, 1, 10–12 (1919–20), pp. 48–56 and reprinted in Schneede, *Zwanziger Jahre*, pp. 50–8.
72 Kokoschka's appeal is reprinted in the article iself.
73 *Ibid.* A similar clear rejection of Kokoschka's view was made visually in Otto Dix's painting *The Matchseller*, where he pasted a strip of the text of Kokoschka's broadsheet in the gutter.
74 See also quotation from 'Der Kunstlump'. 'Arbeiter, indem man Euch die Idee des christlichen Kirchentums vorsetzt will man Euch entwaffnen um Euch umso bequemer der mörderischen Staatsmaschine auszuliefern. Arbeiter, indem man in Gemälden irgend etwas darstellt an das sich der Bürger noch klammern kann, das Euch Schönheit und Glück vorspiegelt, stärkt man ihn, sabotiert man

Euer Klassenbewusstsein, Euren Willen Zur Macht.' *Der Gegner*, I p. 51, Schneede, *Zwanziger Jahre*, p. 54.

75 From 'Der Kunstlump'.

76 F. W. Seiwert, 'Das Loch in Rubens' Schinken', *Die Aktion*, 10, 29–30 (1920), reprinted in Schneede, *Zwanziger Jahre*, pp. 59–60.

77 Gertrud Alexander was on the staff of the *Rote Fahne* from 1920 until 1924. She was one of the small group entrusted by the KPD with the drawing-up of the Cultural Emergency Programme in 1922.

78 GLL, 'Herrn John Heartfield und George Grosz', *Rote Fahne* (9 June 1920); reprinted in Faehnders and Rector, *Literatur*, pp. 50–2 at p. 52.

5 Agitation and art: the press

The German Labour Movement attained the status of a mass move-
ment relatively early in its development. This was helped by the
early introduction of public elementary education and by a long tradi-
tion of adult education in the industrial working class. The workers'
desire for self-improvement had been assisted by progressive entre-
preneurs and by the leaders of the young socialist movement. The
former sought a skilled and adaptable workforce, the latter needed to
train the cadres and officials of their political army who would organ-
ise and proselytise to establish the workers as a political force. Their
intellectual success and the efficiency of their organisation had, in
the words of Friedrich Engels, made the German proletariat the best
educated and most mature in Europe.[1]

Hand in hand with the growing 'maturity' went a strong belief in
the persuasive power of the printed word, and the elevation of Marxian
socialism to the status of a science only strengthened the importance
the party attached to knowledge and interpretation of socialist the-
ories. The German Social Democratic Party therefore laid great stress
on founding presses and publishing houses. It started newspapers and
published books and pamphlets to further the intellectual standing of
the workers and improve their agitational skills.

Hence after 1890, when the social democratic movement managed
to shake off the fetters of the anti-socialist legislation, the SPD began
to set up a comprehensive publishing system for pamphlets, books
and above all newspapers. This was conceived as a vehicle for agita-
tion and education even more than for disseminating news. In social
democratic newspapers' editorials, the discussion of socialist policy
and later also the *feuilletons* (the general and literary supplements of
the mainly political daily paper) were held to be more important than
factual information.

The party press and other forms of publishing expanded rapidly
during the 1890s.[2] By 1914 there were seventy socialist daily papers
with a combined circulation of nearly 1.5 million, almost one paper
for every household voting for the SPD. After the war the social

democratic press experienced economic difficulties, paper shortages and competition from newly established Communist newspapers as well as from the bourgeois 'boulevard press' which published cheaper and more readable papers.

In response the SPD began to remodel its newspapers and make them more attractive by providing more local news and above all by improving the *feuilleton* and giving it a more prominent place. In the words of a leading social democratic editor, 'it was essential to depoliticise local coverage, polemicise less and chat more'.[3] As a result circulation, which had declined after the war, rose to 1.09 million after the end of inflation and 1.3 million in 1929.[4] Compared with these figures the circulation of the new Communist press remained small, with only 395,000 sales in the mid-1920s. This press also sought to adapt itself to the needs of a mass audience, hoping to achieve this through a system of workers' correspondents, whose reports from the workplace and about the home life of the working class were to bring the papers closer to the daily experience of its readers. Even this failed to make the Communist press truly popular. By 1929 circulation had fallen to 210,000.[5]

Real growth occurred in the field of magazine publishing, both in the number of titles and in many cases also in circulation.

The expanded and modernised workers' press of the Weimar period, seeking to entertain as well as to inform, was a major vehicle to communicate visual art and visual imagery to large sections of the working class. This applied less to daily newspapers and more to journals and magazines published by the two parties of the Left or by the mass organisations linked to them. The latter included specialist publications devoted to cultural questions, such as the *Kulturwille*, and illustrated weeklies such as the Communist *AIZ*, the *Arbeiter Illustrierte Zeitung* (Workers' Illustrated Paper, 1926–33) and *Volk und Zeit* (People and Time, 1919–33), the illustrated weekly supplement to many social democratic dailies. Magazines published by socialist or Communist book clubs were also important media for transmitting visual images. These came into being towards the end of the period, addressed themselves to a relatively sophisticated readership and were well produced and well illustrated.

The large and diversified trade union press was generally more technical and political in character, but it also occasionally published drawings and other illustrations. Another category of periodicals addressed themselves to specific groups of readers. Examples of this are the women's journals, such as the social democratic journal *Frauenwelt* (Women's World) or the Communist *Kommunistin* (Communist

Woman). These were also well illustrated. The latter published full-page prints, mostly photographs, while *Frauenwelt* would occasionally include colour illustrations to pin up in the home.

Another category of illustrated literature which expanded in the years after 1918 included calendars, almanacs and anthologies. These were aimed at special groups such as trade unionists or athletes, or they were issued like 'commercial' publications to be given as presents for Christmas or for the *Jugendweihe*, the secular socialist festival which was supposed to replace Confirmation.

Contemporary illustrations, political cartoons and reproductions of classical or modern art generally formed an integral part of many of these publications. The relative preponderance of design against politics, and of classical paintings against graphics with a political message, enables us to link the different characters of press and magazines to the politics and the policies of the Labour Movement. Such an analysis, based on sampling the art-historical and the illustrative material in five leading cultural or illustrated magazines, is presented as Appendix 1.

The spread of illustrations in the press was helped by the development of new formats and new printing techniques. The growth of photography widened the scope for successful reproduction, it was easier to record contemporary events or reproduce works of art. The growth of offset printing also made publishing illustrations easier, quicker and above all cheaper. Thus the social democratic humorous weekly *Lachen Links* told its readers in 1925 that it would henceforth be printed offset. This would not only improve the appearance of the magazine, it would also bring the price down from 30 Pfennigs to 20.

Illustrations in the working-class daily press were mostly photographs, political cartoons and more straightforward political drawings. Occasionally newspapers reproduced works of art by living artists or examples of older, classical art. The latter usually appeared in the *feuilleton* part of the paper as a feature. Illustrations in the political part were normally linked to special events or to dates in the political calendar such as an election or 1 May, or to important anniversaries like the outbreak of the war in 1914, 9 November, the day of the revolution, and, especially for the KPD, 15 January, the date when Karl Liebknecht and Rosa Luxemburg were murdered.[6]

The major socialist and especially Communist newspapers would thus publish from time to time what were in effect posters in miniature, often covering half a page or more.[7] To use a minor paper as an example, the social democratic *Sonntag*, a Dresden-based Sunday

paper, supplied as a supplement to socialist dailies, published a draw-ing with the title *Freiheit* (Freedom) to mark the Reichstag election of July 1932. This was a form of communication frequently used among social democrats, and the cartoon showed three young men with their fists raised, emphasising this anti-fascist salute. On another occasion the paper used the three arrows, the logo of the Eiserne Front (Iron Front) which aimed to defend the Republic against the growing Nazi movement (Plate 35).[8] In this drawing the Eiserne Front is represented in simple, strong lines by an industrial worker. His sharp-featured head and square shoulders stress his masculinity; the emblem of the three arrows on his shirt-pocket proclaims his politics.

On 4 August, the anniversary of the outbreak of war in 1914, the paper reproduced a lithograph by Käthe Kollwitz showing a mourn-ing father and mother. In November the paper marked Remembrance Sunday with a reproduction of Otto Dix's etching of soldiers in a barbed wire entanglement. The *Gelsenkirchner Volksstimme* printed a reproduction of Meunier's *Monument of Labour* to mark the annivers-ary of the revolution in 1927. A month later a 'Proletarian Christmas' was celebrated with a drawing of a mother breast-feeding her child.

In contrast to the relatively gentle art in social democratic papers, the Communist press tended to carry fiercer illustrations. Thus the magazine *Roter Stern* (Red Star, 1924–33), which was often circulated as a supplement to Communist dailies, was more intemperate in its images. One of the early posters from the May Day celebrations of around 1920 shows a muscular worker tower-ing over and threatening a group of capitalists (Plate 36), and in 1927 it attacked the recently concluded *Concordat* between the Vatican and the Prussian government in a photomontage which showed the social democratic minister as the Pope's train-bearer.

The illustrations in the newspapers and magazines which addressed the German work-ing class did not necessarily refer to general or specific political goals, nor did they regularly comment on the current political scene. The demonstrably agitational and didactic art of the period is better seen on hoardings and at demonstrations. On the other hand, illustrated magazines and journals frequently covered visual

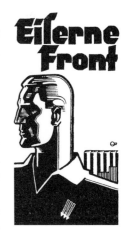

35 *Eiserne Front,* illustration in SDP election newssheet (1932)

36 *The Worker will Rule the World,* poster (1920?)

arts and discussed the meaning and significance of them for their working-class readers. Such discussions and presentations can be found in reviews of art exhibitions and in articles on contemporary artists, especially those who were sympathetic to the cause, if not actually party members.

Different publications did not, in effect, select, reproduce and comment on unique and separate bodies of art. The political movements and their organs have some common traits. In spite of the growing enmity between Communists and Social Democrats during the 1920s, they shared a common ancestral ideology; and in their daily lives, at the workbench and in workers' flats, politics did not take first place. Hence the canon of 'approved art' reflected their separate political orientation as well as their common heritage. Artists like Kollwitz, Hans Baluschek, Daumier, Dix and Frans Masareel were reproduced across the political spectrum.

Such political interpretation applied most clearly to the body of political satire which was so central to the political art of the period, particularly apparent in the left-wing satirical magazines of those years, especially the magazines which overtly or covertly supported the politics of the KPD, commencing with *Die Pleite* which was published by the Malik Verlag. But it can also be found in the social democratic press, especially in *Lachen Links.*

The founder and owner of Malik, Wieland Herzfelde, was an early member of the party. With his brother Helmut (John Heartfield) and with George Grosz he took over a small publishing venture, the *Neue Jugend* (New Youth), in 1906. Malik grew from this and soon assumed a strongly political revolutionary character. 'With the Revolution, our goal became clear', Herzfelde wrote later. 'We no longer addressed ourselves to the young and rebellious artists and intellectuals, we wished to help to ensure that the half-hearted bourgeois revolution in Germany should develop into a proletarian revolution' as it had done in Russia.[9]

Die Pleite failed, however, to win mass appeal. Its circulation never exceeded three thousand and what influence it had was due to the radical and uncompromising nature of the illustrations and to the dialectical thinking which lay behind many of the cartoons, especially those of Grosz. Many of Grosz's drawings first reached a wider public in the form of portfolios of photolithographs published by Malik Verlag. Their appearance in *Die Pleite* generally followed publication in series or book form (Plate 37).[10]

The acerbic and virulent character of *Die Pleite* led to the confiscation of issues and even the prosecution of Grosz and of his

publisher, and the journal was forced to close. Its place was taken by *Der Knüppel* (The Truncheon), which was published by the Communist Party, but with Grosz and Heartfield continuing as quasi-editors. The character of this paper was similar to that of the *Pleite*, but the new, larger-format paper, printed in three colours, was sold through the distribution network of the KPD. This worked largely through the more extensive and more efficient network of *Literatur-obleute*, local subscription and distribution agents.

With the new system, the circulation figures of *Der Knüppel* shot up. It is said to have had a print run of a hundred thousand, but many remained unsold. With the much larger print run the character of its readership changed. Most readers were now workers, but large sections of the working class showed strong resistance to the magazine, a fact which emerged in internal discussions. At the 1926 Agitprop conference of the KPD a speaker demanded that greater effort should be made to expand circulation further.[11]

37 George Grosz, *The Day of Reckoning*, lithograph (1921)

The problem of the paper's relative lack of popularity had already been raised at the tenth national conference of the KPD in the previous year. Criticism was directed at its contents, especially at the illustrations, which were held to be too remote from the feelings and sentiments of the ordinary worker. The critics said that issues relating to the political struggle were being neglected in favour of the 'artistic' character of the drawings. The ideological content of the illustrations, George Grosz's drawings in particular, were held to represent an anarchistic criticism of the disintegration of bourgeois society; they failed to show specific Communist critique. A resolution expressed this formally, urging stricter control over the ideology of *Der Knüppel* and its suitability for agitation, as well as a widening of the circle of contributors and the inclusion of artists from the working class.[12] The KPD officers were anxious not to offend the eminent artists who contributed so extensively to the magazine, and no action seems to have been taken to support the resolution.

Similar critical views were brought forward again at the next party conference in 1927, when a resolution from the Württemberg district

conference accepted the need for a satirical magazine, but urged the editors to improve both illustrations and text to increase the magazine's popularity.[13]

No immediate action was taken even then, but in the following year the party replaced *Der Knüppel* with a new magazine, *Eulenspiegel* (later renamed *Roter Pfeffer* – Red Pepper). Many of the contributors to *Der Knüppel*, including Grosz, Heartfield, Holtz and Schlichter, stopped drawing for this successor magazine. With the new title the editors, at first Otto Nagel and then for the *Rote Pfeffer* Fritz Erpenbeck, adopted a more 'humorous' style.[14]

The move from *Der Knüppel* – politically and artistically radical and highly charged from an emotional point of view – to the less offensive, more concretely focused and more easily understood *Eulenspiegel* was also a change in artistic character. Independent artists, who worked in a variety of media, were now replaced largely by professional graphic artists, mainly from the newly founded graphic atelier of the KPD in the Karl Liebknecht Haus, the headquarters of the party.[15]

Pleite and *Knüppel* stand out among the magazines of the Weimar Left in part for the ferocity of their attacks on the bourgeoisie and the social democratic politicians, whom the KPD viewed as the allies of the ruling classes. They also made sure of the ideological character of the illustrations they published and pulled no punches when it came to drawings like those criticising Friedrich Ebert, the social democratic first President of the Republic. A Grosz drawing called *The Life of a Socialist* depicted Ebert as a king wearing a half-broken crown, sitting on an armchair, his feet on a cushion. A flunkey hands him champagne in a goblet.

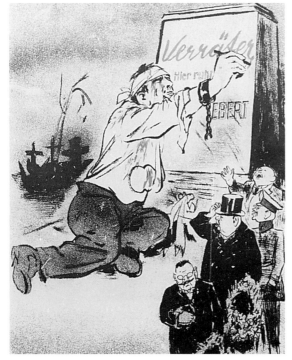

38 Rudolf Schlichter, *The Verdict of History*, *Der Knüppel* (1925)

When Ebert died in 1925 *Der Knüppel* published a drawing by Rudolf Schlichter showing Ebert's tombstone, on which a wounded worker has scrawled the word 'Traitor' (Plate 38). The representatives of government, industry and the army are paying their last respects while in the background a cemetery provides a pointer to the caption which reads '20,000 murdered revolutionaries have testified with their blood'.

By way of contrast to the satirical journals linked to the Communist Party, their social democratic contemporaries struck an altogether more gentle tone. They spoke in a less vituperative language and used milder visual imagery. This applied in particular to *Lachen Links* (1924–7) which carried the subtitle *Ein demokratisches Witzblatt* (A democratic humorous paper). The title makes clear that the paper's main purpose was not to attack a class enemy but to provide general satire. It criticised, but did not condemn outright.[16]

During the relatively prosperous middle years of the Weimar Republic there was in the ranks of the SPD a widespread belief that German society and the new state were on the road towards a better and more just society. Hence *Lachen Links* did not approach contemporary politics in a fundamentally antagonistic spirit, and its drawings did not attack capitalism and the bourgeoisie in general. It mainly denounced excesses and prejudice.[17] Drawings exposed Nazism and militarism, the callousness of the rich and the philistinism of sections of the bourgeoisie. But the magazine also implicitly expressed hope that social improvements were possible and that they would be achieved by confident and assertive workers within the existing economic and social framework and without violent struggle.

The contrast between *Lachen Links* and *Der Knüppel* becomes apparent when they respond to the same event, such as Ebert's death. In contrast to Rudolf Schlichter's devastating criticism referred to above, *Lachen Links* published a drawing venerating the deceased president (Plate 39). The parties of the Right had vilified and slandered Ebert for signing the Versailles Treaty, but the *Lachen Links* cartoon shows him on his bier, with an angel approaching to place a laurel wreath on his head. His detractors, represented by doll-like figures, move towards the structure to continue their attack, but the caption dismisses them with the words 'History, not the hate of the pygmies, will judge'.

The social democratic magazine occasionally used bitter satire but this was generally of the kind which evoked condemnation rather than inducing as strong a feeling of hostility as Grosz's drawings did. Journalist and critic Kurt Tucholsky wrote of Grosz: 'I know of no one who has so faithfully portrayed the face of our rulers down to the last drinker's vein as he has done. The secret – he does not just laugh, he hates.'[18]

This was not a lone voice. Oskar Kanehl, the poet who had thrown in his lot with the Communist Party, wrote in the seventh issue of the magazine *Weltbühne* that 'the comrades painters should dip their brushes and pencils in bile and poison so their pictures are true to nature'.

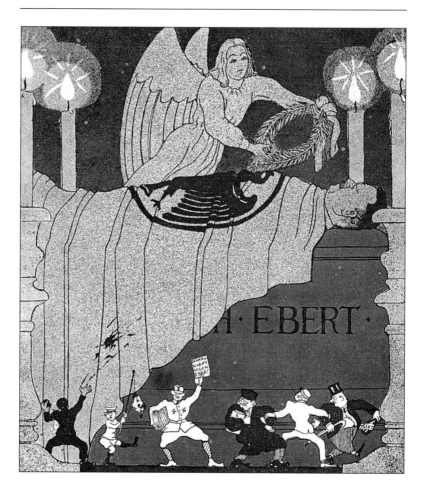

39 Herbert Anger, *History, not the Hate of the Pygmies, will Judge, Lachen Links* (1925)

The implication is that the artist 'gives expression to the deep personal involvement with the cause of the proletariat and its struggle, and that his condemnation of its enemies arises out of such an identification'.

The artists of *Lachen Links*, on the other hand, depicted the scourge of unemployment realistically. But such portrayal, while seeking to enlist the readers' sympathy, was not political in the sense described earlier. Artists like Baluschek and Willibald Krain had long been associated with socialism in Germany, and both were frequent illustrators of social democratic publications. In 1926 *Lachen Links* published a Baluschek drawing which showed a silent mass of men, women and children who, on a cold winter evening, wind their way from the factory to their homes (Plate 40). It is an image full of pathos; it invites compassion but it also conveys a feeling of resignation, not of a demonstration, let alone a revolt.

The illustration has the caption 'Arbeitslos' (Unemployed), and the fact that the drawing was originally published in a collection of prints with the title *Volk* (People) highlights the difficulty of creating a system of political art which would also be widely understood by politically unsophisticated workers. The absence of clear political direction is also suggested in a drawing by Krain on the danger of Nazism, published in what was virtually *Wahre Jakob's* last hour in July 1932. This shows a phalanx of clenched fists rising out of the ground, seemingly to form a barrier against tiny figures which symbolise the fascists. The caption says 'There is still time. Clench your fists now so that you will not have to clench them in your pockets later'. But the drawing does not seem to measure up to the needs of the hour.

The satirical magazines also published poems and other literary pieces, but their agitational and politicising role was determined primarily by their illustrations. This was not so in the case of other cultural journals, where the literary content was more important than the visual matter. However, these also published illustrations and regarded the aesthetic education of their readers as an obvious task.

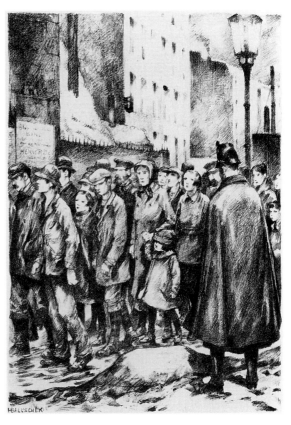

40 Hans Baluschek, *The Unemployed, Lachen Links* (1926)

One of the earliest publications which regularly reproduced works of art was *Die Freie Welt* (The Free World, 1919–22), of the Independent Social Democratic Party (USPD). Modelled on the pre-war social democratic *Neue Welt*, it targeted a more intellectual readership than the latter. And although the USPD was supported by some avant-garde artists, there were only a few such painters or other visual artists among the illustrators. The paper reproduced works by contemporary artists without strong connections with the political Left, for example Corinth, Jaeckel, Hodler and Liebermann, but hardly anything by expressionists.

Freie Welt also published some highly relevant contributions by Grosz, Karl Holtz and Kollwitz, and it used reproductions from classical painters to draw moral and political conclusions for the present.

One example was Daumier's *Europe before the World Revolution*, in which a haggard woman balances herself precariously on a globe shaped in the form of a mine with a smouldering fuse. Goya was also discussed in the context of quasi-revolutionary action (Plate 41). Human misery, the paper wrote, was not a subject for picturesque painting but an object which caused distress for Goya. He drew it in all its ferociousness and rebelliousness and through this sought to move men to join the struggle.[19]

Not only Daumier and Goya, revolutionary painters *par excellence*, were brought into the discussion of contemporary politics. Works by less overtly political artists were also made to serve the cause. Thus Velázquez's great painting *The Capitulation of Breda* was reproduced as an illustration of the reconciliation of enemies. It was clearly a lesson for the times.[20] More general articles on the visual arts and on individual artists discussed their relevance for the socialist reader. Adolf Behne, writing on Rembrandt, highlighted his portrayal of ordinary (proletarian) men and women and Mathias Grünewald's Isenheimer Altarpiece was also interpreted in humanist rather than religious terms.

Such examples show how even classical art could be made to serve political needs. However, *Freie Welt*, like most other left-wing periodicals, did not publish abstract art. Modern art was expected to be realistic. The content of art might anyway present difficulties for the unsophisticated reader, so the style, at least, should not add obstacles

41 Francesco Goya, *With or Without Sense?*, reproduced in *Die Freie Welt*

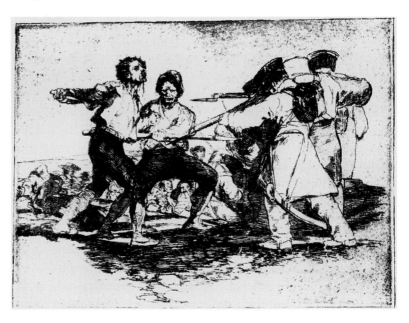

to its understanding. This was in line with the literary policy of the paper, which preferred naturalist, semi-realistic and documentary writing. *Freie Welt* 'sought to reinstate an anthropocentric view of the world ... to affirm that man could again make himself at home in it'.[21]

Not all illustrations in the workers' press had a clearly didactic purpose: many stood on their own without any related text. The selection might have been made with the political and ideological content in mind, but this was not always explained and readers were expected to draw their own conclusions from the illustrations. On the other hand, not all descriptive or critical articles on art, artists or other art-historical themes had a political message. For a paper like *Freie Welt*, culture and art were mostly seen in a social and political context, but the purpose of some illustrations was clearly merely aesthetic.

The idea that art should perform a life-enriching function was very much apparent in the columns of *Kulturwille* (1924–33), a monthly journal devoted to culture and the arts which was published by the Leipzig Arbeiter Bildungs-Institut (Workers' Education Institute). It was the principal social democratic periodical devoted exclusively to educational and cultural questions. Its contributors stood generally on the Left of the party but its general attitude was undogmatic and its influence extended far beyond its native Saxony.

Its frequent illustrations – accompanying the text on most front pages and in the journal – were not selected primarily on political grounds. Indeed, many illustrations were of contemporary art or of designs which conveyed general sentiments rather than relating to specific political goals. Frans Masareel's prints were frequently used as cover illustrations, and woodcuts and linocuts were also popular. The first issue of the journal carried a programmatic front-page article by Valtin Hartig, the editor, which dealt with the cultural and educational needs of the working class. He acknowledged the social importance of education, but said that the education of the working class meant also training in understanding works of art. The linocut reproduced with the article showed two naked figures, man and woman, reaching upwards into the rays of the sun (Plate 42). The caption read 'Leben heisst kämpfen' (To live is to fight).

Freie Welt ceased publication in 1922 when the USPD split into two sections: one joined the Communists and the other rejoined the SPD. For the social democratic working class the most important weekly paper was henceforth *Volk und Zeit*, which appeared throughout the years of the Weimar Republic as a supplement to *Vorwärts* and other social democratic daily papers.[22]

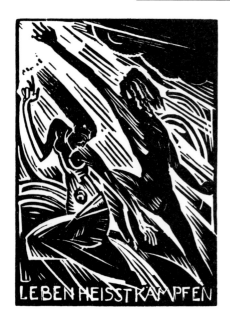

LEBEN HEISSTKÄMPFEN

42 Wernicke, *To Live is to Fight,* cover illustration, *Kulturwille* (11 February 1924)

Volk und Zeit covered current events with photographs obtained mainly from agencies. But it also carried more general articles, including some about art and individual artists, usually with a number of illustrations. In addition the paper published reproductions of paintings, graphic art or sculptures, usually in connection with some public event such as 9 November or the anniversary of the outbreak of war. Thus in November we find a reproduction of Delacroix's *Liberty Guiding the People on to the Barricades,* painted in commemoration of the revolution of 1830, and a Kollwitz drawing, *At the Manufacturer's Gate* from the cycle on the Weavers' Uprising. Three years later the front page remembered the outbreak of the 1914 war with a picture of a Rodin sculpture over the legend 'Call to Arms'. On another anniversary the paper reproduced an etching from Otto Dix's war cycle.

These and other examples of political art printed in *Volk und Zeit* might well be described as landmarks in the history of radical images, but they were not published as comments on contemporary events or as ideological statements. Political art was far from the only art reproduced in the paper. Throughout its existence *Volk und Zeit* explored traditional art and reproduced works by more conventional artists. Thus Hans Thoma, painter of idyllic scenes, whose work evoked popular traditions and folk customs, was often reproduced. So were paintings by the impressionist Liebermann, who was president of the Prussian Academy of Arts. Böcklin's *Self-portrait with Death,* Paul Modersohn's *Rising Moon* and Dürer's *Squirrel* were all reproduced in largish formats, as was Rembrandt's portrait of his wife. Even 'Fidus' (H. Höppener), a highly romantic and politically nationalist painter of the 'body beautiful', was featured in an article which praised him in glowing tones as the 'bold pioneer for a new sexual morality . . . The most sacred subject of his art is the mystery of sexual union in the erotic flames which lead to the eternity of the firmament.'[23]

Such views might have been expounded in any bourgeois magazine. Indeed, here and elsewhere we are faced with examples of the paper's apolitical sentiment in the treatment of visual art. Other visual material was also treated in a way which stressed the beautiful and alluded to the romantic aspect of a work rather than treating the picture critically.

Volk und Zeit concentrated its photo-journalism on national and world events and, unlike the Communist *AIZ*, laid less emphasis on working-class life in Germany, let alone on the achievements of the Soviet Union. Photos of beautiful landscapes, especially of highly romantic tracts, meadows, forests and mountains or old towns and ancient buildings, were a regular feature. Such pictures seem to say to the reader: 'Our country is beautiful, it is yours to cherish and inherit.' Thus *Volk und Zeit* and other social democratic journals and magazines displayed in their illustrations for most of the period a positive attitude towards the new state. For them the Weimar Republic, with all its faults, was their republic. The Labour Movement and the SPD, whose successes would be featured in the magazine, were an integral part of that republic. Only during the last few years of this period, and in the face of a deepening economic depression, do we find a growing number of illustrations which showed workers' misery, their suffering and their struggles.

Compared with this traditional illustrated paper, the picture presented by the *AIZ* was evidence of a new departure in journalism. Published by the organising genius of Willi Münzenberg in association with the KPD but formally independent of it, the *AIZ* was by all criteria a most original and successful newspaper enterprise. In spite of its much larger circulation, which peaked at half a million, the *AIZ* was from the beginning a magazine of criticism and combat. Its illustrations exposed social evils and the economic exploitation of the proletariat, but it was equally concerned with political agitation and the mobilisation of its working-class readers to support the Communist cause and the revolutionary proletariat.

This attitude also influenced the representation of art in the paper. There were fewer articles dealing with artists or art history in a neutral way, and illustrations portrayed the workers' struggle, principally through the Communist Party and with the help of the Soviet Union and the international Communist movement.

Heinrich Mann, a long-time sympathiser, in 1926 praised the style of the *AIZ*. He wrote that the paper 'shows us the world of the proletariat as no other illustrated paper does, even though this world formed by far the largest section of society . . . its illustrations bring out the troubles and the complaints of the proletariat and they show already now the growing self-confidence of [the workers] which manifests itself in the manner in which they help themselves'.[24]

The *AIZ* put its main journalistic emphasis on economic and political issues. Art was not unimportant for its readers, but the paper

viewed it primarily in terms of a political message. Hence articles on art subjects were generally devoted to artists whose work would set examples for workers to follow. An article on Frans Masareel, the Belgian graphic artist who had almost acquired the status of an offical working-class artist in Germany, argued that, while he did not neglect the bad aspects of life, he had also captured the gaiety and the energy of working people at play. The worker recognised himself in Masareel's work and said, 'yes, this is us, the masses of the fighting proletariat'.[25]

In addition to articles or series of articles on modern and other radical artists, the paper reported on exhibitions of particularly significant art, including a show of contemporary Russian art in Germany and of German art in the Soviet Union. Such reviews stressed the new attitude towards the arts in Russia. There, Germans were told, the workers were the bearers of the new culture. German workers were urged to follow the same course, and the *AIZ* would help.[26]

The Communist Party followed Russian practices in other areas too. The German party press, like the Russian, created groups of voluntary contributors, known as *Arbeiterkorrespondenten* (worker correspondents) from within the paper's readership. The *AIZ* also mobilised worker photographers, and Münzenberg helped to organise them in the Verband der Arbeiter-Fotografen (Association of Worker Photographers). Their task was to photograph places where professional photographers could not or would not go and thus expose poor conditions and dangerous practices at the workplace and show up the evils of capitalism.

Such pictures were to be judged not by their aesthetic qualities but by their authenticity. As with the wider-ranging group of worker correspondents, the fact that photographers and readers came from the same social background and were expected to look at the world in the same way would instil confidence in the truth of the pictorial reportage.

Photography, agitation and art were linked through the associations of worker photographers. They, in turn, came into existence with Communist help, but they also had their roots in the artistic inclinations of individual workers. The drive towards artistic activity 'from below' and the mobilisation and training of skills by the political parties are part of the general analysis of the links between the visual arts and the working class and its organisation. It will be discussed in the next two chapters on the parties of the Left and their policy and practice in the field of the visual arts.

NOTES

1 See F. Engels, Prefaces to the 2nd and 3rd edition of The *German Peasants' War*, 1870 and 1875, in *Marx and Engels Selected Works* (London and Moscow, various dates), pp. 604–10, 611–16.

2 For the social democratic press see L. Kantorowicz, *Die sozial demokratische Presse Deutschlands* (Diss. Tübingen, 1922); K. Koszyk, 'Zwischen Kaiserreich und Diktatur', *Die sozial demokratische Presse, 1918–1933* (Heidelberg, 1968).

3 Wilhelm Sollmann at a meeting of the Verein Arbeiterpresse (quoted in Koszyk, 'Zwischen Kaiserreich und Diktatur', p. 122).

4 In 1926 the SPD had 145 daily papers, with local editions, some of which differed only in the title-page.

5 See C. Hempel-Küter, *Die kommunistische Presse und die Arbeiter-Korrespondenten Bewegung* (Frankfurt, Bern, etc., 1989).

6 Karl Liebknecht and Rosa Luxemburg, the leaders of the Spartacists and later of the newly founded Communist Party, were killed by soldiers of the Freecorps on 15 January 1919.

7 The KPD was particularly active in the creation and distribution of such patterns and of clichés or printing blocks to be used by local papers.

8 *Drei Pfeile* (Three Arrows) was the emblem of the Eiserne Front, an anti-Nazi organisation uniting the SPD, the trade unions, the Reichsbanner (a social democratic defence organisation) and the workers' sports organisation.

9 See *Malik Verlag* bibliography edited by Wieland Herzfelde (Leipzig, n.d., *c.* 1960) and especially the editor's introduction.

10 The following portfolios of Grosz's work were published by the Malik publishing house: *Erste Grosz Mappe* (1917); *Kleine Grosz Mappe* (1917); *Gott mit Uns* (1920); *Das Gesicht der Herrschenden Klasse* (1921); *Im Schatten* (1920); *Ecce Homo* (1922); *Die Räuber* (1922); *Mit Pinsel und Schere* (1922); *Abrechnung folgt* (1923).

11 See *Stiftung Archiv*, ZPA I 3/-2 96 f. 10 of 2 June 1926 and ZPA I 3/15 f. 27. See also the report to the party conference of the Partei Zentrale, which stated that the *Knüppel* had been well received but that the discussion of the report from the Agitprop Department had shown considerable disquiet. For figures of the readership of the magazine see D. Grunewald, *Studien zur Literaturdidaktik als Wissenschaft literarischer Vermittlungsprozesse in Theorie und Praxis* (Diss. Giessen), pp. 242–3.

12 *Bericht des Parteitag*, 1925, pp. 691–701.

13 *Ibid.*, p. 418.

14 It is interesting to note that in 1927 Willi Münzenberg told the leadership of the KPD that he would be willing to take over the party's publishing organisation, the VIVA (Vereinigung Internationaler Verlagsanstalten) which published *Der Knüppel*. He wrote, 'I would need to have a completely free hand in the reorganisation of the *Knüppel*. My propsals are to make major changes. I would publish only fortnightly, to have Hartfield [*sic!*] only as a collaborator and no longer as a Principal and to bring the comrades Dr Hollering, Holtz and others into greater prominence.' W. Münzenberg letter 'An das Zentralkomittees der KPD, Sekretariat, die Genossen Thälmann, Dengel und Eberlein', 11 June 1927 (ZPA).

15 The tenor of *Eulenspiegel* was more 'socially critical' and 'emotionally engaged' than the *Knüppel* had been. See U. Horn in H. Olbrich *et al.*, *Sozialistische Karikatur* (Berlin, 1971), p. 143. See also A. Beier-Red in *Bildende Kunst* (1963), p. 513. *Eulenspiegel* was published in two colours and in tabloid form.

16 The title ('Laughter on the Left') refers to the official record of the Reichstag debates which recorded expressions of derision by SPD or KPD in these terms. *Lachen Links* was a continuation of *Der Wahre Jakob*, which had ceased publication in 1922. From 1928 the magazine reverted to its original title.

17 See the comments in the *Weltbühne* (25 January 1925).

18 Kurt Tucholsky, 'Fratzen von Grosz', *Weltbühne* (18 August 1921), p. 184.

19 *Freie Welt*, 2 (7 May 1919). See also issues 7 and 10 of 1919.

20 *Freie Welt*, 25 (9 November 1919).

21 See R. W. Sheppard, *Artists, Intellectuals and the USPD, 1917–1923*, unpublished MS.

22 *Volk und Zeit* was published or printed in different local editions. These varied often only in respect of the advertisements.

23 *Volk und Zeit*, 10 (1929). For 'Fidus' see J. Frecot *et al.*, *Fidus* (Munich, 1972).

24 *AIZ*, 9 (1926).

25 See Gertrud Alexander, 'Frans Masareel, der Freund und Kämpfer des Proletariats', *AIZ* (April–May 1925).

26 *Ibid.*, p. 521.

Art exhibitions and the Labour Movement 1918–33: provision and reception

M odern art and the art of the past had potentially reached an audience of hundreds of thousands of working-class readers through books, magazines and newspapers, but these readers saw original art only as reproductions. With the exception of political cartoons and graphic illustrations, the workers' press of that time could use only comparatively poor methods to reproduce original works of art like paintings and sculptures. The images were mostly small and in black and white, and they could do little justice to the original work, although they nevertheless had a strong influence on readers.

The impact of art viewed outside the home and beyond the confines of the print media is harder to assess, if only because the opportunities to view art at first hand were extremely limited for the average member of the working class.

However, both the social democratic and the Communist parties, as well as groups and individuals associated with the two, did much to try to bring art to the worker and encourage the worker, through exhibitions, to experience original art, often for the first time. Most shows, however, took place either at the start of the Weimar Republic or, surprisingly, towards its end, although the SPD had other things to worry about than art and culture. The threat of fascism was already casting its shadow over the activities of the Left. This and the devastating effect of the economic depression forced the SPD, unlike the Communists a party of government, to concentrate its energies increasingly on political and economic matters at the expense of cultural ones.

This was at the very end of the period. Before then, a system to mount exhibitions had to be developed, decisions had to be taken on where these shows should be held and what they should contain: aesthetic art to please the worker or didactic works to encourage active participation in the class struggle.

The whole ethos of museums and art galleries was, certainly before 1918, oriented towards bourgeois values. On the one hand museums were expected to foster scholarship, on the other their task was to buy

and collect works of art and other objects. The restricted opening hours and the general ethos of the staff of museums and galleries militated against working-class viewing. Only here and there had museum directors and curators arranged guided tours of collections, and the liberal middle class in places like Hamburg and Mannheim founded societies to help increase the popularity of the arts. Areas of concern of these societies included the propagation of art among the working class.[1]

The Social Democratic Party generally supported such endeavours and even before 1914 the occasional slide lecture on art topics, such as 'Labour in the Visual Arts', figured among the educational activities of the SPD. One apparently unique exception involving the display of works of art, albeit by amateurs, was an exhibition of art, mainly by young workers, in Berlin in 1909. It had been arranged by Adolf Levenstein, physician and amateur social investigator, who had previously surveyed workers' attitudes, leisure and lifestyles and published the results.[2] Kollwitz thought the exhibition very interesting and commented on the fact that while older workers depicted neutral subjects, the young drew and painted city and industrial scenes. It seems that the show mainly attracted the middle class and very few workers turned up to see the work of their comrades.

One feature of social democratic activity, however, had always brought art in some form to the attention of working-class audiences: the Christmas Bazaars which the party and the trade unions staged in the larger towns. It was also hoped that exhibitions, which offered books and items suitable for presents at prices workers could afford, would help develop workers' tastes and wean them away from mindlessly aping ornate and *kitschig* bourgeois tastes. These bazaars-cum-exhibitions tried to present workers with examples of good but simple design and persuade them to discard the sugary-sentimental oleographs which used to hang on the walls of even the politically most progressive working-class home. In place of dancing nymphs or bucolic hunting scenes, it was hoped that workers would display good landscapes or still lifes in simple but strong colours.

Most items on offer were reproductions, but original prints were also occasionally on sale.[3] As we have seen, a whole industry to produce prints for the home already existed in Germany. Now publishers allied to the parties of the Left would sometimes issue reproductions of political art. Thus a set of Daumier cartoons was advertised as being suitable decorations for the home of the class-conscious worker.

During the years of the Weimar Republic the pace quickened. Exhibitions of art for workers, often with political themes, became more

common and original art was brought to the attention of workers in an organised form. Exhibitions mounted by socialist and Communist parties or affiliated organisations throughout the Weimar years ranged from the aesthetic and educational to the ideological and didactic. The former were linked mainly to events staged by social democratic organisations, the latter were more the hallmark of Communist exhibitions; but there were exceptions.

A list of art exhibitions which addressed themselves specifically to the German working class or which contained material relevant to the politically engaged worker is given in Appendix 2. The information was gathered from the press and other contemporary sources but the total scope of such events is probably larger. Unfortunately in many cases we only know the basic facts about an exhibition, and information about the works shown or about attendances is incomplete. It is therefore impossible to subject the information to even the most simple form of quantitative analysis.[4] We know, however, enough about several of these exhibitions to permit some generalisations.

Even a cursory perusal of the list shows that exhibitions were concentrated at the beginning and the end of the Weimar period. This suggests that the public display of works of art was itself related to the intensity of political activity. The months after the November revolution and the first few years of the republic saw, especially in Berlin, a spate of exhibitions which aimed to stimulate workers' interests, although the impetus rarely came from the workers themselves. Those involved in organising and mounting the shows were generally committed socialists or Communists, or at least sympathisers with the cause. Some of the Berlin district authorities arranged art exhibitions in schools.

Other efforts to popularise art through exhibitions came from the artists themselves. Thus in February 1919 *Vorwärts* published an appeal by Friedrich Natterroth, later one of the founders of the Bund für Proletarische Kultur (League for Proletarian Culture), for the foundation of a co-operative of socialist artists, the Genossenschaft (later Bund) sozialistischer Künstler. Natterroth was a writer not an artist, and he addressed writers and artists, suggesting joint action to help impoverished colleagues financially.

The artists hoped that such action would enable them to establish enterprises to sell works of art and to buy materials on a sound economic footing. Natterroth expected artists would be able to work for political parties and other working-class organisations in designing posters and other publications.[5] The new co-operative also hoped to benefit by staging exhibitions in Berlin. The shows included works

by well-known artists like Baluschek, Kollwitz and Willibald Krain. One exhibition was held in one of the factories of electrical giant AEG, another in the bookshop of the *Vorwärts* publishing enterprise. Other exhibitions toured schools in working-class districts of Berlin.

The purposes of these school exhibitions was partly educational, to stimulate the pupils. But the organisers also hoped to encourage the authorities to display new pictures 'now that the portraits of Emperors and the pictures of the war had disappeared'. But the reviewer doubted whether works by Baluschek or Kollwitz were really suitable for such a purpose. In her view they were too topical and perhaps also too harrowing. She advocated instead 'reproductions of beautiful works of painters like Giotto or Hodler or of some of the painters of the youngest generation, whose pictures would repay repeated attention'.[6]

One major attempt to interest workers in art was the exhibition of workers' art which the Arbeitsrat für Kunst mounted in 1920 in the Haus der Proletarischen Jugend in the east end of Berlin.[7] Although the exhibition included works by some well-known artists (Chagall and Feininger are mentioned as well as Taut's designs in glass) most of the works were by amateur working-class painters and sculptors. There were also examples of children's art.

The exhibition did not set out to categorise art or encourage enthusiasts to 'do better', and its purpose was much more ambitious than just bringing workers face to face with established art (Plate 43). The organisers did not claim to follow the customary maxim 'art for the

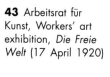

43 Arbeitsrat für Kunst, Workers' art exhibition, *Die Freie Welt* (17 April 1920)

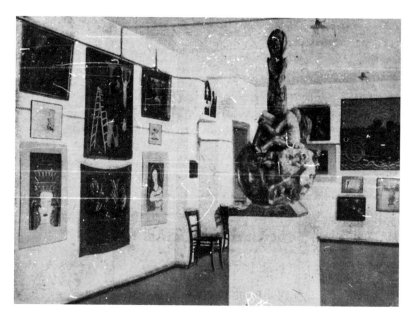

people' (*die Kunst dem Volke*) used on such occasions. They thought that such a slogan was condescending, and put the artist outside the community. Instead, the leaders of the Arbeitsrat thought in terms of *der Kunst das Volk* (a people for the arts). They wished to co-operate with the workers' representatives and ensure that art was no longer a luxury and a mere plaything for the rich. Art and nation should be ·one and art should become an integral part of daily life. 'It would be ideal, if what was shown was art itself, not an art exhibition. If it was reality, not a panopticon.'[8]

In more positive terms, Adolf Behne, who created the exhibition, wrote that he wanted to make the point that art can be created outside the establishment and the snobbish art academies. This was the reason for including drawings by children, and for not attaching any names to the exhibits.[9] But the selection was nevertheless not arbitrary, as shown by Behne's comments on an exhibition of workers' art organised in 1919 by the Naturfreunde, a socialist hiking and holiday organisation. He found that it lacked originality and only a few exhibits showed imagination.[10]

The *Arbeiterkunst* exhibition evoked some positive response within the Labour Movement. The *Rätezeitung*, an organ of the movement of Workers' and Soldiers' Councils, welcomed the fact that the works were shown anonymously. The paper hoped the exhibition would encourage more workers to try their hand at art. Indeed, the paper argued, workers could do equally well if they would only rid themselves of all they had learnt at school which had so fettered their imagination. Beyond that it was hoped that a new artistic sensitivity would influence the workers' choice of decoration and furniture for their homes, and that workers, together with artists, would make life more beautiful.[11]

Little of this happened in fact and, as the first hoped-for links between progressive artists and the radical proletariat failed to mature, the obviously limited attempts to bring about a deeper understanding of art in sections of the working class through a training in aesthetics and a liberation of the imagination failed with it. They might have been more successful in the long run if art education in schools had followed a freer, less technical and less academic approach. And where the schools failed, the education of adults could not easily succeed. Courses for adults in the *Volkshochschulen* concentrated on various aspects of art history or art appreciation. Teaching in the Communist MASCH (*Marxistische Arbeiter Schulen*) aimed to train illustrators, and they were too concerned to produce effective practitioners for political agitation to train artists, even amateur ones.[12]

We must clearly look at the art shown in the various exhibitions and addressed to the working class in a political context. Social democratic parties and trade union organisations were committed to trying to enrich the aesthetic environment and the quality of life for the working class. They continued to hold general 'cultural' exhibitions in which art figured together with other objects.[13] Even Communist organisations at times adopted such an approach.

Two such exhibitions mounted by SPD and KPD respectively were held in 1925 in connection with 'Weeks of Culture' in the central German cities of Gera and Gotha. In the words of a contemporary observer, the Gotha exhibition demonstrated 'the rise of the proletarian feeling for art and how it advanced upwards' from the petty bourgeois philistine sentiments, which made them fill their home with bric-à-brac. 'The way went upwards through criticism and accusation to the creative pictures of a new life.' The Gera exhibition not only showed works by politically committed artists – Felixmüller, Vogeler and others – it also showed art created by local workers as well as examples of handicraft.[14]

The reasoning behind some social democratic attempts to improve workers' tastes and raise their appreciation of art is brought out in the application which the party's Education Council – the Reichsausschuss für sozialistische Bildungsarbeit – made to the Ministry of the Interior. The party applied for a subsidy for a proposed exhibition of arts and crafts for the working-class home, the *Arbeiter Heimkunst Ausstellung*. This was to be a travelling exhibition to show workers 'the good, cheap and yet artistically valuable household articles which were available to workers'.[15]

One of the major exhibitions staged by a social democratic party was the *Leipziger Kunstaustellung*, which was shown in the Museum der Bildenden Künste in conjunction with a so-called week of culture in 1924. It had been organised by the Arbeiter-Bildungs Institut, a semi-public body in charge of adult education in the city, and it beamed out a broadly political message.

This exhibition sought to mark the tenth anniversary of the outbreak of war, and war, revolution, work and the social problems of the time were the themes. It showed works by Dix, Grosz, Felixmüller, Schlichter, Barlach, Kollwitz, Ehrlich, Chagall, Zille and others, including several local artists. As the author of the introduction to the exhibition wrote, 'The artist of today ... will portray the truth honestly and without embellishment and he will uncover the intolerable miseries of the times which do not form part of the divine order of things'. He would not speak glibly of 'the falsity and pretence of bourgeois society and of the suffering of the worker'.[16]

Most of the exhibits consisted of prints, woodcuts and lithographs, rather than paintings. The catalogue said this merely reflected 'the changes in our consciousness which is today socially oriented' and the list of exhibits confirms that many, if not most, of the works shown had a socially critical if not a clearly political message. The most obviously political and agitational work at the event was probably the poster *Nie wieder Krieg* (No more War) which Kollwitz had created for the conference of socialist youth organisations, held during that week (Plate 44). The theme of war also featured prominently elsewhere in the exhibition, and two terrifying prints shown were reproduced in the programme of the *Kulturwoche*. They were Otto Dix's *Attack under Gas*, from the *War* cycle of etchings – all of which were on show – and Kollwitz's *The Volunteers*, a woodcut from a cycle of seven also entitled *War*.

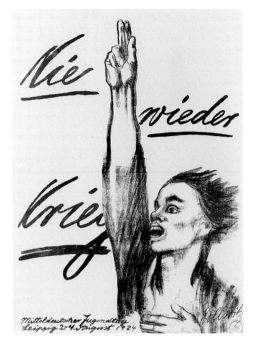

44 Käthe Kollwitz, *Nie wieder Krieg* (No more War), poster (1924)

Other works were more neutral in character, but the exhibition was by and large conceived as 'a reportage and a portrayal of mores and morals [*Sittenschilderung*] of the twentieth century [and] an impassioned protest against all that stood condemned, a call for a future free from suffering and hatred' rather than as *l'art pour l'art*.[17]

Those responsible for the exhibition had been much less sanguine about its chances of success and were amazed by its popularity, given that the visual arts had hitherto been in the nature of a closed book. They regarded the attendance figure of three thousand and the marked interest of the young as very satisfactory.

By contrast to this social democratic venture, the series of art shows which Otto Nagel mounted in Berlin, first in 1924 and then in department stores in 1926, were less clearly ideological or political in character despite Nagel's strong links with the KPD. The 1924 exhibition, held in the Wertheim Department Store on Alexanderplatz, showed works by artists who had joined the Künstlerhilfe, a group mobilised by the Internationale Arbeiter Hilfe (IAH, the International Workers' Aid organisation).[18] The IAH was at that time engaged primarily in helping the victims of the famine in Russia, and the pictures were sold to raise money for this.

The 1926 series of exhibitions was known as *Volkstümliche Kunstschauen* (popular art shows). They were also mounted in department stores and were thus likely to be seen by large numbers of

people (Plate 45). Nagel claimed that he exclusively showed in his exhibitions 'work which could be readily understood by the masses and with which they could establish affinities'.[19] His exhibitions mixed strongly political and engaged art – artists like Baluschek, Dix, Grosz, Kollwitz, Nagel, Schlichter and Zille predominating – with more neutral works, sometimes with a local character.

The composition varied from one location to another. The first exhibition, held in the Stein Department Store in Berlin's Wedding district, was the most politically committed, with disturbing works such as Otto Dix's painting of an old whore captioned *Venus of Capitalism* and a picture by Birkle which showed a worker crushed by a machine. By way of contrast, the second show, at Wertheim's in Neukölln, paid much greater attention to the aesthetic aspects of art. The result was a compromise, with tendentious art overshadowed by the rest, but with interesting examples of architectural photographs and plans.

Writing of the last show in the Lindemann Department Store in Berlin Spandau, the critic Alfred Kemenyi (pseudonym Durus) wrote in the *Rote Fahne* that this exhibition lacked 'its proletarian consistency ... In the Spandau show we find also a section of petty bourgeois artists from the locality which consists of weak, dull and repetitive studio painting.' The paper also said that the shows 'presented a harsh but highly realistic and unforgiving art' and that they 'mirrored the workers' own blighted lives and the struggle of their class'.[20]

It was, however, the political and socially critical part of the exhibitions which attracted the most attention and criticism. Representatives

45 View of the workers' art exhibition in Berlin department stores (1926)

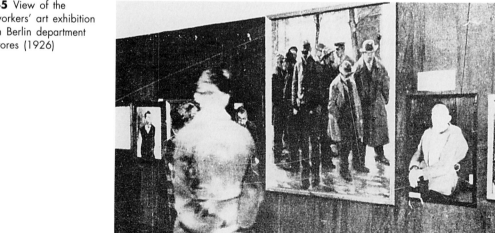

of the bourgeois parties in the districts concerned attacked the allegedly morally corrupting character of some of the exhibits, asking the police to intervene. They complained that the exhibitions were accessible to minors and that copies of some of the works were on sale in postcard format for 10 Pfennigs.[21]

These accusations were rejected by a senior police officer who inspected the exhibition. He wrote that

The exhibition has obviously an explicitly Communist or socialist tendency. Apart from pictures which showed in a crass way the misery of poverty, the horrors of war and, in sharp contrast to these, the high life and feasting of the rich, we find works which castigate the sexual goings-on of the well-to-do or the moral depravity of the poorest sector of the population, prostitution and the like.

All this, he added, was treated realistically, but in a satirical vein so that the moral seriousness with which it was created could not be doubted.[22]

It seems that some workers also objected to the portrayal of the unorthodox, the nude and the allegedly 'lewd'. Women often expressed disgust at the 'obscene' and the violent. Dix's *Venus of Capitalism* was in this view too brutal and should be removed; art should transmit 'truth and beauty' to qualify as great art. But their menfolk seem to have been less squeamish. The political content of the exhibition, at least, seems to have met with the approval of all categories of visitors.

Aesthetics apart, the question remains whether such an exhibition would strengthen the resolve of the proletariat to persevere in the class struggle. This was the subject of a debate in the columns of the leading left-wing cultural and political journal *Weltbühne* (World Stage), where Behne argued that such art would only depress the workers, who knew their own misery well enough. It would make more sense to show such exhibitions in the Kaufhaus des Westens (the leading department store in rich western Berlin) to show the bourgeoisie the reality of the daily life of the proletariat. Behne said workers would be better mobilised if they were shown modern abstract art. 'To arrange Red and Green in such a way that both coloured areas posit the greatest amount of strength and power' was more revolutionary than all *Elendsmalerei* taken together.

This unsubstantiated proposition elicited a reply from John Heartfield that even the most daring hypotheses about colours would not move even a dozen workers into action, let alone to fire a rifle – and that, after all, was the only purpose of revolutionary art.[23]

Nagel, who was a keen populariser of visual art, estimated that his 'Art in Department Stores' shows had attracted 160,000 visitors, although obviously not all of them were workers. He said the art shown could be understood by workers everywhere, as he had chosen artists 'who in their art had established close ties with the proletarian masses' and he showed only 'works that could be readily understood by these masses and with whom they could establish an inner rapport'.

Considering that almost all works from the first show sold out, there must have been some substance in this claim. Nagel also observed that the art shown was particularly popular among young workers, who, he felt, had a great longing for original art for their home.[24]

The selection committee had consisted of Nagel, Professor Sandkuhl, Behne and Bruno Reimann, the owner of a Berlin art school, and the result was bound to be a stylistic mixture. 'Durus' described it as a compromise between so-called abstract art and tendentious art. Its principal success, he thought, lay probably on the revolutionary-propagandist level.[25]

Later Communist-inspired exhibitions tended increasingly to demonstrate clearly political purposes. Significantly, they also tended to depart from the pattern of the pure art exhibition and become cultural exhibitions or exhibitions of propaganda. Almost by way of a continuation of Nagel's *Volkstümliche Kunstschauen* the Communist Rote Frontkämpfer Bund, the 'Red Guards', staged an anti-war exhibition, the *Proletarische Kunst und Anti-Kriegsausstellung* in the spacious halls of the ULAP, the Urania Landesaustellungs Park in Berlin. It showed works from Nagel's exhibition, together with literature and other educational material.[26]

War was clearly a suitable topic for such exhibitions. In 1929 the Anti-War League (Bund der Kriegsgegner) toured major cities with a show which included Otto Dix's great painting *The Trenches* (*Der Schützengraben*). But there were also stands which dealt with the fate of the war-wounded and with the housing shortage and the misery of insanitary housing.[27] Such exhibitions dealt with topics of general concern and were much visited. The anti-war exhibition was reportedly seen by thirty thousand people in Dresden alone.[28]

Not surprisingly, an exhibition on the theme of women's suffering staged two years later under the title *Frauen in Not* (Women in Need) was equally popular (Plate 46). It was promoted by the Communist women's journal *Weg der Frau* (Women's Way); but its appeal was broader and it was opened by Käthe Kollwitz, whose political sympathies lay with the SPD rather than with the Communists.

Prof. Christoph Voll: Im Waisenhaus

Ausstellung:
Frauen in Not

Eine der wichtigsten Ausstellungen seit Jahren ist die „Internationale Ausstellung Frauen in Not", die Anfang Oktober im Haus der Juryfreien in Berlin (Platz der Republik 4) eröffnet wird und den ganzen Oktober andauert. Die Ausstellung findet auf Veranlassung der neuen Zeitschrift „Der Weg der Frau" statt. Die wichtigsten Künstler aller Länder, die zu dem jetzt vor dem Krisenwinter besonders aktuellen Thema etwas zu sagen haben, sind vertreten. Von deutschen Künstlern nennen wir u. a. Käthe Kollwitz, Hans Baluschek, Otto Dix, George Grosz, Karl Hofer, Joachim Ringelnatz. Die Sowjetrussen stellen kollektiv aus.

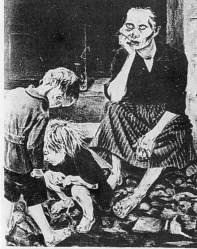

Georg Kinzer: Vor der Haustür

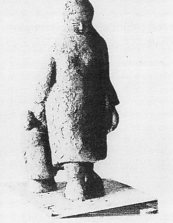

Fridolin Baur: Frau und Kind

46 'Frauen in Not' (Suffering Women), touring exhibition (1929–30)

Frauen in Not was one of the largest and, artistically speaking, one of the most prestigious exhibitions staged by a working-class organisation during this period. The dire straits in which women, especially working-class women, found themselves, and the negative impact of the prohibition of abortion by the notorious paragraph 218 of the Criminal Code, had been the subject of widespread popular protests. Communist organisations were very active in the campaign, but there was also much support from bourgeois women's groups.

The exhibition showed work from a wide range of artists, many without links to the KPD or the political Left. Organiser Fritz Schiff wrote that

it brings together works by great bourgeois artists like Kokoschka, Otto Mueller, Edvard Munch, and the socially critical and aggressive works by Kollwitz, Grosz, Alice Lex-Nerlinger, and, last but not least, drawings by Berlin schoolchildren which together form an accusing and fighting whole.[29]

There were also works by sympathetic French, Dutch and Danish artists and, above all, art from the Soviet Union, 'where women are no longer suffering but where they are comrades in the building of socialism'.[30] *Frauen in Not* toured widely throughout Germany and was well attended, but we do not know whether this was due to its value as an art show or its character as an act of general protest.[31]

Not surprisingly, the last years of the republic were hardly conducive to art exhibitions mounted by organisations of the Labour Movement, which were increasingly preoccupied with the effects of the economic depression and the growing strength of the Nazi Party.[32] Social democratic organisations continued to mount exhibitions, although of a more gentle and less political kind. In 1930 the Hannover SPD and local trade unions organised an exhibition 'The World of Work' which brought together a mixture of works by well-known artists sympathising with the Left, works by local artists and pictures lent by the Deutsche Kunstgemeinschaft (German League of Artists).[33]

An even more locally based exhibition was shown in the Hamburg Kunsthalle, the city's major fine art museum. Called *Trotz alledem, Kunst* (Art in Spite of Everything), it was mainly an exhibition by amateurs who engaged in painting, graphic art or sculpture in their spare time. Visitors were urged not to judge the exhibits by professional standards. Its aim was to show 'that together with the economic struggle of the proletariat, there are also cultural forces which sought expression'.[34] Another section was devoted to prints by professional Hamburg artists produced for the Griffelkunst, a local association to disseminate graphic art on a subscription basis at low costs and for a membership which included some workers.

These two exhibitions underlined the problems associated with attempts to spread knowledge and enjoyment of the visual arts in the working class, especially when such art was conceived in aesthetic rather than political terms. The education committee of the Hamburg SPD, which organised the first exhibition, saw it as the forerunner of regular exhibitions which would bring together art from all over

Germany. But this was unlikely to happen because such worker artists lacked organisations or other institutional bases.[35]

The Hamburg artists whose work was displayed in that exhibition were, however, not true amateurs. They had generally received some training in a relevant craft, such as lithography, or had attended an art or crafts school. Their worker status refers generally to their working-class background and to the fact that they were forced by economic circumstances to be artists only sporadically and mostly in their spare time. Their passion to paint or sculpt is evident from the short biographies given in the leaflet on the exhibition. Even Max Deiters, who worked as an illustrator for social democratic newspapers, wrote that his painting suffered from the large amout of time taken up by his daily tasks:

Only occasionally can I actually paint one of the many pictures which remain unrealised within me. My drawing and painting is my contribution to the class struggle. Both should speak a clear and easily understood language in order to stir the spectator [to action] for the most important aim of our century, the transformation of our society.[36]

These statements notwithstanding, the art of the Hamburg worker artists displayed in 1930 was generally non-political in character, and this applied also to the artists who worked for the Griffelkunst, founded in 1925 in Hamburg-Langenhorn, one of the suburbs established in the postwar period on garden-city principles for workers or others on relatively low incomes. The artists' scheme was clearly very much in line with the wider aim of encouraging a healthier and more purposeful life and more attractive physical surroundings for those living in the new communities. It was a 'consumers', rather than a 'producers', organisation, which aimed to awaken a feeling of joy in possessing original works of art while helping artists economically by guaranteeing them a measure of financial support.[37] Workers, however, formed only a small part of the membership and the selection of artists or of works offered for purchase was not influenced by the artist's background.[38] None of the well-known politically engaged artists who worked largely in a print medium like Baluschek, Grosz, Kollwitz or Krain figured in the list of Griffelkunst artists.[39]

The last major series of Communist-inspired didactic exhibitions were those held towards the end of the Weimar period by the Assoziation der revolutionären Bildenden Künstler Deutschlands (ASSO, Association of Revolutionary Visual Artists) (Plate 47). This body had come into existence in 1928, following a Russian model, and local groups soon developed.[40] From 1929 the Berlin ASSO group

ROTE KUNST IN LEIPZIG

"Zwei Wege"
(Der Sprung ins Wasser oder der Marsch in die Freiheit)
Gemälde von A. Frank

Nach der bedeutenden Berliner Ausstellung „Frauen in Not", die wir in Nr. 43 der A-J-Z ausführlich gewürdigt haben, sind nun auch in Leipzig die revolutionären bildenden Künstler bei der 1. großen Leipziger Kunstausstellung mit ausgezeichneten Arbeiten hervorgetreten. Ihre Werke stellen sich mit teilweise stärksten künstlerischen Ausdrucksmitteln in den Dienst des proletarischen Klassenkampfs. Sie heben sich dadurch von den bürgerlichen Ausstellern ab, die noch immer glauben, daß man in dieser Zeit schärfster Klassengegensätze ein ästhetisches Wolkenkuckucksheim „fern ab vom Getriebe der Parteien" errichten könne. Das ist der tiefste Grund, warum die Massen der Werktätigen heute den Veranstaltungen der sogenannten „reinen Kunst" fernbleiben, die ihnen nichts mehr zu sagen hat, während die Werke der jungen proletarischen Maler und Bildhauer die Not und den Kampfwillen der Arbeitenden verkörpern, die für ihre Leistungen ein unmittelbares und bei jeder kritischen Einstellung förderndes und ermutigendes Verständnis haben. Gerade die Gegenüberstellung mit den Werken der von bürgerlichen Kunstträumen Befangenen, wie in Leipzig, ist für die erstaunlich große Zahl von Besuchern ein unvergeßliches Erlebnis. Hoffentlich wird nach Berlin und Leipzig auch in den anderen Großstädten die proletarische Kunst ihren Weg in die breiteste Oeffentlichkeit zu finden wissen!

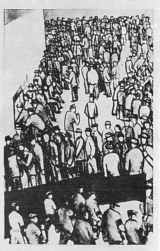

Zwei technisch und künstlerisch neuartige Arbeiten von K. Massloff
„Die Aerzte des Kapitalismus" „Nationale Selbsthilfe"

„Wirtschaftskrise"
Aquarell von Fritz Kochan

47 'Rote Kunst in Leipzig' exhibition (1930)

mounted a series of thematic exhibitions in the Europahaus. One series went under the title of *Künstler im Klassenkampf* (Artists in the Class Struggle), showing works by a number of ASSO artists or by a group like Die Abstrakten who were later to join ASSO.[41]

Other exhibitions consisted of works which the group had submitted to the *Grosse Berliner Kunstausstellung* in 1931 and 1932 and which it withdrew after police intervention. There is little doubt that the works submitted had been deliberately selected for their political

content and for their outspoken comments on issues like abortion. Not surprisingly, this provoked the usual protest about the allegedly offensive and obscene character of some of the works, and they were removed at the request of the Prussian Directorate of Building, the owners of the complex in which the exhibitions were held.

Politically, ASSO's decision – on two occasions – to withdraw all works by members of the group from the art show as an act of defiance and hang them in separate exhibitions was an astute move. The association could justly claim that this was one of many acts of censorship and reactionary policy in the cultural field. In a leaflet issued after the removal of works in 1932 ASSO said that it showed that 'society is increasingly sharply divided between the adherents of capitalism and the revolutionary proletariat. Revolutionary artists know that they have only one task, namely to fight on the side of the latter. Their art is not created for its own sake. It is "a weapon in the class struggle".'[42]

ASSO members were mostly deeply committed to the Communist Party cause, which made it easier for them to carry out agitational activities as well as making it less difficult to bear the personal impact of the economic depression which marked the last Weimar years. Many of them had been trained in graphic work and worked professionally in this field, and their work tended towards simple drawings making few points and presenting a clear political message in short, snappy texts.

The ASSO exhibition of works after their removal from the *Grosse Kunstausstellung* in 1932 was quite possibly the last workers' art exhibition in the years of the Weimar Republic. If so, it was one of the last acts of defiance of authority and the last attempt at indoctrination through art before the Nazi takeover at the end of January 1933. Henceforth there were to be no more exhibitions by German working-class organisations. Indeed, within a few months the organisations were themselves to be banned, their assets seized and many of their leaders killed, imprisoned or forced to leave the country.

A similar fate befell much of the committed art with which the Labour Movement had so largely identified and which workers might have seen in the exhibitions here discussed. Unique paintings and pieces of sculpture as well as examples of graphic art were removed from public collections, secreted away, sold abroad and in many instances destroyed during the fascist drive, first against Weimar culture in general and later in respect of the so-called *entartete Kunst*, the allegedly 'degenerate' art which included the political art associated with the Left and many works by Communist artists.

NOTES

1 The changes in the social and political climate which followed the revolution made the staff of German museums reflect on their educational and curatorial roles. For a brief account see Chapter 3.

2 Levenstein's most cited work is *Die Arbeiterfrage* (Munich, 1912). It is a most illuminating study of the lifestyle and attitudes of the German workers before 1914, but the group of workers on which the enquiry was based is far from fully representative.

3 For a lively and well-illustrated account of the way Christmas was celebrated, Christmas presents and the (commercialised) Christmas market see Christa Lorenz, *Berliner Weihnachtsmarkt* (Berlin (DDR), 1988).

4 Attempts have been made to reconstruct some of the exhibitions of the Weimar period. See Neue Gesellschaft für Bildende Kunst, *Internationale Ausstellung revolutionärer Künstler. Versuch einer Rekonstruktion* (Berlin, 1975).

5 See *Vorwärts*, 28 February 1919. See also *Freiheit*, 121 (1919). Apparently many artists left the Artists' Co-operative after a meeting in April when the membership of socialist organisations was insisted on as a condition of membership: *Freiheit*, 186 (12 April 1919).

6 Lisbeth Stern in *Sozialistische Monatshefte*, 1 (1919), pp. 675–6.

7 Karl Friedrich was an anarchist whose premises in the Petersburgerstrasse also served as a meeting place for radical youth organisations. The *Proletarische Jugend*, the youth organisation of the USPD, had its headquarters there.

8 Adolf Behne in *Freiheit* (5 January 1920), reprinted in Akademie der Künste, Berlin (West), *Arbeitsrat für Kunst* (exhibition catalogue) (1980).

9 A. Behne, 'Zur Arbeiterkunstausstellung', *Freie Welt*, 2 (17 January 1920), p. 8, where there is also a photograph.

10 Behne in *Freiheit* (23 February 1919).

11 'Kunstausstellungen für Proletarier', *Rätezeitung*, 53 (1919).

12 The MASCH are discussed more fully in Chapter 8.

13 For a photograph of a social democratic Christmas show see *Volk und Zeit* (17 December 1922).

14 See W. Lindemann, *Die proletarische Freidenker Bewegung* (Münster, 1980; reprint of 1926 original), p. 64. See also *50 Jahre Leipzig ASSO* (1979), p. 11.

15 Bundesarchiv Potsdam, Reichsministerium d. Inneren, Kunstausstellungen, Akte 8984. The SPD received a subsidy from the Reichsministerium as well as from the Prussian Ministry of the Interior.

16 From the introduction to the exhibition in *Arbeiterkulturwoche und Gewerkschaftsfest Leipzig* (1924), pp. 14–15. A list of the 114 works of art shown is given on pp. 21–2.

17 Oswald Bauer in *Kulturwille*, 7 (1924), p. 133.

18 Nagel was one of the two Secretaries of the *Künstlerhilfe*; Erwin Piscator was the other.

19 Nagel as quoted in the catalogue of the exhibition of his *Berliner Bilder* (Berlin, 1955).

20 See reviews in *Rote Fahne*, 18 February; 31 August and 1 September 1926. Some of the works shown are reproduced in *Wem gehört die Welt* (exhibition catalogue), Zentrales Partei Archiv, pp. 170–2. Most of the reviews in the *Rote Fahne* are by the Hungarian Alfred Kemenyi who signed mainly as A. Kamen and 'Durus'.

21 Landeshauptarchiv Brandenburg, Rep. 30 Berlin C nr 2018, f. 119.

22 *Ibid.*, ff. 122–4.

23 See the articles by Behne and Heartfield in *Wiltbühne*, 22 (1926), pp. 346–8 and 434–5.
24 Otto Nagel, *Berliner Bilder*.
25 *Ibid.*
26 'Durus' in *Rote Fahne*, 106 (1926).
27 See *Rote Fahne*, 192 (1926).
28 See *Kulturwille* (1929), p. 12. See also Hütt, *Bildende Kunst* (1962), p. 224.
29 *Ibid.*
30 A 16-page catalogue of the *Frauen in Not* exhibition can be found in the *Nerlinger papers* in the Akademie der Künste in Berlin.
31 See Fritz Schiff, 'Frauen in Not', *Weg der Frau*, 6 (1931), p. 17.
32 By mid-1930 unemployment had reached three million and the Nazis had polled 18 per cent of the vote at the Reichstag election of July 1930.
33 The Kunstgemeinschaft was founded in 1926 by Heinrich Schulz, then Staatssekretär at the Prussian Ministry of Education, to help artists to sell their work by arranging and circulating exhibitions. See H. Schulz, *Zwei Jahre Deutsche Kunstgemeinschaft, 1926–27* (Berlin, 1928).
34 From the broadsheet on the exhibition.
35 From the undated copy of an article in the *Hamburger Echo*.
36 From the broadsheet on the exhibition.
37 On the Griffelkunst see *50 Jahre Griffelkunst* (Hamburg, 1975).
38 *Ibid.*
39 A list of Griffelkunst artists up to 1930 is given in the exhibition broadsheet.
40 The work of ASSO is discussed more fully in Chapter 8.
41 See Appendix 2.
42 From a copy of the leaflet in the Fritz Hüser Institut, Dortmund.

'Let the arts accompany them': traditions of socialist cultural movements

After war and revolution the social democratic stance towards the arts changed from the somewhat grudging support given by the Central Education Council to a more positive attitude. Cultural activities were now to assume a salient position among the tasks which the SPD set itself. The arts were no longer seen as a mere provider of relief from serious political tasks, and the party demanded full access to all aspects of culture for all citizens.

Vorwärts, the party's leading paper, wrote that the struggle of the working class for their material improvement was only the means to achieve a truly humane community life. The SPD would gradually become a *Kulturpartei*, a party of culture. Paul Kampfmeyer, a socialist publicist, claimed in 1918 that socialism was no longer a bread-and-butter question for the worker. The worker 'desired to become a whole man, physically as well as spiritually'.[1]

Sport, music and the theatre were all seen as elements to enrich the lives of workers and other citizens, and it was agreed that all individuals should have ready and cheap access to these. Workers, supported by their new cultural organisations, could freely enjoy cultural activities, possibly attaining high standards of performance. This was seen as evidence of the successful emancipation of the working class and of the major role of workers in the new state.

In 1925 the SPD established the Sozialistische Kulturbund (Socialist League of Culture) with the express purpose of 'stimulating and strengthening all creative artistic forces in the working class'.[2] The League united on a more or less formal basis the major organisations catering for the leisure-time and cultural needs of workers, although it was not very active in the field of the visual arts. The social democrats, with their traditional view of the visual arts and the status of the artist, did not attempt to organise artists who sympathised with their political aims into any formal groups or seek to encourage the training of amateur artists, as the Communist Party was to do with some success. Yet in the general cultural discussion, the visual arts already occupied a more central role.

The concept of the socialist party as a *Kulturpartei* aimed to strengthen the feeling that the working class, which the SPD still claimed to represent, was now emancipated and integrated into the new state and the democratic nation. The cultural aspirations of the working class would be a big step in the transition to a socialist society and the *Kulturpartei* was not just a political device to widen the party's appeal among middle-class voters, whom the SPD increasingly sought to attract after 1918.

The arts already occupied a key place in this process and were supposed to aid the creation of the 'New' Socialist Man and the 'New' Socialist Woman, a change in the human psyche which, even under capitalism, would create occasional models of ideal society. The workers' attitude and outlook would be changed by getting to know great works of art and appreciate their beauty, and they could then look to the future with greater confidence. Having experienced art together with others, they would create communal ties of friendship and comradeship and these, in turn, would carry within them the seeds of the new society.

Experiencing culture and the arts intimately was then expected to have other major consequences for members of the working class. Beautiful objects or ideas able to awaken emotions would counteract evil environmental influences. Art, including the visual arts, was an expression of the sublime and was expected to induce quasi-religious feelings in the devotee and strengthen his or her resolve to fight for a better future.

During the Weimar Republic the belief grew that experience of the arts could free the worker's soul and offer an antidote to the emotion-stultifying atmosphere of the factory and the grey surroundings of the *Mietskasernen*, the barrack-like blocks of rented flats where most workers lived. In the new democratic state the political struggle had helped improve the miserable proletarian existence somewhat, but there was still a need for a 'psychic and perhaps even physical expansion in the life of the individual man and woman, as a reaction and a counterbalance against the dull everyday life, against the big city and against the machine'.[3]

Richard Weimann, Secretary of the Education Council of the SPD, said that 'the mechanics of our life need, by way of compensation, a great amount of beauty'.[4] Art would allow the transmission of feelings, stimulate political activity, induce enthusiasm and help to give those under its influence a new socialist and revolutionary feeling for life. This would strengthen the communal bonds which brought people closer together and thereby strengthen socialism itself.[5]

The psychological significance and the ability of the arts to increase solidarity were first recognised and practised by the groups of young workers organised in the Sozialistische Arbeiter Jugend (SAJ), the Young Socialist Workers, founded in 1908. The association gained major support only after the war.[6]

Against the background of economic depression and the social disorder of the immediate postwar period these young workers advocated a new lifestyle for their leisure hours, with emphasis on enjoying nature, music and the arts as part of active, communal activities.

With their own somewhat puritanical conduct and their rejection of bourgeois formalities of dress and behaviour, the SAJ members wished to create a new *Lebenskultur*, a lifestyle for the young. This youth culture would cultivate intense interpersonal relationships, as well as providing for personal conduct which would give scope for self-expression with the help of the muses.[7]

Among the muses the creative fine arts, hitherto rather neglected, played a growing role. The visual arts did not always directly influence that *Ausdruckskultur*, the display of personal creativity through dress, song, dance and hiking which characterised the lifestyle of many members of the SAJ. All these activities gave expression to their search for beauty and their striving for community. Their quest extended also to painting or print, which they wished to bring into their personal lives by influencing the choice of furniture and furnishings, and of the pictures and other items with which they surrounded themselves (Plate 48).[8]

The search for the simple, functional and beautiful was not restricted to the younger generation. Older members of the SPD also made propaganda for the 'New Habitat', the *Neue Wohnen*. Social democratic organisations, as well as trade unions or the Kulturbund, sought to counteract the widespread philistinism and conservative taste which manifested itself in many working-class homes, where in other respects radical thinking would prevail. Pictures above all were often evidence of a tolerance for Kitsch, if not a positive liking for it.[9]

But if Kitsch was common inside the home, the strongest impetus in favour of functional and simple design came from outside it, through the

48 Bruno Taut, illustration from *Das Neue Wohnen* (c. 1925)

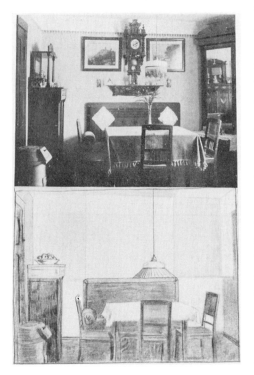

social architecture of the Weimar period. Many of the leading modern architects and planners were involved in designing relatively cheap housing for workers and the low-paid. Architects like Gropius, Mies van der Rohe, the genius behind the Weissenhof Housing project, and Bruno and Max Taut, or municipal building officers like Ernst May in Frankfurt or Martin Wagner in Berlin, were foremost in the field.

Many of the new housing estates and blocks of flats were built by cities in which social democrats had a predominant position or by public housing corporations in which the trade unions usually played a prominent role. Much of the public housing of the Weimar years was designed in a modern idiom with flat roofs and plain, mostly white walls, often with strongly coloured woodwork. The flats in the new estates had plain, functional interiors and they invited a similar approach to internal furnishings. Designed as workers' housing, they could mostly be afforded only by the better-paid workers, but as an idea they deserve Mies's description 'part of the great struggle for a new way of life'.

The new estates were generally built at the edge of the cities, and they often had communal provisions such as crèches or playgrounds, communal laundries and other social facilities. All this was expected to make those who lived there more socially responsible and to create a new community spirit. 'Our era must create new forms for both the inner and the outer life ... and this style must find its concrete expression in city planning and in housing.'[10]

The sometimes radical provisions of the new housing developments carried within them the seeds of conflict between functional aesthetics and traditional tastes. An example can be found in the famous (or infamous) 'Frankfurt kitchen' incorporated into many of the extensive suburban housing projects of that city (Plate 49). This galley-type minimal kitchen with its ultra-functional design carried with it the implied suggestion that the hitherto family-based meal might in future change or even disappear, with some eating taking place away from the home and in the wider community.

The proposals for new working-class housing were seen by the social democratic

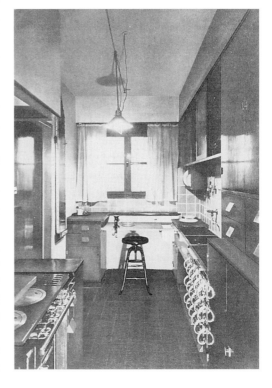

49 *Die Frankfurter Küche* (Frankfurt kitchen), from *Das Neue Frankfurt* (c. 1929)

cultural organisations as a 'salient part of workers' culture'.[11] Their
exponents saw the proposals for better designs in the home and for
the introduction of art into the daily life of the working-class family
as steps towards realising a socialist lifestyle. For them the new func-
tional home was the appropriate environment for a movement which
claimed to follow a scientific ideology and believed that the ration-
ality of modern technology and a desire for clarity and simplicity
should also manifest itself in the socialist worker's domestic environ-
ment.[12] It was probably not fully appreciated that these proposals also
implied the destruction of the traditional working-class aesthetics with
their collectivist bias.

The German Labour Movement and modernism in architecture
and design met not only in the field of social housing and in the
design of the modern home; they also came together from time to
time in the design of office blocks and other buildings for the SPD
and the trade unions designed to meet the needs of their members
and workers in general. Indeed, what we might call the 'public aes-
thetics' of the social democratic labour movement can be studied in
the design of edifices for party, trade unions or other relevant organ-
isations. Before 1914 we are concerned with the unions' headquar-
ters buildings and with the Gewerkschaftshäuser or Volkshäuser which
grew in number and size during this period. Questions of aesthetics
also came clearly to the fore when it came to the design of monu-
ments to be erected in memory of those who died in the revolu-
tionary struggle, above all those killed in the defence of the Republic
against the nationalist insurrection in the spring of 1920.

In these monuments, and in the public architecture of the Labour
Movement in general, the choice of modernist design was not always
obvious. Prior to 1914 the central party organisation and the grow-
ing trade union movement operated mostly in rented accommoda-
tion, and this applied generally also to the growing number of social
buildings erected by the party or the trade unions. They tended to
be run by local trades councils. They included premises which com-
bined offices, restaurants, public halls, lounges and other social space
as well as accommodation for workers in transit.

A splendid example of this was the Hamburg Gewerkschaftshaus,
known from its location as the Besenbinderhof (Plate 50). This was
a grand structure designed by Heinrich Krug in a neo-Renaissance
style, conceived as an enduring monument to the strength of the
Hamburg Labour Movement. 'A breath of the future wafts through
the building', wrote the *Hamburger Echo* to mark its opening. It used
only solid and expensive materials like granite and oak, and the façade

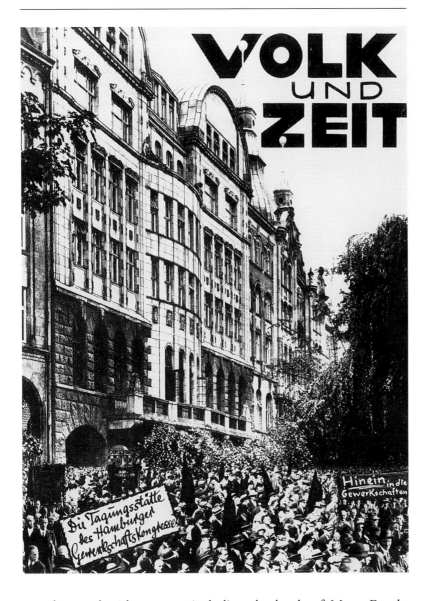

50 Besenbinderhof, the Hamburg trade union building, *Volk und Zeit*, 36 (1928)

was decorated with statuary, including the heads of Marx, Engels, Lassalle and Liebknecht.[13]

Even after the war such buildings were often built or rebuilt in pastiche styles rather than in a modern idiom. When after the war the Leipzig Volkshaus (1904–6), which had been largely destroyed by fire, had to be rebuilt, this was done, despite protests, in its original neo-romanesque style.[14] In the case of other, similar buildings it was thought to be more important that the design should fit into that of the surrounding buildings than that it should state a commitment to

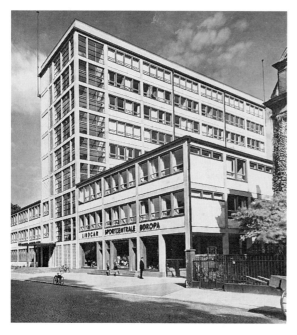

51 Max Taut, Design
for trade union
headquarters

a contemporary style. In commission-
ing their headquarters, the central trade
union organisations often chose mod-
ern architects, sometimes after open or
restricted competitions. Thus Max Taut
designed the building for the Ger-
man Metalworkers' Union as well as a
building for the ADGB in Frankfurt
(Plate 51).

A similarly dichotomous attitude
can be observed in the memorials which
social democratic organisations erected
in the years following the revolution.
These commemorated mostly those
killed in the revolutionary struggle or
in defence of the new state against the
right-wing putsch under the leadership
of Wilhelm Kapp and General von
Lüttwitz in March 1920.[15] One of the
most famous of these was the Denkmal der Märzgefallenen in Weimar,
designed by Gropius, commissioned by the Weimar Trades Council
and erected in 1922 (Plate 52). It followed an abstract multi-faceted
design, crystalline in form, surmounted by a small pyramid. The whole
block was cast in concrete, probably on cost grounds. The abstract

52 Walter Gropius,
Denkmal der
Märzgefallenen,
Weimar, concrete and
metal (1922)

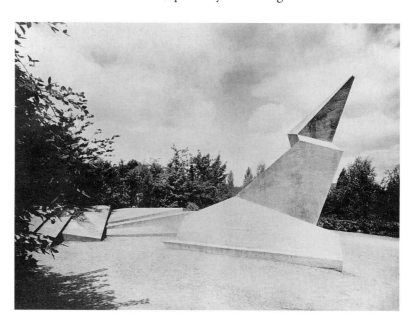

form was seen not so much as a symbol of
mourning for the dead but as a symbol of the
purity of the cause and of the upward thrust
for a better society.[16]

The choice of the design was not without
controversy, with opposition mainly from the
middle classes. The Weimar monument was
to remain the only such edifice erected under
socialist auspices which used an abstract design.
Other monuments tended to follow the well-
worn path of tradition used in war memorials
and the like. Thus in neighbouring Gera the
victims of the Kapp Putsch were commemor-
ated in a monument in the shape of a Greek
tomb, complete with a pediment with a recess
in which stood a woman with a child in her
arms (Plate 53). She was flanked by two half-
naked male figures, one with a boy next to him.[17]
Other monuments used columns, obelisks or
slabs, sometimes together with a torch or a flame hewn in stone.

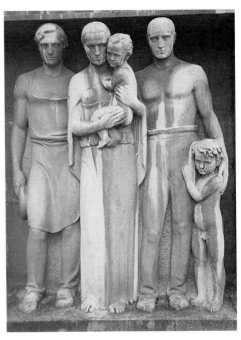

53 Werner Zelmar,
Denkmal der
Märzgefallenen, Gera
(1922)

Apart from the 'Gropius' monument and the Berlin Revolutions-
denkmal commemorating Karl Liebknecht and Rosa Luxemburg and
designed by Mies van der Rohe for the Communist Party, the only
other artistically significant work was the memorial to the victims
of the revolutionary fighting in Bremen in the shape of a Pietà by
Bernhard Hoetger.[18] The Gera monument, or Wilhelm Liebknecht's
tomb discussed earlier, were almost certainly more easily understood
by ordinary people than the Weimar structure. At least the figures of
the Gera monument were in contemporary dress rather than the
antique attire of the reliefs on the latter.

Classical architecture and the symbolisms of antiquity might have
been part of the general *Bildung* of the German middle classes, but they
were clearly outside the experience of the working class, whose edu-
cation was elementary and whose visual experience had been largely
bound by the architecture of poor housing and mean streets.

The restricted scope of working-class visual imagination was recog-
nised by educationists and cultural propagandists in the SPD. They
argued that workers looked at visual art with the same eyes with which
they looked at everyday things. Engrossed in the daily struggle for
existence, their emotional and intellectual horizons were inevitably cir-
cumscribed, and they therefore demanded everywhere the concrete and
the easily understood. 'He seeks the things which normally surround

him in his everyday life. Its purpose is fulfilled if it mirrors his normal environment.'[19]

Taste in pictures, decor or furnishings generally followed that displayed in middle-class homes even among class-conscious socialist workers. This applied also to furniture, in as far as the worker had the means to be selective. In the mostly dark and ornate furniture and the fussy furnishings which might be found in the parlour of the better-off working-class home, bourgeois tastes were replicated in a cheapened version, using veneer rather than solid wood and stuccoed decorations in place of carved wooden ones.

The acquisition of such symbols of bourgeois respectability was an example of hand-me-down taste, but at the same time it symbolised a measure of economic success by the buyer and it was in some way also a confirmation of a degree of social emancipation. Seen from that angle, the proposal to substitute the functional but possibly cheaper-looking modern furniture for a traditional counterfeit culture might well have been regarded by some workers as an act of self-degradation.[20]

Proposals for functional interiors and calls to reject Kitsch and useless decorations in furniture and in pictures met with little positive response by the socially aspiring urban workers. They were rejected partly for economic reasons – workers could not afford to buy new furniture – but it was also felt that advocating functional furniture and the use of bold colours was an attack on the traditional proletarian lifestyle which had long existed in the old-established working-class quarters of the big cities, and indeed an attack on the working-class aesthetics which it exemplified.[21]

As we have seen, exhibitions and Christmas fairs nevertheless sought to persuade workers to use plainer forms and primary colours in their homes and hang good reproductions of modern art on their walls. Social democratic publishing houses sometimes produced cheap reproductions of paintings for display in the home, mostly of simple, uncontroversial landscapes and still lifes. Occasionally they were of works with a specific political message, such as the *Schmuckblätter* from May Day broadsheets already discussed, or the reproductions of Daumier cartoons which were advertised as being 'particularly suited to the homes of revolutionary workers'. In Hamburg the social democratic *Hamburger Echo* sold simple prints of local scenes at 1.50 Marks for a set of six.[22]

The SPD also offered for sale copies of portraits of socialist leaders which it regarded as suitable decoration for workers' dwellings. Local socialist bookshops sold reproductions of prints and paintings. The

press might recommend suitable works. The magazine *Frauenwelt* listed mainly paintings and etchings with romantic themes and offered landscapes like those its readers might have enjoyed during excursions.[23] Inexpensive original works of art, mostly prints, were sold at the annual exhibitions organised before Christmas, with present-giving for the festival in mind.[24]

Average workers were, however, bound to reject all abstract, merely symbolic or excessively distorted art and design, and much of the art of the past would initially be alien to them. Religious and sacred art was largely outside their normal experience, but at its most sublime such works, according to critic Adolf Kreiter, could nevertheless move the onlooker. Art would affect the worker because the power of the conviction it carried would transcend the boundaries of class experience and appeal to basic humanity. Kreiter subsumes such fundamental characteristics of a work of art under the heading of imagery. 'The subject world of the past cannot be resurrected, but to appreciate the richness of its forms, to let it widen our horizon, can only be beneficial.' But this did not mean that the aims of the present could be neglected.[25]

The Leipzig exhibition of 1924, mounted in connection with the *Arbeiterkulturwoche* and the immediate reason for Kreiter's essay, was oriented towards art related to the actual experience of the proletariat and its political aspirations. Opinions about the character and function of visual art for workers expressed during those years ranged from the view of those who, like Kreiter, stressed the universal application of the truly great in art, via writers like Valtin Hartig who sought ways by which art could be adapted more specifically to working-class needs and experience, to the extreme position of those who looked at art in terms of its political message and who hoped for the creation of proletarian art. This view, widely held in the Communist Party and by the exponents of a Marxist aesthetics, will be discussed below.

In the contemporary social democratic discussion the *Aesthetik der schwieligen Faust* was now almost universally rejected. The party, which in the years of the Republic received growing support from sections of the middle class, was now even less inclined than before the war to condemn bourgeois art as such.

But at the same time, the party was not totally uncritical of these art forms. The widespread influence of commercialism in visual arts was generally condemned, even if this was not regarded as grounds for its wholesale rejection. Artistic quality and the creativity of genius were generally viewed as more important than social background. A

writer in the reformist *Sozialistische Monatshefte* (Socialist Monthly) wrote that concepts such as bourgeois and proletarian art were 'infantile disorders' which had been overcome. Social Democrats, unlike Communists, rejected the simple equation of proletarian art with art by workers.[26]

Yet the belief that only socialism could provide the basis for a high level of cultural achievement continued. During the revolution the views of some social democratic critics echoed those of socialist artists, who envisaged that a new era for the arts would arise in a socialist society. For John Schikowski, the literary editor of *Vorwärts*, capitalism could not produce a great, all-embracing style of art because of its internal contradictions. However, this would change with the social equality which would be achieved under socialism. 'Out of the common deep-rooted harmony of the masses of the people a uniform style will arise. In it all the arts will come together in one organic and impressive effect.'[27]

With the decline of such utopian hopes, the discussion faced the more concrete problem of finding art which was widely acceptable but which, at the same time, would increase the working-class receptiveness to the visual arts. Valtin Hartig saw a solution in terms of a new *Volkskunst*, a 'popular art' which would also be a people's art. It was hoped that such art would establish communitarian ties as the arts had allegedly done in the Middle Ages when the building of churches and cathedrals provided such a focus. For Hartig art which would really absorb the masses must draw on the world of experience of the masses. It could not be artifically created because 'Ordinary men and women see form and content as one in a work of art form. Hence a common workers' art which will enthuse the masses will draw its themes from the world of experience of these same masses.'

Folk art embodied similar elements, and Hartig thought that it might further the attainment of this goal. He commented on the fact that in Japan ordinary household utensils were still produced by hand and he saw this operating against the current separation of life and art. In practical terms he suggested that workers who went on holidays and hikes in the countryside might seek out some of the still existing folk art and, by doing so, bring a feeling for beauty back to their homes.[28]

Hartig was aware of the ambiguity of existing folk art, its backward-looking character and its links with contemporary nationalism. But he reminded his readers that although popular art embodied much conformity and conservatism, it had also provided the background for some radical art which had portrayed the life of the poor and

oppressed. Neither Hartig nor others seem to have developed this theme further, let alone attempted to give it practical form. Had he or others developed the concept of the popular arts they might have included the technique and the art of photography which was just then developing new forms under the influence of Expressionism and of the *Neue Sachlichkeit* (New Reality).

Photography as a hobby had attracted a growing number of workers during the 1920s. Here was a group of potential artists and creators of images who could produce social portraits and pictures for agitation and propaganda. The Communist movement had recognised this potential early on and it began in 1926 to mobilise the talents of these working-class photographers for political agitation. The SPD eventually followed suit with the creation of the Arbeiter Lichtbild Bund (Workers' Photography League), but its approach to the new art form was initially very much in line with its general approach to culture and the arts.

The working-class hobby photographers, much like their middle-class colleagues, aimed to produce the 'beautiful' snapshot, the well-focused and modulated photograph of a well-chosen subject, be it a building, a landscape or a portrait. Portraits and pictures of buildings figured prominently in the albums in which keen photographers tended to show their works in exhibitions. Those who sought to influence the camerawork of the socialist photographers were, at first, mainly concerned with redressing the balance of the types of pictures taken. They were also concerned about the way in which the photographers interpreted reality, concentrating on the outward face of the object, for example the beauty of old buildings, and glossing over the depressing character of the working-class district where they might be situated. The more politically committed urged their colleagues to show both aspects of reality, the beautiful and the dismal. Together with the traditional themes they should produce the social photography which would assist the movement in its struggle.

In producing such work, the idea that the photo must be beautiful would have to be discarded, but the portrayal of working-class life did not have to lead to the creation of a new kind of 'genre' art which concentrated on the atmospheric and the picturesque. The new social photo should not be *Elendsfotografiererei*, photographing misery, and should not have to cover only the negative and the ugly side of working-class life. The photographs should also show the happier side of the life of the proletariat and give rise to hope. This applied not only to the choice of subject but also to the conceptualisation of the picture. Thus while the print might show hard contours and the

composition have elements of the asymmetrical, it should not lack something friendly, even humorous.

For the social democratic hobby photographers organised in the Arbeiter Lichtbild Bund the social photograph remained only one type of photograph, and there is little evidence that such pictures entered the social democratic press in large numbers, despite the appeal for a mass effort by the League to extend its activities and form a photographers' 'fighting front' against fascism. '[Today] there is no longer time [for pictures of] a birch idyll or for autumn scenes . . . we need pictures for the anti-fascist struggle.'[29] By comparison the ethos and political stance of the Communist Organisation of Worker Photographers, the Vereinigung der Arbeiterfotografen, were more ideological and more closely enmeshed in the political struggle, as we shall see in the next chapter.

In the social democratic camp, views on suitable works of sculpture, painting or print for a proletarian audience derived less from aesthetic concepts or stylistic considerations than from general attitudes to the role of art in the life and the leisure pursuits of the modern worker. Neither the class background of the artist nor the political character of the works were thought to be of salient importance. The cultural achievements were to push this development further, and political and socially critical art was expected to assist this process, but it was not an exclusive contribution. The appreciation of art was conceived largely as an individual act, and the organisation of worker photographers is one of the few instances of the socialist Labour Movement using artists or art consumers collectively.

One factor which must have influenced the attitude towards culture and the arts was the embourgeoisement of the SPD after 1918. The party was losing its character as a class party. It was not only able to mobilise white-collar workers, but it also succeeded in gaining support from some members of the lower middle class and the middle class, including academics and professionals.

The SPD could call on the latter's knowledge and expertise: they were selected for office disproportionately to their numbers and they acted as experts, advisers and speakers at conferences. Whatever their own political beliefs, they introduced some of the values and attitudes from their bourgeois background into the social democratic milieu. In contrast to the Communist Party, the SPD had little formal or informal contact with the artistic avant-garde, and the party did not tend to use visual artists for the general discussion of its propaganda or for the education of its members.[30]

In the adult education institutions, which had relatively strong links with social democracy, only a few courses gave instruction in art or dealt with art-historical themes. Moreover, in contrast to the deliberate practice of the Communist Party's adult education institutions, neither the SPD nor the evening schools offered instruction in any of the visual arts.

The SPD's identification with functionalist architecture presents, however, an exception to its general opposition to the art of the avant-garde. As we have seen, there are very few references to expressionist and non-representational art in the working-class press or in the illustrations in publications issued under the auspices of either of the two working-class parties. Only occasionally do we find voices, such as that of Adolf Behne, which regret this omission and draw attention to the revolutionary powers inherent in some abstract or near-abstract painting.[31]

Planning and design apart, there was no pressure group inside the SPD which sought to commit the party to a particular style in art. Paintings, prints or sculptures were regarded rather as part of the workers' environment, in particular in the home, which made for the 'good life'. The latter was also the aim of a number of groups which sought to create new lifestyles and new communal ties. The 1920s saw in Germany the creation of a number of organisations concerned with *Lebensreform*: freethinkers, naturists, vegetarians and, not least, the youth movement; in our context the Young Socialist Workers were the most significant.

As we saw at the beginning of this chapter, the Young Socialist Workers looked at paintings and other works of art as providing an 'experience' similar to that derived from the beauties of nature or from their dances and songs. In their quest for deep personal experience some members of the Young Socialist Workers went as far as to discount the importance of the daily political struggle. They spoke of a potential conflict between the search for justice and a search for culture. 'Culture implied the blossoming forth of life and illuminating it beyond the inevitable purely biological limits. Culture means exuberance and enrichment, and fulfilment and beauty.'[32]

The search for the beautiful also showed itself in other areas of socialist activities, notably in the media and in publishing. *Volk und Zeit* not only printed many attractive 'artistic' and 'unpolitical' pictures, it also carried photographs of beautiful landscapes, pictures of sportsmen and sportswomen, with implicit reference to the 'body beautiful'.

We find a similar attention to attractive presentation, good typography and fine illustration in the books published by the first of the workers' book clubs, the Büchergilde Gutenberg. This book club was a venture of the Printers' Union, which also produced an educational journal, the *Typografische Mitteilungen*, for many years. This reported regularly about fine printing and reproduced examples of avant-garde Typography, modern printing and graphic design.

In 1921 the four printing trade unions also established the Volkskunstverlag, the People's Art Publishing enterprise, with the name *Das Bild* (The Picture). This venture set out to produce and sell art reproductions at prices which workers could afford, but the publishers addressed themselves to all sections of the population and especially to members of the printing trades. The reproductions were almost all of paintings by well-known, traditional artists selected with the ethos of the unions' educational activities in mind. It was hoped that they would fit offices and public spaces as well as the family home.

The experience of art, the publishers wrote, 'should become as central to the working class as a visit to the Volksbühne or to a concert. It would lead to greater inner freedom, personal maturity and sensitivity.' Thus art would contribute to the workers' fight for their emancipation of which the Volkskunstverlag was a part.[33]

The specific institutional art and design of the SPD during that period was often traditional and dull. This applies not only to the design of buildings but also to their external and internal embellishments and decorations. More often than not these followed traditional lines, academic in execution rather than revolutionary in intent. Thus the Leipzig Volkshaus contained a columned entrance hall to the main assembly hall, an imitation of a classical *propyleum*, conceived as a memorial for the heroes and leaders of the past. A series of frescos in the dining room of Schloss Tannich – the conference, training and holiday centre of the SAJ – provided comment on life in general, not a statement related to socialism.

In the years of the Weimar Republic the SPD saw itself as a pillar of the state. A party which for much of the time was in coalition government at national, *Land* and municipal level often used a widely accepted style of art rather than identify with the art of the avant-garde. Hence it is not surprising that Gustav Leuteritz, leader of the SPD in Hamburg, could claim that the People's Houses could vie with any city hall in artistic significance. They were a sign 'that in their buildings the working class has developed as far as all other sections of society'.

All in all, the visual art brought to the notice of the bulk of social democratic workers during the Weimar period was weighted towards the traditional and the 'beautiful' rather than the critical and the tendentious. This applies even to the last few years before the end, when Germany was engulfed in worldwide economic recession and by the rising tide of fascism. Millions of unemployed and growing misery had sharpened the political debate. Social democrats were increasingly agitated by the growing threat from the Right and attacks from the Communists. The defence against the latter and the fight against the National Socialists took up an increasing amount of their energies.

In this situation the ideals of cultural socialism and the cultivation of the beautiful inevitably received less attention. The imagery of the political battle sharpened, but it must be a matter of doubt whether visual symbols or the emotive appeal of paintings, prints or sculptures strengthened political loyalty or cohesiveness.

NOTES

1 See Görlitz Programme of SPD, *Vorwärts* (18 August 1921), cited by C. Rülcker, 'Arbeiterkultur und Kulturpolitik im Blickwinkel des Vorwärts', *Archiv für Sozialgeschichte*, 14 (1974), pp. 115–55. See also P. Kampfmeyer, *Arbeiter Bewegung und Sozialdemokratie* (Berlin, 1921), p. 272.

2 *Die Blankenburger Tagung* [des sozialistischen Kulturbund] *Sozialistische Bildung* (November 1926).

3 Leo Kestenberg, 'Die Aufgaben der Kunst', in *Sozialismus und Kultur* (report of the first conference of the Sozialistische Kulturbund, 1926) (Berlin, 1927).

4 Richard Weimann, *Kulturwille* (1924), p. 110.

5 O. Greiner, 'Die Bildende Kunst und ihre Bedeutung für das Proletariat', *Sozialistische Bildung* (1929), pp. 142–7.

6 Given the overall strength of the SPD, the SAJ was a relatively small movement; its membership was never much above a hundred thousand. Recruited largely from the children of skilled workers, it was a kind of elite of members active on party business, apart from their intense preoccupation with their own affairs. The party exercised the final control over the SAJ by appointing the two secretaries of the association, who in turn often criticised the leadership from the Left. See F. Walter, *Jugend in der sozialdemokratischen Solidargemeinschaft: eine organisationssoziologische Studie* (Internationale Wissenschaftliche Korrespondenz zur Geschichte des Sozialismus und der Arbeiterbewegung, 1987), pp. 310–76.

7 J. Zimmer, 'Die Sozialistische Jugend als Kultur und Freizeitbewegung' in H. Fielhauer and O. Bockhorn, *Die Andere Kultur* (Vienna, 1982), pp. 179–94.

8 For an introduction to the visual arts written especially for the Socialist Youth see A. Behne, *Die Ueberfahrt am Schreckenstein*, published by the SAJ's Arbeiterjugend Verlag in 1924.

9 The widespread German concern for the aesthetics of the home is contained in the very word *Wohnkultur*. It is also manifested in the fact that architects and artists were deeply concerned with furniture and furnishings. An early example can be found in the *Wiener Sezession*, and, following this, the *Wiener Werkstätte*.

10 Reprint of *Das Neue Frankfurt* (Frankfurt, 1968), p. 87 and B. M. Lane, *Architecture and Politics in Weimar Germany* (Cambridge, 1968).

11 Tony Schulz in *Vorwärts* (2 May 1927), cited in Rülcker, 'Arbeiterkultur', p. 128.

12 See F. Schuster, 'Die Neue Wohnung und der Hausrat', in *Das Neue Frankfurt*, 5 (1926/7).

13 See E. Domansky, 'Der Zukunftsstaat am Besenbinderhof', *Arbeiter in Hamburg* (Hamburg, 1983), pp. 373–85.

14 See B. Taut, *Freiheit* (23 September 1920).

15 The right-wing insurrection was defeated by the combined forces of the German working class and the progressive section of the middle class and a general strike.

16 See R. P. Baake and M. Nungesser, ' "Ich, bin, ich war, ich werde sein": Drei Denkmäler der Deutschen Arbeiterbewegung in den Zwanziger Jahren', *Wem gehört die Welt* (exhibition catalogue), Zentrales Partei Archiv (Berlin, 1977), pp. 280–98, also quoting *Das Volk* (4 April 1921); B. Hüter, *Das Bauhaus* (Berlin (DDR), 1976).

17 *Volk und Zeit* (21 September 1921).

18 See *Wem gehört die Welt*.

19 See A. Kreiter, 'Was Bedeutet dem Arbeiter die Kunst', in *Arbeiterkulturwoche* (Leipzig, 1924).

20 See G. Selle, *Kultur der Sinne* (Cologne, 1981); Anon., *'Vorwärts und Nicht Vergessen': Arbeiterkultur in Hamburg um 1930* (Hamburg, 1981), chapter 'Wie richte Ich meine Wohnung ein?', pp. 74–94.

21 Selle, *Kultur der Sinne*, p. 154.

22 *Vorwärts und Nicht Vergessen*, pp. 250–62, *Roter Stern* (20 June 1924).

23 See Erica Bonte, *Frauenwelt* (1927), pp. 292–3.

24 *Volk und Zeit* (2 November 1919).

25 Kreiter, 'Was Bedeutet'.

26 See W. Heine, *Sozialistische Monatshefte* (1925).

27 See J. Schikowski, *Sozialistische Monatshefte* (April 1920).

28 See Valtin Hartig, 'Volkskunst' *Kulturwille* (1 June 1924); Hartig 'Arbeiterbildung', *Die Tat*, 18.

29 See also Fritz Heine in *Das Neue Bild*, 1 (1930), p. 7.

30 Baluschek, Krain and Kollwitz had artistic links with publications linked with the SPD.

31 But see the controversy between Behne and Heartfield in the *Weltbühne* in 1926.

32 See Franz Lepinski, *Jungsozialistische Blätter*, 1 (1922).

33 *Typografische Mitteilungen*, 1911–1933 is a rare periodical. A copy is in the Library of the former Free German Trade Unions (*Freier Deutscher Gewerkschaftsbund*) in Berlin.

'Art as a weapon': Communist aims and techniques and the visual arts 8

Previous chapters have touched on the effect of the social demo-
cratic heritage on the thinking and the practice of its offspring, the
German Communist Party. Social democratic commitment to the
pursuit of culture and its positive attitude towards a significant part
of the national cultural heritage was at first shared by the new party,
even though this heritage was essentially a bourgeois one, while the
Communist Party was from the beginning strongly committed to the
revolutionary class struggle.[1]

Yet in spite of its radical ideological stance the party did not iden-
tify with the avant-garde in artistic matters. The KPD, in the words
of Gertrud Alexander, rejected the Dada-inspired radical, anti-culture,
anti-arts attitudes of Grosz and Heartfield – both party members – and
the mostly Communist circle around the Malik Verlag. The official
party line viewed such policies as negative and destructive.

Writing about the Communist cultural policy of these early years,
Alexander noted that these individuals thought they were performing
a revolutionary service for the proletariat, but that they could only
have done so 'if they had enlightened the worker with a clear, his-
torically critical analysis and had by such means turned him into a
true revolutionary'. She agreed that in the course of the revolution
works of art might be destroyed, but said that the revolutionary
should do everything possible to protect them from destruction.[2]

What is more, the KPD, whilst establishing its own ancillary organ-
isations in the political field, did not do so for cultural activities. The
party accepted that Communist workers would remain members of
social democratic culture and leisure-time organisations or join these
organisations. This was in spite of the fact that the KPD was from
very early in its existence bent on creating a monolithic and largely
centrally controlled organisation.[3]

As well as a relatively tolerant policy towards the SPD, the KPD
also subscribed at this time to a policy of a 'United Front from above
and from below'. Communists who belonged to social democratic
cultural organisations were expected to agitate within these bodies

for practical co-operation with the KPD and to try and convert the membership of the old organisations to support the policies of the new party. With one exception the Communist policy of unity from below was not successful and it was abandoned towards the end of the 1920s.

In 1927, in line with a broad policy switch away from co-operation with other parties on the Left, the KPD gave up its common front policy in cultural matters in favour of strong, anti-SPD tactics. With ever shriller language it condemned the SPD organisations as 'social fascists', to be fought with all the vigour the party could command. Under the slogan 'Heran an die Massen' (Move to the masses) the KPD sought to attack the SPD by all means at its disposal, from caricaturing them in poster, print and on the stage of the Agitprop theatre to a call for actual physical attacks on social democrats.[4]

At the same time the KPD began to create its own organisations in the field of culture and the arts. This process usually started with creating formal oppositions within the respective social democratic organisations. These Communist cells and groups were often created by infiltration and they frequently led eventually either to the secession of a minority of the membership or, in the case of the Arbeiter Theater Bund (Workers' Theatre League), to a virtual Communist takeover of the old organisation and the establishment of a new social democratic organisation.[5]

The growing enmity between the two parties affected the cultural field. While the social democratic organisations continued more or less in their traditional role as providers of culture and recreation, the newly formed Communist organisations became increasingly involved in political action rather than in satisfying the leisure-time needs of their members. It may have been for that reason that the new associations never attracted large memberships. Their ability to fill meetings and functions was increasingly hampered by the deepening economic crisis and the resulting unemployment, which affected the Communist section of the working class particularly severely. The new Communist organisations for sport, music, theatre and other pursuits were increasingly mobilised for the political struggle.

The coming together of Communist workers with genuine commitment to cultural activities resulted in some areas, notably in music-making and in the Agitprop theatre, in new and original artistic developments, albeit ones which were strongly politicised. Overall, however, the Communists' departure from social democratic cultural organisations meant a transition from the organisation of culture to the culture of the organisation. With the sharpening of the inter-party

conflict the experience gained by the KPD in mobilising its ancillary mass organisations, for example the Red Fighters, was now applied to the cultural field.

The various sections of the cultural movement were co-ordinated through the Ifa, the Interessengemeinschaft für Arbeiterkultur, an association fostering working-class culture.[6] The Ifa was concerned with strengthening the work of individual organisations, partly through mounting cultural exhibitions at which the individual cultural societies displayed their wares, and tried to recruit new members.

At the same time the Ifa was strongly committed to the political struggle and the fight against the *Kultur-Reaktion* which, in its view, comprised not only nationalism and clericalism but also social democracy. It appealed to the new organisations to identify fully with the revolutionary political struggle and 'to form the storm battalions of the red cultural front'.[7]

As far as the cultural activities of the Communist masses were concerned, Communist organisations were less involved in exploring and pursuing visual arts than their socialist counterparts. Indeed, the generally intensive preoccupation with the arts by some sections of the social democratic organisation was castigated by Communist cultural organisations who spoke scathingly of the 'wallflower of cultural fads in the manner of the Left of the SPD'.[8]

There was thus in the extreme Left of the German Labour Movement nothing to parallel the *Ausdruckskultur* (culture of expression) of, for example, the Young Socialist Workers movement during its formative period discussed earlier. Yet if we look at the public face of the KPD and some of its institutions, such as those concerned with agitation, publishing and the organisation of artists, we find novel and at times highly effective imagery. The visual artists who were associated with the development of Communism were in some respects more original and innovative and generally more hard-hitting than those who had identified with social democracy.

This applied to two aspects of the visual arts: their role in expressing ideological commitment and political goals in visual images; and the elaboration of the contribution of the visual arts, drawing, painting, print-making and sculpture to the creation of a proletarian culture. The first of these takes up themes already touched on in the discussion of the working-class press and in Chapter 6 on art exhibitions. The problems connected with the creation of a proletarian culture have links with the last chapter and with the discussion in Chapter 4. In its general and more theoretical aspects it transcends a particular political movement which gave rise to it; indeed, it is still with us today.

Following its educational and cultural programme, the Communist Party elaborated its view on the role of the arts, including the visual arts, within the life of the party. As the SPD had done after the publication of its own *Guidelines*, the KPD urged 'the wider use of illustrations and of cartoons for the embellishment of pamphlets, leaflets, posters and newspapers'.[9]

Altogether, the Communist Party saw the visual arts as a tool to popularise its ideas and policies. Hence the arts had to be taken to the members and to be cast in forms which could be widely understood.

At the same time the new party stressed the importance of appealing not only to the intellect but also to the emotions – 'to touch and move the basic proletarian mood of the masses'. Pictorial representations of the right kind of images would help in this. The Communist Party's emergency programme on cultural policy, discussed earlier, was not much more specific about the role of the visual arts to educate the worker. Yet when the authors of the programme proposed that the party should found a 'revolutionary cultural journal' which would be addressed primarily to intellectuals and professionals, they stressed the importance of illustrations. Examples should be chosen which would refer to the economic and cultural position of *Geistige Arbeiter* (intellectual workers), and the programme cited as illustrations some dealing with the build-up of the Soviet Union and the cultural decline in Germany.[10]

The first attempt to put Communist ideas for the visual arts into practice was in the programme of the Rote Gruppe (Red Group), which was formed in 1924. This was an informal group of visual artists and members of the performing arts. In its manifesto the group confirmed its commitment to the belief that a good Communist was a Communist first and foremost, and a skilled worker or artist only afterwards.[11] The activities which flowed from this were expected to take precedence over professional work. Group members regarded it as their principal task 'to contribute, together with the local Communist parties, in order to improve the effectiveness of Communist propaganda by means of writing, the visual arts and the theatre'. More concretely they proposed the establishment of art-educational facilities within local parties and the creation of sample designs for wall-newspapers as well as advice about the construction of placards and banners (Plate 54). In general they resolved to dedicate themselves to improving the hitherto rather amateurish attempts to proclaim the revolutionary policy of the party in words and pictures.

The membership of the Rote Gruppe included some of the best known and most active of the contemporary artists who were

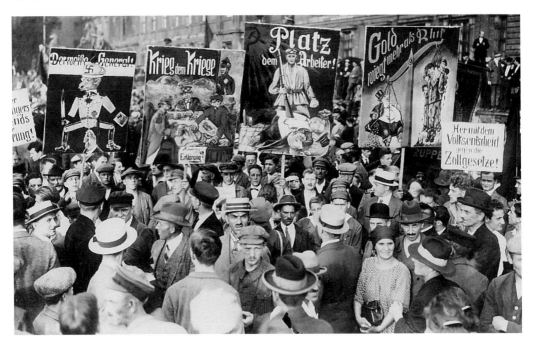

54 Placards at the Berlin trade union demonstration (24 July 1925)

associated with the KPD or sympathised with it. Among them were George Grosz, Otto Dix, John Heartfield, Rudolf Schlichter, Otto Griebel and Otto Nagel, who were also mostly active as contributors to the *Knüppel* magazine.

The Rote Gruppe appears to have remained in existence until the middle of 1927. During that short period members of the group apparently exhibited collectively and made a number of declarations on art-political issues, but there is little evidence that it had much influence on Communist agitational practice.[12]

After the short-lived and rather ineffectual Rote Gruppe, the Assoziation der revolutionären Bildenden Künstler Deutschlands (ARBKD), generally referred to as ASSO, was a much more effective and lasting attempt to mobilise politically radical artists to serve the Communist Party.

The ASSO was conceived on the model of the Russian Association of Revolutionary Artists, the 1927 meeting of which was attended by German colleagues. Following this contact, and in line with the general Communist practice of copying Russian institutions and experience, the ASSO was formally launched in March 1928. It remained in existence until 1933 and had by then expanded from a small, Berlin-based group of professional artists and graphic designers to a national society with branches in many cities and an estimated membership of about eight hundred, of whom nearly half were amateur illustrators, the so-called *Arbeiterzeichner*.

The impetus to form the ASSO came from artists in the Graphics Studio which the KPD had just established in the Karl Liebknecht Haus in Berlin, the national headquarters of the party and the editorial offices of the *Rote Fahne*. The artists who worked there included Bruno Angeluschew (Bruno Fuk or Fuck), P. P. Eckmeier, Alfred Beier-Red, Laszlo Dallas (Griffel), Alois Erbach (Aleus), Sandor Ek (Alex Keil), Jolan Szilagyi (Joli) and Günter Wagner (gü). Its head was Max Keilson, who was also the Secretary of the ASSO. A further basis for ASSO was the group of Communist members in the National Economic Defence Association of Visual Artists, the Reichswirtschaftsverband Bildender Künstler, which served as an economic and political pressure group for artists. Pressure from within that organisation had led to the establishment of a cell of Communist artists, and in a formal sense ASSO emerged out of that.[13]

In these circumstances it is not surprising that the material plight of the artists initially occupied a major place in ASSO's appeals. Its manifesto provided a Marxist analysis of the general position of the artist in society. Starting with Marx's famous dictum that social being determined conciousness, it went on to link artistic life and achievement to the economic and social base of society. ASSO believed that in a capitalist society the production of art, like that of every other commodity, was linked to the profit motive and the artists were unable to develop their talents freely. The coming revolution would sweep this system away and ensure the liberation and advance of humankind. Claiming that the artists were every bit as exploited as the proletariat, the Communist artists urged their colleagues to march alongside the fighting proletariat. 'Artists, like members of the working class, have nothing to lose but their chains.'[14]

Although there is some continuity between ASSO and the Rote Gruppe, some of whose members joined ASSO, there are interesting differences between them. The Rote Gruppe was composed of established artists – Communists of long standing, artists with anarchist inclinations and less politically committed individuals who had belonged to the opposition in the Novembergruppe. They stressed the importance of training ordinary party members in simple artistic skills in order to improve the quality of Communist propaganda and were apparently less concerned with bringing art to the masses for their enjoyment.

The founding members of the ASSO held art in higher esteem and accorded it a much more powerful role in the general process of political education and propaganda. The statutes of the association declared that, in contrast to artists' associations based on a common style and the belief in *l'art pour l'art*, ASSO sought to 'further the

class struggle in a way which will adapt [art] to the needs of the workers in terms of both style and content'.[15]

The relative disregard by ASSO of art form as against content can be seen in the acceptance into membership of some of the artists from the Berlin group Die Zeitgemässen (Contemporaries), formerly Die Abstrakten (Abstracts). Its members – Nerlinger, Fuhrmann, Lex and others – had started their career in the Sturm (Storm) circle of Herwarth Walden and had thus worked in an expressionist or abstract medium. They later moved politically towards the KPD and artistically to membership of ASSO. 'We came to recognise', Nerlinger wrote in 1956, 'that there cannot be a revolutionary form as such and that it can arise only if the content itself is revolutionary. This convinced them of the need to take part in Communist activities with paintings, prints, cartoons and posters.'[16]

ASSO did not seek to impose a common style of art on its members, nor did it distinguish between pure and applied art. The founders and many of the people who were later to join the organisation were already active in applied art. Often employed as graphic artists or illustrators, they were used to creating drawings, prints or other objects with an immediate and specific political or propaganda aim in mind.

Many of the ASSO artists were regularly involved in visual agitation in the cause of the KPD. They created posters and banners for meetings and demonstrations and they designed and built objects to be carried like icons in these demonstrations, almost as if they were religious processions. Artists also converted vans or lorries to floats and decorated them with pictorial representations and exhortations, reproducing slogans and messages. Such three-dimensional structures, in contrast to the customary posters and drawings, were often surprisingly abstract in design. The artists obviously realised that the sizeable distance between the object and many of the demonstrators demanded a simplified construction, bold outlines, strong colours and clear, functional lettering.

The Communist Party put great emphasis on the ephemeral displays in the form of graffiti or of drawing for agitation during elections or other campaigns. Indeed, Alfred Kemenyi ('Durus'), the art critic of the *Rote Fahne*, thought that vigorously designed slogans, together with the use of bold colours and good lettering and drawings, could produce strong and persuasive images. Such artwork could be produced even by workers with little or no formal training in art and he thought that one could almost speak of a new folk art coming into being.[17]

Political slogans and general political propaganda were also conveyed through more simple visual images in small prints which were

55 Hans Grundig, *Streik, Kämpft mit der RGO*, linocut (1929)

sold very cheaply at meetings or even in pubs. In Dresden ASSO artists, notably Herbert Gute and Hans and Lea Grundig, were active in that field and a look at the prints which they made during the last few years of the Republic is illuminating. They were simple, at times almost crude linocuts, 'commissioned' by the local Communist Party and printed by the local party paper for free distribution or for sale for 20 or 30 Pfennigs at political meetings and at performances of the Linkskurve, the local agitprop theatre.

These small prints made their point through a combination of image and text. They were a mixture of the celebratory, the exhortative and the warning. Of the total of eighteen such prints which Lea Grundig discovered in her studio many years later, some dealt with events and institutions, like the 1 May demonstrations, others reproduced salutary events from the workers' life.

One drawing shows an obviously unhappy young lad who is being taken by his father and grandfather to the Children's Home run by the IAH, the International Workers Aid. Here the unstated suggestion is that the boy's mother is either ill or dead so that the child has to be taken to a home. Many prints on the other hand make their point more directly by means of a legend or exhortation cut in the text. Two prints, for example, show children – obviously at Christmas time – who are the victims of their family's poverty. In one a boy stands with his mother in front of a toyshop and is told that he cannot have the train set in the window. Another boy in his sparsely furnished home holds a list of Christmas wishes in his hand, knowing full well that they will not be met.

The captions are clearly essential to understand the print. More direct and informative are those works which illustrate a demonstration with the legend 'Streikt, kämpft mit der RGO' (Strike, fight with the Red Trade Union Opposition) cut in large letters in the print (Plate 55). Another shows a woman throwing herself out of a window,

presumably to her death. The caption, white on black, read: 'Suicide is no way out. Fight with the KPD' (Plate 56).[18]

Hans and Lea Grundig, born into a working-class and middle-class milieu respectively, are good examples of average ASSO artists and their work. They had joined the Communist Party in 1926, but their early work shows no specific political engagement. However, the deepening economic crisis towards the end of the Weimar period affected them directly – it even forced Hans for a while to return to his original trade as a house-painter – and they became more deeply involved in political agitation.

In one exhibition of his work Hans Grundig showed a painting of his wife in a garret surrounded by posters which he had 'painted for the KPD and which showed the sad consequence of undernourishment and of tuberculosis'. He also showed a still life of the food which an unemployed worker could buy for the weekly dole money. Here was 'a critique of the social evils which could

56 Hans Grundig, *Suicide is no way out. Fight with the KPD*, linocut (1929)

be found everywhere' and thus an attempt would be made to make the well-to-do aware of them. The Grundigs were also active as actors and scene painters for the Dresden Agitprop theatre group, the Linkskurve, and during the performances Hans Grundig drew quick-fire political cartoons which were later auctioned for party funds.[19]

The mixture of pure art, propaganda art and agitprop seems to have been a fairly common phenomenon among the committed and organised Communist artists during those hectic last few years of the Weimar Republic. In Hamburg Adolf Wriggers, a cartoonist for the Communist *Hamburger Volkszeitung*, also drew leaflets and made woodcut portraits of working-class leaders which were reproduced as postcards and sold.[20]

The KPD encouraged ordinary workers to draw, signwrite and construct messages and images. Communist educational institutions, notably the MASCH, the Marxistische Arbeiter Schulen, offered courses

in art where artists active in the field of agitprop often taught art to workers. Thus Emil Kritzky in Hamburg, Herbert Gute in Dresden and Alfred Frank in Leipzig taught at the local MASCH.[21]

The teaching of art at the MASCH was generally strictly practical. Typical courses covered calligraphy, poster design, figure and cartoon drawing and the art of the woodcut. Courses in art history were offered occasionally, but the principal purpose of the instruction was to train workers who would help with political agitation in their spare time. Their teachers, who were likewise engaged in such work, could base their instruction on actual experience. Kritzky, Gute and Frank had come to their art from an initial training in a trade. Their background was proletarian and their original training had been in carpentry, painting and decorating, and chromolithography respectively.

Those who attended these classes were mostly young factory or office workers who, in the evenings, drew, painted or cut in wood or lino.[22] Relatively few of the members of ASSO had been through the traditional art training of art academy, master pupillage, Prix de Rome etc. of the successful professional painter or sculptor. The ASSO artists had a hard time economically. In 1930 eighty per cent of Hamburg artists earned less than 50 Marks per month and only four per cent earned over 150 Marks.[23] The average wage of a miner in the same year was about 200 Marks a month.

Out of the circles of workers who attended courses at the MASCH and other amateurs arose the *Arbeiterzeichner* (worker illustrators) movement. They aimed to use their drawing and calligraphy skills to help the political agitation of the KPD. In March 1931 the *Arbeiterzeichner* became affiliated to ASSO, a move probably dictated by the party. The *Rote Fahne* described the act as a necessary step to strengthen ASSO and at the same time to deepen the Marxist consciousness of amateur artists. The paper wrote that, without such an arrangement, individual amateur artists would paint simply for their own pleasure and edification. It hoped that by being organised within the framework of ASSO, they would be persuaded of the fact that 'for a class-conscious *Arbeiterzeichner* the primary purpose of his drawing and painting was revolutionary agitation and propaganda'.[24]

The aim of art training in the MASCH was therefore clearly not the stimulation of art for its own sake, or the creation of 'proletarian artists with artists' conceits', but the formation of inventive and effective revolutionary agitators who would be able to use their skills for the good of the party. At the same time it was hoped that the education of workers in art would assist the proletariat. 'It would help to

improve taste, fight Kitsch and show the world what powerful talents were slumbering in the proletariat.'[25]

'Durus' wrote in 1930 that 'the group of formally untrained or little trained draughtsmen could be more effective in their work than more sophisticated professionals'. He saw in the activities of these working-class amateurs the first buddings of a future proletarian art. He also believed that the relatively unsophisticated workers could produce drawings and other works which might be more easily understood by the proletarian masses among whom he lived. 'The front of amateur *Arbeiterzeichner* or the poster-artists ... will be able to perform more effectively than the technically more qualified artist who was not so well attuned to life on the shop-floor.'[26]

The dividing line between the amateur and the professional artist cannot always be clearly drawn. The MASCH and the joint endeavours of professionals and amateurs in the field of propaganda art did, indeed, produce some artists who were to work independently and who developed their own personal style.[27] This applied in particular to the group of gifted amateurs which Alfred Frank had gathered around him in Leipzig. This included Hans Romanit, Oskar Erich Stephan, Gerhart Bettermann and Franz Nolde, who were later to make their mark as independent artists.

This discussion on MASCH and its students points to the inevitable conflict between the ethos and practice of the professional artist and that of the amateur sketcher and illustrator. The first was dedicated to transforming imagination or fantasy into a work of art. Amateurs, with often painfully acquired skills, would be expected to dedicate themselves and their artistic talents to the task of agitation and propaganda towards a common political goal.

In general ASSO did not seek to initiate or prescribe subjects for its members' art or lay down a common style, but at the beginning it expected artists who wished to join to be in broad sympathy with the aims of the Communist Party, if not to be actual members of it. Thus an application to join by the Cologne group Progressive Künstler (Progressive Artists) was rejected because they were suspected of anarchist leanings.[28] There were also misgivings about the suggested membership of some radical bourgeois artists such as Otto Dix, even though allowing them to join would have raised the artistic profile of the group. But leading and orthodox members like Max Keilson and others insisted that ASSO should continue to admit only artists who held 'correct' political views even if their artistic standing was not of the highest. In his view:

it is the task of the ARBKD [ASSO] to work in the spirit of the revolu-
tionary movement ... we would not like to do without the collaboration
of those 'prominent' [bourgeois] artists who are true artists, but we cannot
change our attitude ... Our brush must be turned against the bourgeoisie
... we fight against it in order to change it.[29]

This policy kept the membership small and correspondingly inef-
fective and the association decided therefore in 1929 to widen its
intake and, as far as the limited size of the artists' community per-
mitted, to turn itself into a mass organisation which would represent
all progressive artists in the country.[30]

The immediate impetus to become a mass organisation was the
limited success of an exhibition on the theme of Capital and Labour
which the Berlin ASSO staged in May 1929. The exhibition failed to
enthuse the workers to whom it was primarily addressed or to convince
the broad masses of uncommitted artists of the correctness of ASSO's
policies. It became clear 'that the cost and the amount of time spent
on the project were not commensurate with the results attained'. It
also became clear to the leadership of ASSO that the working masses
could only be approached and persuaded through newspapers, posters,
illustrations, books and pamphlets, dust-jackets and the decoration of
demonstrations with banners and other devices.[31]

With the consequent widening of its ranks ASSO now saw its task
as a dual one. It was still concerned with encouraging members to
be active in the economic representation of the visual artists via the
Reichswirtschaftsverband der Bildender Künstler and through that
with making the artists' community more politically aware. But more
importantly in our context ASSO was expected to educate and per-
suade members to become better in their art and to use their art
in the service of the proletariat and its revolutionary class struggle.
This meant expanding the ideological discussion within the local
groups. In Berlin especially ASSO held regular meetings and training
courses at which political themes figured as prominently as artistic
ones.[32]

At the centre of the discussion stood the relationship between
Marxism and art which aimed to ensure that members who were as
yet not fully convinced should have the correct ideological basis for
their work. In their assessment of the function of art, Communist art
critics and writers on aesthetics had interpreted the art of the past in
terms of its tendentiousness to express the ideas of the ruling class.
One of these, the art historian and critic Fritz Schiff, who regularly
took part in ASSO discussions, suggested that 'the class-conscious
worker would look at the art of the past essentially as an example

of social and class movements. In the styles of the various epochs a Marxist recognises the various stages of the dialectical process.'[33]

ASSO itself proclaimed that it based its views on art on Marxist principles. For its members, it was an incontrovertible truth that the modes of production determined the political, social and above all the intellectual processes, including the creative processes which produced works of art.

The issue facing the Marxist art historian and art critic was not simply one of 'tendentious art or pure art'. All art was 'tendentious'; what characterised art for the workers was that it approached its subject from the position of the fighting proletariat. For ASSO the adequacy and effectiveness of a work of art and its ability to serve the cause of the fighting proletariat was primarily determined by its content, not its form. It was to be judged by a number of criteria. To make an impact, a work of art had to make its mark in the concrete historical situation in which it was shown, according to what event or situation provided the impetus for its creation, and to what extent it was likely to serve the cause of the proletariat.[34]

Looking at the theory and practice of ASSO art and the work of ASSO artists after an interval of more than half a century presents great difficulties. We lack today almost all written records of its activities. Most of the art created by its members at the time and exhibited, whether in one-person exhibitions, general group shows or collectively under the auspices of the Association or grouped under its name in general art exhibitions, has been destroyed by fascist action or lost in the ravages of time.[35] The catalogue of an exhibition in Dresden in 1985 of the work of Eugen Hoffmann, a leading ASSO artist, states that, with few exceptions, his political and socially critical works of the 1920s could not be traced.[36]

But even allowing for such vagaries it seems certain that not all artists organised in ASSO created politically relevant art and that many of those who did so continued to paint or draw subjects with little or no political significance. The ASSO group in Leipzig was founded only in November 1929 with the group of artists around Alfred Frank as a nucleus. Camouflaged as Freischaffende Künstler Sachsens (Free and independent Artists of Saxony), they showed their work in the first *Grosse Leipziger Kunstausstellung* in 1931 and exhibited under their own name the following year (Plate 47).

On the first occasion, ASSO members exhibited a total of eighty-six works, of which thirty had broadly social themes. One year later we find that nineteen individual ASSO artists showed a total of eighty-one works of which 60 per cent were concerned with the workers' struggle.[37]

'Social Art' is clearly a vague term, especially if judged in terms of the Marxist *Tendenzkunst*, which the ASSO expected from its members. They were opposed to the kind of genre painting which merely recorded events in the life of the poor. Reviewing an exhibition of *Junge Dresdner Kunst* (Young Art from Dresden), the art critic 'Durus' condemned paintings by Otto Griebel, one of the founders of the Dresden ASSO, as petty bourgeois *Elendsmalerei* He added:

> Griebel puts store on being called a proletarian painter, but he seems to confuse the sentimental with the proletarian. The milieu of his talented visual reportages was indeed a proletarian milieu, but the way in which he tackled them was not revolutionary. There is too much passivity in these social sketches. The will to change the world, not just to explain it, is not sufficiently stressed.[38]

Griebel retorted that the paintings had been selected not by him but by the gallery. He rejected the allegations and referred 'Durus' to his new great painting *Die Internationale*, which had not been seen in Berlin, as proof of his radical approach to art.[39]

Die Internationale (Plate 57), painted in Dresden in 1928–9, has indeed been widely acclaimed as a prime example of the new revolutionary art stimulated by ASSO. Its crowded masses – full figures or

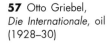

57 Otto Griebel,
Die Internationale, oil
(1928–30)

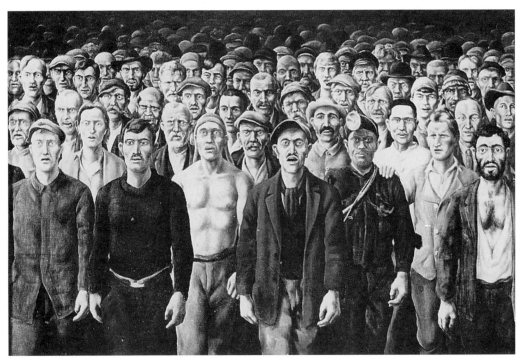

just heads – fill nearly every square inch of the painting and the range of people portrayed in the picture stresses the international character of working-class solidarity. At the same time the self-portrait of the artist, who stands in the first row with his hand on the shoulder of the miner next to him, symbolises the common cause between artist and worker.

Die Internationale is one of a series of works, mostly oils, painted at that time by ASSO members, which showed workers and their milieu in a new light. The workers were no longer suffering and oppressed, but proud or even heroic. They were shown either in the role of a fighter, as for example in Curt Querner's *Demonstration* of 1930, or as a skilled worker such as in Wilhelm Lachnit's *Communist Frölich*, which showed a compositor on the Dresden KPD paper (Plate 58). Another example is the simple, tender yet unerotic portrayal of young lovers, often painted against an industrial background as in pictures by Bergander or Grethe Jürgens from 1932. They are dressed in their work clothes or, in Jürgens's paintings, dressed almost in uniform (Plate 59).

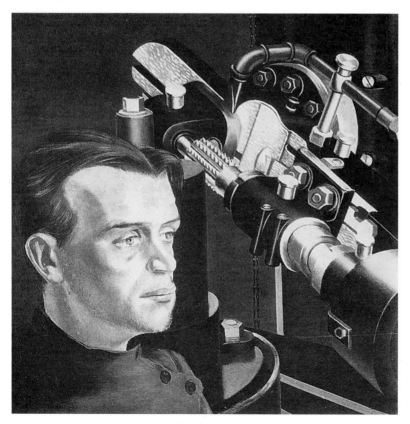

58 Wilhelm Lachnit, *Kommunist Frölich*, oil (1928)

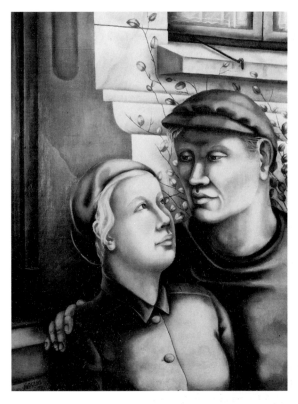

According to a perceptive and clearly sympathetic art historian writing some fifty years later, such paintings are evidence of the

close ties which existed between many artists and the working class and its revolutionary party . . . within the capitalist system and under conditions of the hardest class struggles, the portrayal of the proletariat in the visual arts developed and matured. . . . [under such conditions] A large number of works of art were created which manifested the existence of a new and self-confident proletariat in which the image of the socialist man and woman was already becoming apparent.[40]

The power of these paintings and their persuasiveness cannot be doubted. It is less clear that they represent a vital new style of painting which had been stimulated by the contemporary artistic and political discussion in the ranks of ASSO and supported by the Com-

59 Grete Jürgens, *Ein Liebespaar* (Lovers), oil (1932)

munist Party. Assessing this argument poses some historical and methodological problems. It has been suggested that 'although the destructive element did not entirely disappear from the proletarian–revolutionary art of the second half of the 1920s and of the beginning of the 1930s the constructive and creative aspect of the working class and the workers' movement [*Arbeiterschaft*] moves centre stage and becomes the dominant element in revolutionary art'.[41]

This assessment allocates a central role to ASSO and the revolutionary ideology which motivated its members. Ulrich Kuhirt claims that such a shift from the portrayal of the worker as a mainly suffering and oppressed human being to an optimistic, confident, fighting and at times heroic activist can also be traced in artists unconnected with ASSO, and Kuhirt cites trends which he sees in some of Kollwitz's later works, especially her *Propellerlied* and her *Demonstration*.[42]

He also sees a general development in the way in which working-class artists and artists who identified with the working class looked at the world. In the first few years after the revolution, the emphasis was on the art which showed up the fissures and the evils of bourgeois society and the sufferings of the workers. This was the case in

the satirical magazines studied earlier and it was through these illustrations that the art of Dix, Grosz and Schlichter reached a working-class public. Thus Grosz's highly destructive drawings of capitalist society in his *Face of the Ruling Class* (1921) were reproduced as a set of slides by the KPD.

The new generation of ASSO artists, on the other hand, tended to be more concerned with using their art to strengthen the will of the workers to fight and to do so under the 'leadership of the Communist Party as the leading force of the revolutionary movement'.[43]

Another area of leisure-time activities where the Communist Party had a role to play was that of photography, which became popular among workers in the 1920s. Workers were interested in the technical aspects of photography and in taking pictures, mainly family photos or snapshots of events. Some working-class photographers were Communists and it was only natural that the party should seek to mobilise these activists to assist with its own communications.

The harnessing of this interest for political ends was above all due to the perception and the organising genius of Willi Münzenberg, head of the Neues Deutschland (New Germany) publishing enterprise and the publisher of the pioneering *Arbeiter Illustrierte Zeitung*. He recognised the potential of the relatively young technique of photography for mass communication and sought to mobilise the growing group of working-class hobby photographers. In 1926 he tried to help photographers improve their skills with a new journal, *Der Arbeiterfotograf* (The Worker Photographer), which combined technical instruction with the discussion of political issues.[44] The following year Münzenberg organised these hobbyists in a common interest group, the Vereinigung der Arbeiterfotografen Deutschlands (VdAFD), the Association of German Worker Photographers.

This association soon developed into a strong and well-organised group of working-class amateurs. At its peak it had a membership of about 2,400 organised in over ninety local branches.[45] Its activities are recorded regularly but briefly in the *Arbeiterfotograf*, but these reports are much less important for our understanding of workers' photography than the more substantial and theoretical articles in the journal itself. Here discussion centred on photography's role in the wider cultural and political scene.

We saw that the social democratic amateur photographers organised in the Arbeiter Lichtbild Bund emphasised aesthetic satisfaction and the expression of individual taste. Those responsible for the policy of the Association of Worker Photographers saw it as their primary role to assist in agitation and propaganda among the working masses. The

majority of its members were Communists or sympathisers, and Franz Höllering, editor of the *AIZ*, also edited the *Arbeiterfotograf.*

Münzenberg was anxious to turn the *AIZ* into a genuine proletarian paper, and to achieve this he wanted to widen the character of its photographic coverage and reduce the paper's dependence on bourgeois press agencies. Initially he aimed only to create a support group of keen photographers who would be 'technical auxillaries for the class struggle' and would supply the magazine with pictures reflecting working-class life at the grass-roots, and above all in the factories, where professional photographers could not gain entry.

From such informal beginnings, worker photographers broadened out into an organisation with a wider political brief which was to use its photography to assist the whole of the working-class press and approach its task from the point of view of the proletarian class struggle. The members were expected to be more than providers of photographs because the well-chosen photo was in itself a *Massenbeeinflussungsfaktor*, a vehicle for mass influence. Such photographs should be used more extensively to counter what the Left believed to be the ever-growing power of the bourgeois media, including the weekly illustrated, the magazine press, and, above all, the cinema. Worker photographers had to do more than photograph and project, they must select and focus their object, improve their techniques and attempt to raise the temper of the conflict.[46]

Worker photographers 'should not stop at an accurate portrayal of segments of facts and events. They must bring out the underlying relationships and show the contradictions of social reality.'[47]

Discussion within the VdAFD about the nature and function of the pictures to help in this task centred on the objectivity of the photograph, its power of persuasion and the influence of individual vision and creativeness on the picture itself. For the worker photographers, believers in a scientific theory of society, the photograph was an objective record of reality. The camera was only an 'observation machine' able to reproduce nature, show the world as it is, and nothing artificial should be done to distort the picture.[48]

This approach would clarify the distinction between the pretty images of bourgeois photography and the realistic approach of the Marxist. The amateur photographers believed initially that they would be able to convince and convert simply through the incontrovertable visual evidence of such documentary photography.[49]

But the 'pure' picture was never as persuasive as the photographers had hoped. The *AIZ* soon realised that a single photograph without commentary would not by itself provide the propagandist function

the paper needed, and photographs of groups or montages of pictures would need appropriate captions to counter the propaganda of the opponents of the working class and substantiate the point of view of the revolutionary proletariat.[50]

Another debate centred on what the photographs should portray. Critics said a picture of a beautiful scene could be seen as a sign that workers were becoming escapist and blind to the needs of their own background, looking at the world through the petty bourgeois eyes of their surroundings rather than through the eyes of their own class. The truly proletarian photographer should concentrate on depicting the life of the worker, and needed training in Marxist theory to interpret the work.[51]

Our photographers should tear down the veil from the photographs of the bourgeoisie and we must tell the world at the top of our vengeful voices about the reality of proletarian life, its ugliness, and its odiousness. There must be no glossing over, no touching up to make things beautiful. We shall raise the fighting spirit of our class by making our pictures convey class-consciousness, mass consciousness, aggressiveness and solidarity.[52]

The prevalence of petty bourgeois tastes in photographs taken by the *Arbeiterfotografen* was a matter of concern to the functionaries and theoreticians of the movement. Perhaps the majority of the photographs submitted for exhibitions and many of those exhibited still showed traditional subjects – portraits, family groups, landscapes and still lifes.[53] The functionaries also worried about the widespread tendency to concentrate on the beautiful aspect of the object. Franz Höllering, who saw most of the pictures submitted to the *AIZ*, wrote in 1928 that while the association had taken great strides forward there were still many workers who aimed at producing an 'arty' kind of photograph, operating with light effects, manipulating shadows.

Not all writers who discussed the function of photographs in the columns of the *Arbeiterfotograf* saw the process by which the worker selected the subject in terms of a rational selection and ideology. Some saw a fuzzier divide between photography and art. The freedom of the painter to employ colour and fantasy and introduce extraneous material could not yet be practised by the photographer, but the latter could bring out the spiritual in the human race and 'put more meaning into a photograph of the dirty boots of a sewage worker than any academic painter in the portrait of a bourgeois dignitary'.

Unlike Höllering, Communist educationalist Edwin Hoernle was more inclined to stress the fact that the photographer, like the painter, employed a variety of technical skills which could determine the

quality of a photograph. But the way to turn a photographer into an artist involved finding the great theme which expressed 'basic facts and causative factors in society' and corresponded to what in the case of the great artists and thinkers we call 'intuition'.[54]

Such views differ from the belief of the camera as 'observing machine' which the technical cadres of the proletariat would have only to administer and to service. Others justified the technical manipulation of the photograph in order to realise a new vision, as attempted by the New Photography. This was not the result of a bourgeois attempt at obfuscation but a genuine attempt to create a new and truer reality.[55]

The New Photography effectively used photographic techniques to redefine the object being photographed, producing a new reality based on the camera's optics rather than on the human eye.

The photographic process of seeing allows no other fetters than those of the materials with which the photography is held down. Its aim must be to express the subject in its briefest and most convincing form ... undistorted and unmanipulated except if the goal requires it. And this goal lay not in artistic values but in the interests of the proletariat.

The new photographers, on the other hand, defended their approach as one of purity and independence. '*Arbeiterfotografen* are directed by our needs for the new forms which for us mean concentration on essentials, on clarity and sobriety.'

NOTES

1 For the Educational Guidelines of the German Communist Party see L. Hoffmann and D. Hoffmann-Ostwald (eds), *Deutsche Arbeiter*, 2 vols (Berlin, 1972), 1, pp. 99–102. Also in *Die Internationale* (1921), 3, pp. 682–3. For the party's later 'Emergency Cultural Programme' see Chapter 3 and references cited there.
2 On Gertrud Alexander see F. Albrecht, *Deutsche Schriftsteller in der Entscheidung* (Berlin, 1970), pp. 150–5.
3 By appointing and dismissing regional and local officials down to a very low level, the leadership, known appropriately as 'Die Zentrale' (The Centre), could assure compliance with the party and exercise considerable influence on the selection of delegates to conferences. Powerful personalities could nevertheless create a strong local following for themselves and attempt to influence the party line.
4 See H. Weber, *Hauptfeind Sozialdemokratie: Strategie und Taktik der KPD, 1929–1933* (Düsseldorf, 1982); E. Rosenhaft, *The German Communists: Political Violence, 1929–1933* (Cambridge, 1986).
5 The history of the Arbeiter Theater Bund is an example of such a takeover. As membership was institutional it was comparatively easy for the KPD to create spurious organisations and affiliate in large numbers and thus take the organisation over quite legally. The SPD disaffiliated its membership and created its own organisation under the old name but deprived of its assets.

6 The IFA was established by the KPD only in 1929 with the aim of co-ordinating and strengthening the work of the Communist cultural organisations. Its activities were hampered by the widespread economic difficulties. See among others 'Die kulturpolitischen Aufgaben der KPD und die Arbeit der Ifa', *Kampf um die Massen*, 5 (September 1929).

7 See IFA *Rundschau*, 3, 2–4 (*c.* 1930), p. 31.

8 See H. Wunderer, *Kultur und Massenorganisationen in der Arbeiterbewegung 1890–1933* (Frankfurt, 1980), pp. 165–8; IFA *Rundschau*, 2, 7–8, p. 56; 3, 2–4, p. 28.

9 From the circular issued by the KPD after the *Reichskonferenz der Bildungsobleute* held in 1922 in Zentrales Partei Archiv I 2/707/1. See also C.I. E.C. Circ. Oct. 1922, cited in *Wem gehört die Welt* (exhibition catalogue) (Berlin, 1977), p. 193 n. 21.

10 See Zentrales Partei Archiv, I 2/707/107.

11 See U. M. Schneede, *Die Zwanziger Jahre: Manifeste und Dokumente Deutscher Künstler* (Cologne, 1979), p. 106.

12 See J. Kramer, 'Die Assoziation Revolutionärer Bildender Künstler Deutschlands' in *Wem gehört die Welt* (exhibition catalogue) (Berlin, 1977), pp. 174–204.

13 See reminiscences of F. E. Gehrig-Targis under the title 'Dokumente und Materialien zur Geschichte der ARBKD' written in 1960 and deposited in the Archives of the Staatliche Museen in Berlin (DDR).

14 From the Manifesto of ASSO, quoted in Schneede, *Die Zwanziger Jahre*, pp. 146–9 at p. 149.

15 *Ibid.*

16 From the Nerlinger Archiv in the Berlin Akademie der Künste.

17 'Durus' on 'Die Kunst der Strasse', *Rote Fahne* (12 September 1930).

18 Lea Grundig, 'Zeit sich zu erinnern: Anlässlich des 50. Jahrestages der Gründung der ASSO', *Bildende Kunst* (1977), pp. 287–93.

19 Hans Grundig, *Zwischen Karnival und Aschermittwoch* (Berlin, 1960), pp. 200–5.

20 See 'Engagierte Kunst in Hamburg, 1848–1971' (exhibition catalogue) (Hamburg, 1972), p. 33.

21 On the MASCH see Gabriele Gerhard-Sonnenberg, *Marxistische Arbeiterbildung in der Weimarer Zeit* (Cologne, 1976).

22 From a statement by Gerhart Bettermann, born 1910 cited in *50 Jahre ASSO in Leipzig* (1979, the catalogue of an exhibition of Bettermann's works).

23 See *Widerstand statt Anpassung: Deutsche Kunst im Widerstand gegen den Faschismus, 1933–1945* (Berlin (BRD), 1980), p. 34 citing Otto Nagel from his article 'Das Ende der Bildenden Kunst', *Sozialistische Monatshefte*, 1 (1932), p. 152.

24 'Durus', *Rote Fahne*, 52 (3 March 1931).

25 See U. Kuhirt, 'Die Arbeiter Zeichner Bewegung', in W. Jacobeit and U. Mohrmann (eds), *Kultur und Lebensweise des Proletariats* (Berlin (GDR), 1973).

26 'Durus', *Rote Fahne*, 8 October and 29 October 1930.

27 Gerhard-Sonnenberg, *Marxistische Arbeiterbildung*.

28 See Gehrig-Targis Ms (note 13), f. 2.

29 *Ibid.*, f. 93 quoting Max Keilson and S. Ek (A. Keil), *5 Jahre im Kampf um die revolutionäre Bildende Kunst in Deutschland*, reprinted in D. Schmidt (ed.), *Manifeste, Manifeste, 1905–1933* (Dresden, 1965), pp. 414–29.

30 *Ibid.*

31 *Ibid.*, p. 415.

32 U. Kuhirt, *Künstler und Klassenkampf in Revolution und Realismus* (exhibition catalogue) (Berlin, 1978), pp. 44–52 at p. 52.

33 Fritz Schiff, 'Kunst und Proletariat', *Volksbuch* (1930), pp. 78–84 at p. 80.

34 Ek, *5 Jahre*, pp. 422–3.
35 The assiduous collecting and exhibiting of ASSO art in the DDR did not uncover much information or material about the internal affairs and discussions of the organisation.
36 See catalogue of the exhibition of works by Eugen Hoffmann (1892–1955) in 1985 at the Galerie Rähnitzgasse in Dresden.
37 See G. Winkler, 'Die Gruppe der Leipziger ASSO', *Bildende Kunst* (1980), pp. 18–21; and *50 Jahre Leipzig ASSO* for the figures.
38 See exhibition catalogue, *Otto Griebel, Curt Grosspietsch, Werner Hofmann* (Leonhardinum, Dresden, 1965), p. 25.
39 See Griebel's letter to the *Rote Fahne* of 20 April 1930 together with a postscript by 'Durus'.
40 See U. Horn, 'Zur Ikonographie der deutschen proletarisch-revolutionären Kunst 1917–1933' in *Revolution und Realismus . . .* (Berlin (DDR), 1978) (exhibition catalogue), pp. 53–69 at p. 69.
41 U. Kuhirt, *Künstler und Klassenkampf*, p. 49.
42 *Ibid.*
43 *Ibid.*
44 On Münzenberg see B. Gros, *Willi Münzenberg: Eine politische Biographie* (Stuttgart, 1967).
45 Originally the VdAFD covered the whole of the working class and there was no party-political commitment, although 60 per cent of the members were organised in the KPD. This changed after 1930, when workers close to the SPD founded their own organisation, the *Arbeiter Lichtbild Bund*. The AdFD became henceforth more partisan.
46 See Leopold, 'Das Bild, Eine Waffe im Klassenkampf', *Arbeiterfotograf*, 5, 11 (1931), p. 27.
47 See *Arbeiterfotograf*, 5, 6 (1931), p. 142, quoted in Büthe *et al., Der Arbeiterfotograf: Dokumente und Beiträge zur Arbeiterfotographie 1926–1932* (Cologne, 1978), p. 42.
48 See F. Höllering, 'Die Erberung der beobachtenden Maschine', *Arbeiterfotograf*, 2, 10 (1928), pp. 3–4.
49 See Höllering, 'Proletarische Tendenz und bürgerliche Kunst in der Fotografie', *Arbeiterfotograf*, 2, 12 (1928), p. 2.
50 Büthe *et al., Der Arbeiterfotograf*, p. 41 quoting J. R. Becher's preface to H. Willmann, *Geschichte der Arbeiter Illustrierte* (Frankfurt, 1974).
51 Büthe *et al., Der Arbeiterfotograf*, pp. 84–5.
52 See E. Hoernle, 'Das Auge des Arbeiters', *Arbeiterfotograf*, 4, 7 (1930), pp. 151–4 at p. 154.
53 See F. Höllering, 'Der Arbeiterfotograf als Reporter und Künstler', *Arbeiterfotograf*, 2, 5 (1928), pp. 3–4.
54 See E. Hoernle, 'Mensch vor Deinem Auge', *Arbeiterfotograf*, 4 (1930), pp. 251–2; 'Fotografie und Kunst', *Arbeiterfotograf*, 5, 7 (1931), p. 3.
55 On the New Photography see Werner Graff, *Es kommt, der Neue Fotograf* (Berlin, 1929). For an English edition of important texts see David Mellor (ed.), *Germany, the new Photography, 1927–1933* (London, 1978).

Political agitation and images

The revolution had given the political parties a new and powerful position in the state. For the working-class parties – the SPD, the Independent Social Democrats and the newly established KPD – this meant freedom from the petty prosecutions and restrictions to which they had been subject during the Wilhelmine Empire. This new freedom showed itself in their political agitation and propaganda. Before the war political agitation and communication were generally restricted to the spoken and the printed word. The latter used mainly leaflets and broadsheets, produced in large numbers and widely distributed. The only way of emphasising a point was through typography or the use of red print. Now the illustrated poster became an important vehicle of political propaganda.[1]

Such posters made their first appearance during the election campaign for the National Assembly, which was charged with drawing up a constitution. All parties engaged in poster warfare and in the weeks before the election, fixed for 19 January 1919, the German capital experienced a vigorous poster campaign.

Berlin's streets became a riot of colour. The normally grey façades of houses now resembled an agitated mask . . . Shop windows, shutters, houses, crates and boxes were bedecked in poster finery . . . Poster pasters advanced . . . with brush and paste-pot . . . like goblins in the night, putting their posters so high that they could be reached only with mountain-climbing equipment.[2]

Max Pechstein drew the artist as a worker in the cover illustration of a programmatic brochure *An alle Künstler!* (To all Artists) (see Plate 27).

Dozens of posters competed for public attention and sought to influence mass opinion, and this continued throughout the Weimar Republic. Given frequent elections and other political campaigns, a wave of colourful posters stared at the electorate from hoardings for much of the time. The political poster was a powerful weapon for emotive political propaganda. It appealed to the loyalty of traditional supporters while hoping to persuade the as yet uncommitted. Its images dealt nearly as much with opponents' evils and mistakes as with the party's own virtues.

Contemporary critics and protagonists believed that the new political art poster also had an educational function. Its images were expected to strengthen enthusiasm and create solidarity on a deeper and more reflective level. The left-wing art critic Adolf Behne wrote that 'the poster should give a lead to large masses, arouse them and command their attention. It should be a cause of far-reaching intellectual changes of view' (Plate 60).[3]

These comments were made in the context of the publication of a series of government posters aimed at mobilising support for the National Assembly election and for rebuilding the German economy. They were unique in the annals of German political art because no other organisation had been concerned with poster propaganda on such a big scale or on such a broad subject.

But in general Behne's ideals were not often realised, and there is little evidence of poster art which attempted to invite deep reflection. Overall we are clearly concerned with communicating sets of visual stereotypes which were expected to strengthen confidence in the justice and truth of the policies of the party. At the same time it was hoped that the poster would fix in the minds of actual and expected supporters an image of the enemy, be it in class or in party-political terms.

60 A quarter-century of SPD election posters, *Mai Zeitung* (1922)

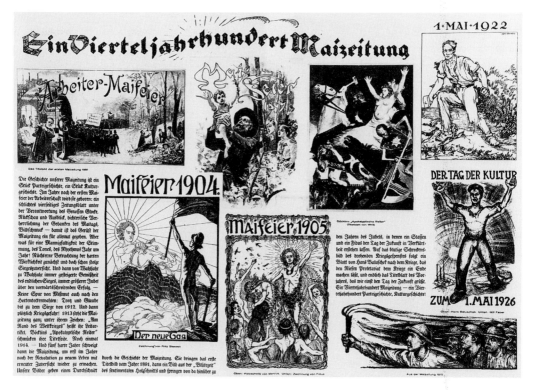

But the poster, like other types of political art, did not serve just the ends of political advertising. Some examples may have been crude and derivative, produced routinely by the graphic designer or the commercial draughtsman, but others were created by well-known artists and should be seen in terms of the artist's whole œuvre.

The political poster and related mass art of the period embodies at its fullest the political iconography of the two parties of the German Left. We first discussed this in respect of the May Day imagery and the illustrations in the working-class press during the two decades before the outbreak of the First World War and before the split in the German Labour Movement. Here we shall look in a similar way at the images projected by the two major parties of the Left. But we must also attempt to interpret the visual agitation in aesthetic terms and as examples of the political commitment of some major artists of that period.

The posters initiated by the Werbedienst of the German government after November 1918 provided an early example of a poster campaign. At least sixty-four posters, identified by the symbol of a torch, were issued by this 'propaganda service' in the weeks and months after the revolution. The organisation was already well versed in publicity work,

61 Cesar Klein, Propaganda poster for the National Assembly Election (1919)

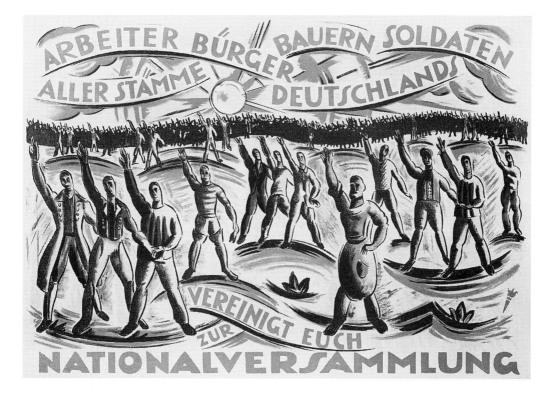

having previously been part of the foreign affairs department of the Supreme War Command (Oberste Heeresleitung). It now came under the direction of social democrat Phillip Scheidemann, one of the People's Representatives and soon to be the first prime minister of the new Republic.[4]

Two social democratic writers, Bernhard Kellermann and Paul Zech – who had been a member of a Soldiers' Council and was responsible for its propaganda – were in charge of commissioning posters, and they charged a number of mostly expressionist artists to design them.[5] They are characterised by their symbolic use of figures and colours, and many of them expressed socialist ideas and sentiments.

The artists commissioned included Cesar Klein, Hans Richter, Heinz Fuchs and Max Pechstein. To mobilise popular support for participation in the election Klein drew groups of apparently happy male figures, their hands raised as if to avour what the caption proclaimed, that 'Workers, peasants, soldiers and citizens of all German lands [should] unite in support of the National Assembly' (Plate 61). Their affirmation of a belief in the utopian national community of the future is underlined by the symbol of the rising sun which bathes the scene in golden light and by the colours used: the blue, white and red of the tricolour and the black, red and gold of German radicalism. A similar sentiment was conveyed in a lithograph by Max Pechstein (Plate 62). Using only black and red, it shows a worker, a trowel in one hand and the other outstretched as if in salutation with the caption 'The National Assembly, cornerstone of the Socialist Republic'.

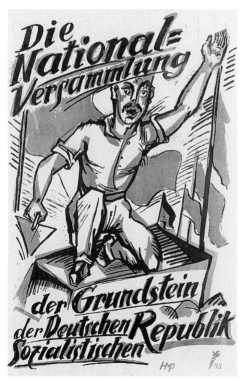

62 Max Pechstein, Propaganda poster for the National Assembly Election (1919)

These posters and a few others in the series carry a very general message in support of the socialist ideals to which the government subscribed. Other posters published by the Werbedienst referred to more general aims and ideals such as peace, freedom and the rebuilding (*Aufbau*) of the Republic, or they merely exhorted the German people to unite and work for the common good (Plate 63).

Such general slogans and maxims clearly aimed to establish a new, national consensus in support of the new state, but those responsible for them also expected that the modern and radical art form would in itself contribute to

the awakening of such sentiments. They thought a style of art which had been associated with general revolutionary ideas before the war would strengthen the belief in socialist ideals on the emotional level as well. These reflections were thought to apply particularly to the working class. The workers, with their fresh, unsophisticated and impressionable minds, were expected – erroneously as we now know – to be especially receptive to this new style of art.

The sentiments of the Werbedienst undoubtedly leant towards the Left, and the Right accused the service of bias in supporting government policies. There was a negative echo even among supporters of the parties of the revolution, and contemporary observers reported that many workers rejected the expressionist posters, arguing that they slighted the ideals of the revolution and ridiculed the workers themselves. 'The pointed and angular style of the new art and the fact that the entire composition of the picture was oriented towards mood and feeling, while passing over all details, meant that it was really intended to be a caricature.' And even when the general mood of the poster was accepted, 'one sensed in character of the design a lack of consideration and of respect'.[6]

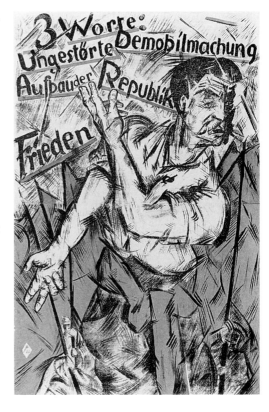

63 H. Richter, Propaganda poster for the National Assembly Election (*Three words: Demobilisation, Reconstruction, Peace*) (1919)

The popular reaction to 'revolutionary art' published in Munich at the time of the Räte Republik seems to have been similar. Prints produced by Alois Wach, Fritz Schaefler or Richard Sewald in the *Münchener Neuste Nachrichten* or in the *Süddeutsche Freiheit* depicted revolutionary concepts and slogans. These were done in a strongly expressionist style (see Plate 26), which many workers could not understand, let alone appreciate: the workers felt ridiculed and saw the art as provocation. Indeed, according to Titus Tautz, a member of the 1919 Künstlerrat, a delegation of workers appeared before Landauer to urge that he, Tautz, should be arrested.[7]

In general the affinity between the artistic avant-garde and the proletariat was not as close as artists and intellectuals had hoped, and this influenced the style adopted by the parties themselves. When the SPD, and later the Communist Party, produced their own political posters they generally turned to

64 George Wilkes, SPD election poster (*Workers, vote for your party, for Social Democracy*) (1924)

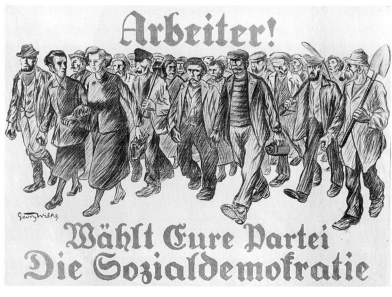

Arbeiter!

Wählt Eure Partei
Die Sozialdemofratie

65 Gottfried Kirchbach, SPD election poster (*Citizen, vote Social Democracy*) (1930)

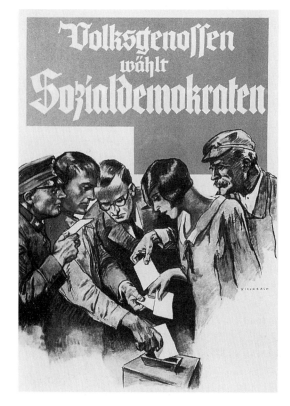

Volksgenossen
wählt
Sozialdemokraten

artists working in more traditional styles. Social democratic posters, above all, were generally executed in a realistic style and they showed figures or scenes which the broad masses would immediately recognise as being accurate both in terms of their own experience and in the representation of it (Plate 64). Allowing for the change in political circumstances and purpose, the style of socialist agitational art after 1918 in many respects continued that of the prewar *Mai Zeitungen* and of the *Wahre Jakob*, although hardly any of the pre-1914 illustrators worked for the party and its publications after 1918.[8]

In some respects the design of social democratic political posters followed the consensual tradition which we observed in the propaganda of the Werbedienst. Their appeal was often directed at the whole community, and posters and the like brought out the idea that the electoral appeal of the SPD was no longer confined to members of the working class but that the party now sought to mobilise white-collar workers and members of new

professions like teachers and lower-rank public servants. The groups
of socialist voters conjured up in many SPD posters seem to under-
score the party's mass appeal by representing a social mix. We find
this in a 1930 social democratic poster by Gottfried Kirchbach which
shows a white-collar worker, a uniformed railwayman and a well-
dressed young woman crowding round the ballot box (Plate 65).

This and the heading *Volksgenossen*, a term later introduced into
common parlance by the Nazis, shows that, at least in the view of
those responsible for electoral propaganda, the concept of a workers'
party had been discarded in favour of an appeal directed at the nation.[9]

Kirchbach (1888–1942) produced a large number of social demo-
cratic posters and other graphic work which epitomised the positive
but at times slightly sentimental image which the SPD used for some
years in its electoral propaganda and which went hand in hand with
the view of the party as a mainstay of the Weimar state.[10]

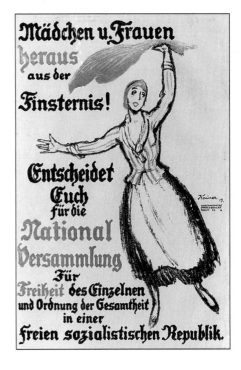

66 L. Kainer,
Propaganda poster for
the National Assembly
Elections (*Women and
Girls, come out of
the darkness and
demonstrate in favour
of the Socialist
Republic*) (1919)

Equally important in the SPD posters are references to the newly
enfranchised women voters. The Werbedienst posters almost exclus-
ively portrayed men; only one poster appeals expressly to women, urg-
ing them to come forward and support the socialist republic (Plate
66). But SPD posters repeatedly and effectively sought to mobilise
women's special interests. They did so mostly through visual refer-
ence to the traditional role of women – linking
their interests to the needs of the family and
appealing for their vote by referring to the needs
of their children.

In this way the SPD translated into visual form
the traditional stereotyped view of the working-
class woman as a bearer and educator of children
and as homemaker. This view of the role of
women was widely held within the party.[11] Only
occasionally do we find a poster with a more
general theme addressed to women, such as an
appeal to the equal rights and duties of citizen-
ship (Plate 67).[12]

As the political and economic situation in
Germany became more explosive, so the propa-
ganda of the SPD became more acerbic. The
party's election posters concentrated more on the
growing conflict between capital and labour and
between the SPD and the bourgeois and nation-
alist parties and, above all, on the threat from the
growing Nazi movement.[13]

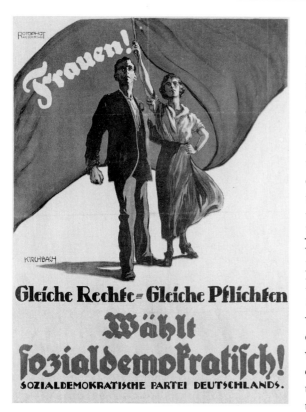

67 Gottfried Kirchbach, SPD election poster (*Women! Equal rights, equal duties: Vote for the Social Democratic Party*) (1924?)

With this shift in the focus of social democratic agitation the style of the posters changed. Designs conveying a positive, optimistic message continued, but several now used the cartoon style of the social democratic satirical magazines such as *Der Wahre Jakob*. Among the enemies of the Weimar democracy the social democratic poster now included the duped Communist worker, the representatives of the military or the Nazis, the Catholic Church and the Junkers, with the social democratic worker triumphant over all (Plate 68). More poignant and more salutary was Karl Geiss's famous poster, *The Worker in the Swastika State*, which urges a vote for the SPD to avert the dangers of fascism and shows the German worker bound on the contorted cross of the Swastika (Plate 69). It was a theme which John Heartfield was to take up two years later when he juxtaposed the rose-window of a church in southern Germany with a naked Christ bound on the spokes with the figure of a man similarly bound on the Nazi cross.[14]

In spite of the occasional use of symbols like the red banner, which forms a suitable background to Kirchbach's exhortative poster for the election to the Constituant Assembly or of posters using the image of the 'giant proletariat', the general tone of the socialist poster during most of the Weimar years was that of realistic pathos, and the men and women portrayed in them were assertive rather than aggressive. Even where the reference was to poverty and social injustice, the workers' suffering was shown in their demeanour not in their dress.

It is only at the very end of the Weimar Republic, when the threat from the Nazi forces had become almost overwhelming, that the SPD adopted a new propaganda technique. In response to the widespread use of the Swastika in Nazi propaganda, German social democracy used the symbol of three arrows (*Drei Pfeile*). The arrows were originally the emblem of the Eiserne Front, the 'Iron Bond' which had been established in December 1931 by the SPD, the Reichsbanner (defence

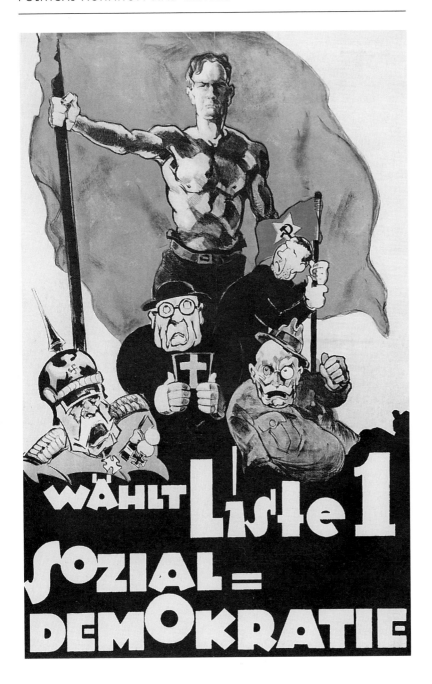

68 SPD election poster (1928)

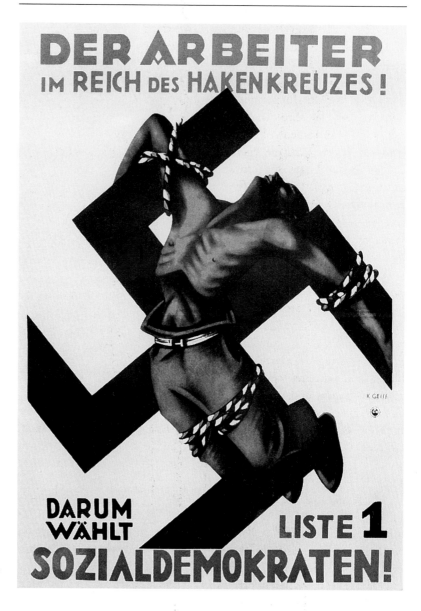

69 K. Geiss, SPD
election poster (*The
worker in the Swastika
State*) (1932)

league for social democrat organisations) and the Workers' Sport Organ-
isation with the express purpose of combating fascism.

The symbol of the Three Arrows represented the constituent organ-
isations, but also the physical aspects of the struggle against Nazism.
In the latter the arrows formed a visual *Leitmotif* or logo and were used
on the membership medals, on stickers to be used in correspondence
or stuck on buildings. The Three Arrows were widely used on leaflets,

handbills and posters of the two elections of 1932, the last free elections of the Weimar period.

They were on the one hand a symbol of the hoped-for but not fully realised organisational solidarity of the three sections of the social democratic movement. But they also served as spears in the struggle against the Swastika and all it stood for. The arrows were used in conjunction with the word *Freiheit* (Freedom), with which members of the three organisations greeted each other. *Freiheit* was written in large letters on hoardings, across posters and in other forms of communication.

The SPD's local *Wahlzeitungen*, the special election broadsheets, used the symbol in various forms. One paper carried a drawing of workers, clerks and civil servants, their arms raised in salute and held in parallel with the Three Arrows. During the election campaign printing blocks and patterns were sent to local parties and newspapers and used in a cartoon, which also incorporated the word *Freedom*. In another image, the arrows were directed at the miniature figures of Hitler and Chancellor von Papen, who was widely suspected of being willing to help Hitler to power, while a huge worker in the foreground lent further emphasis to the socialist strength (Plate 70).[15]

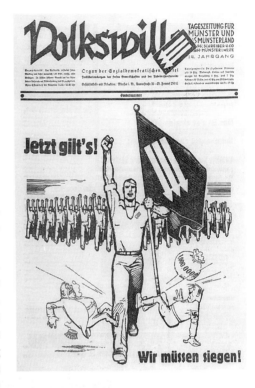

70 *Die drei Pfeile (The Three Arrows), illustration in Volkswille* (1932)

The symbol of the *Drei Pfeile*, with or without the slogan, seems to have been used more extensively than other SPD images. The arrows might be used simply as a tool, they might attack the Swastika, sweep away the fascist rubbish or be carried like a weapon. The arrows often carried the word *Liberty* and became a visual expression of a joint fight. Karl Mierendorf, then one of the youngest Reichstag Deputies, and others believed that the cement keeping the socialist movement together was symbolic and emotive and that ordinary people responded better to propaganda which was simple but strong. Alas, events overtook their ability to test their hypothesis.

In contrast to the generally mild and optimistic tone of the social democratic poster, the illustrations used in Communist agitation and propaganda tended right from the beginning to be more aggressive and more condemnatory. This followed the general political orientation of the Communist Party, which stood from the start on the

extreme left of the political spectrum. The Communist Party had its
origins in the Spartakus League, which was named after the leader of
the uprising in Rome.

Strongly influenced by the Russian October Revolution, Spartakus
had sought to bring about similar revolutionary changes in Germany.
Soviet influence extended even to poster design where the broad
outlines of Russian constructivist design can be traced and where some
designs were obviously imported or borrowed. Already one of the few
illustrated posters of the infancy of the Communist Party refers to its
revolutionary stance, albeit in a somewhat muted form. This poster
shows Karl Liebknecht pointing with his left arm to the socialist
Ministers – Ebert and Scheidemann can be recognised – who are
clearly fleeing before the demonstrating masses. With his right hand
he beckons the same masses to advance (Plate 71).[16]

Later Communist posters spoke an even more decisive and more
violent language, reflecting the growing acerbity of the inter-party
conflict and the fact that Communist agitation and propaganda were
based on a monolithic and centrally controlled party system. This
was in turn modelled on the Bolshevist principle of democratic cent-
ralism rather than the more dispersed system of political and organ-
isational control of the social democratic movement from which it
had sprung.[17]

71 KPD election
poster (1919)

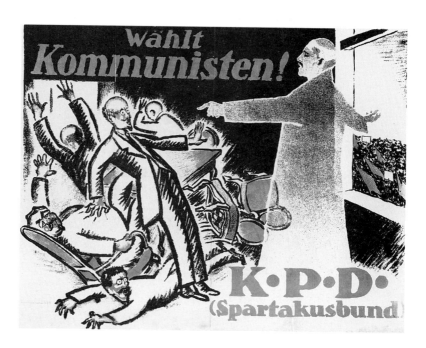

This centralised control applied also to the field of agitation and propaganda through the party's Agitprop Department, which was formally created in September 1923 but which became active only gradually. With it Communist agitational material, including posters and other visual material, began to show unique and often original artistic features. This system was supported after 1927 by the new central graphic studio of the party in the Berlin Karl Liebknecht Haus.[18]

The studio produced designs for illustrations in books and magazines as well as for posters and other propaganda material. The KPD also commissioned work from outside artists. Some of this was circulated to the Communist press in the form of printing blocks. The Agitprop Bureau, which was the party's central office in charge of agitation, also sought to encourage the local production of posters and handbills through the distribution of patterns which could be either retraced or copied manually. Such patterns could be new designs or well-known drawings, such as George Grosz's *Abrechnung folgt* (Day of Reckoning) (Plate 72).

This design was originally produced in 1922 for a cycle based on Schiller's *Die Räuber*. It was reused in different political contexts, and the clenched fist, as a symbol of defiance, probably served as the model for the Communist salute *Rotfront*, first used by the Red Fighters.[19] The design itself was by John Heartfield, who superimposed the picture of a clenched fist on a crowd scene (Plate 73).

The use of patterns for agitation was in no way restricted to works of art. On the contrary, the central office encouraged the use of

72 (George Grosz), Election drawing, using copy of Grosz's original drawing (see Plate 37)

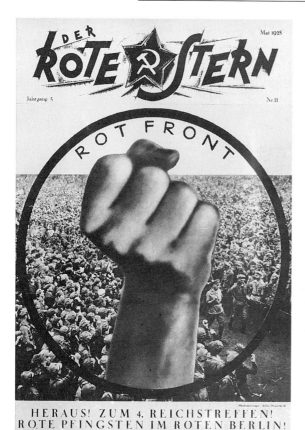

DER ROTE STERN

ROT FRONT

HERAUS! ZUM 4. REICHSTREFFEN!
ROTE PFINGSTEN IM ROTEN BERLIN!

73 Call to attend the national meeting of the Red Fighters, design by J. Heartfield, *Der Rote Stern* (1928)

quite simple designs and images to illustrate a point of view or attack opponents. Among the latter, the allegedly gullible social democratic worker figured increasingly often, and was shown up in Communist propaganda by ridicule rather than by direct attack. These attacks often used animals, such as the obtuse cow, the stupid sheep or the blinkered donkey to make their point. A contemporary assemblage of such patterns and motifs distributed by the party to local branches brings this out (Plate 74).[20] In general it was expected that such patterns would either be copied direct, possibly via stencils, or that they would be varied and adapted to local conditions.

The stereotypes of Communist agitation included, of course, the fat capitalist and other pillars of the state, sometimes shown as two-dimensional figures or cut-outs. The designs used in the campaigns were not confined to the drawing, whether poster, handbill or simply chalk on walls or pavements. With an inventiveness rarely found in the SPD, Communist propagandists made use of three-dimensional models, simple puppets and masks to caricature their opponents. But they also used positive caricatures, as in the more than life-size figure of Lenin. The visual agitation also produced more elaborate constructions. These included a soldier in a barbed-wire entanglement or a model of a bomber plane to symbolise the horrors of war. All of these would be carried aloft in demonstrations or displayed prominently at meetings (Plate 75).[21]

On a simpler level the KPD also advocated the use of cut-out figures with movable limbs, fashioned like string puppets. They were symbolically coloured – black for the capitalists' clothes, blue for their moneybags and grey for the fallen soldiers. If possible, the moving limbs of the figures would not only show contrast but they would demonstrate the dialectical relationships between the classes and groups which they represented (Plate 76).[22]

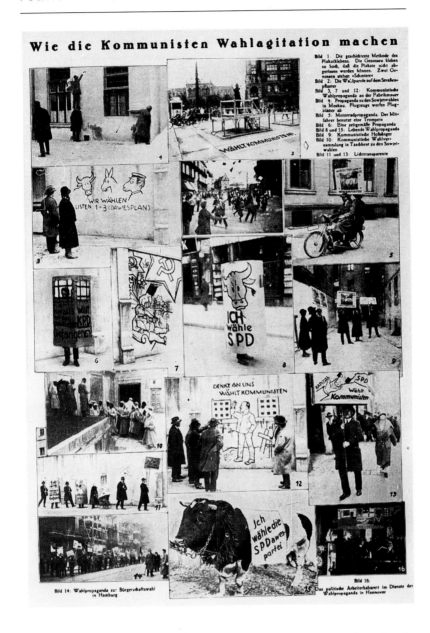

74 Examples of KPD election propaganda, photomontage (1924)

The imagery used in Communist agitation was strong but simple in its design, drawn with relatively few lines and 'not too futuristic'. The party actually urged that posters and other propaganda should not be too symbolic in character. Symbolism, we are told, did not appeal to the masses, hence the visual messages should conform to the 'needs and the comprehension of the masses'.[23]

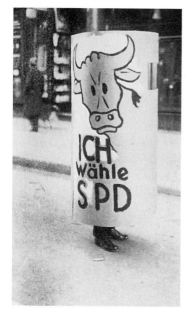

75 Communist placard (1928)

With the new, more centralised policy which relied on country-wide distribution of designs and warnings against using too sophisticated and allegorical illustrations, the party had rejected the use of original art in their propaganda and publicity in favour of the simple but more immediately effective caricature and sketches.[24] This development seems paradoxical in view of the fact that the KPD had for many years published in its magazines and even in its newspapers drawings or montages by well-known left-wing artists such as Grosz, Heartfield and Schlichter and that quite a few such illustrations were reproduced on posters or handbills.

Many such drawings were probably better known to the Communist worker than the name of the artist who produced them. The images were widely reproduced in the working-class press and on their hoardings. 'From innumerable hoardings they spoke to the masses in a language which sought to incite or arouse [and] to proclaim throughout the streets the revolutionary tasks of the proletariat.'[25]

We are here clearly concerned with a change of direction in the agitational policy of the KPD which proceeded in parallel with changes in its cultural policies. As we have seen, the KPD abandoned

76 Designs for string puppets (KPD) (1928)

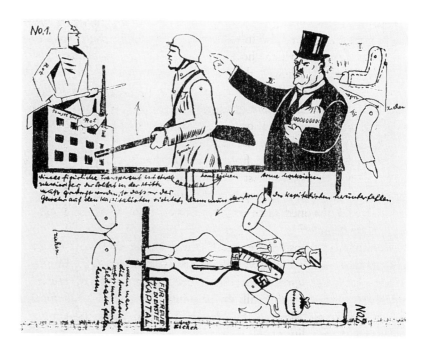

its old Common Front policy which had supported a joint front with the social democrats. It now used ASSO and the developing groups of worker photographers and worker illustrators who were to assist in creating a proletarian art as effective weapons in a cultural fighting front.

The underlying thinking which led to the foundation of organisations of worker practitioners in the visual arts was the belief that the specific experiences of proletarian existence, coupled with the use of Marxist dialectic to help interpret such experience, would create art which could be readily absorbed and easily understood by fellow workers.

Analogous to the mobilisation of worker-photographers active in the established media, the *Arbeiterzeichner* (amateur illustrators), many of whom were later to be organised in the Association of Revolutionary Visual Artists, were expected to play a leading role in political agitation. Admittedly, such amateurs would not be as skilful as professional graphic artists. Their drawings would be

more primitive and more childlike than the works of revolutionary professional artists, but by way of compensation we find that ordinary factory workers, untrained in drawing, were often more original in their work. They were often more independent, uninfluenced, unacademic and fresher in their approach. From a proletarian point of view their work was better agitation and better propaganda than drawings of professional artists.[26]

Similar considerations also influenced more professional propaganda. Some of the posters which the KPD issued for the last elections of the Republic also eschewed the sophisticated and more abstract in favour of a style which one might describe as populist if not folksy, and which concentrated more on depicting the enemies of the working class than on the aspirations of the workers themselves. Thus in an election which saw Heartfield's famous poster of an outstretched hand with the caption 'Five fingers has the hand, with five fingers you attack the enemy, vote list 5 Communist Party' and some other posters which sought to strengthen the convictions of the wavering, the KPD commissioned some eighteen posters from Viennese graphic artist Victor Slama.[27]

Although these posters are clearly the work of an accomplished artist, many of the figures have the simplicity, even crudeness of outline and action, of some of the home-made images stuck or painted on buildings, drawn with chalk on pavements or carried on placards in demonstrations. Many of Slama's designs also show the sinister character and stupidity of the enemy or predict his inevitable defeat.

In a double-take poster the loud-mouthed but duped social demo-
crat is shown as a cut-out figure on wheels who promises 'victory for
socialism via a coalition', while the muscular and hard-hitting Com-
munist worker drives a soldier, a capitalist and a cleric away with a
blow from his extended right arm (Plate 77). The symbolism of the
poster is enhanced by the colours. The representatives of both parties
are red but the red of the worker's arm and clothes is dirtied by work,
while the clean clothes of the social democrat indicate the party
official.[28]

Other Communist posters also made the iniquities of the SPD a
reason for voting Communist. In one poster a fist comes down on
the negotiating table around which representatives of government,
industry and of the social democratic trade unions are sitting. It aims
to highlight the futility of the negotiating policy. Another picture
shows a manacled hand reaching out of a prison-like building and
above it are the words 'betrayed by the SPD'.

The 'left-wing' election posters of the years between revolution
and advent of fascism used the image of a head or a full figure which
proclaimed the election slogan or the policy of the party. Only occa-
sionally did the poster illustrate real physical inter-party conflict. One
exception is when the 'giant proletariat' or red superman is shown in
Communist agitation against fascism confronting the representative of
the 'social fascist', social democracy. The giant also defends the Soviet

77 A. Malsov (Victor
Slama), Communist
election poster (1928)

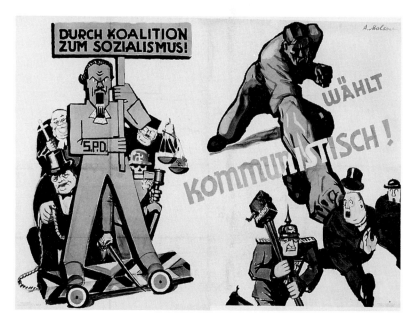

Union against its detractors and highlights the allegedly aggressive tendencies of the great powers against Russia. Likewise, in the case of the extreme Right, it draws attention to the threat of physical violence by the Nazis against 'Bolshies' and Jews.[29]

In general the left-wing propaganda displays a tendency towards simplified design and flat styles with firm outlines. This contrasts with postwar posters from the Conservative and Nationalist parties, which tended to hark back to the academic and the picturesque techniques which are consonant with the traditionalist policies of the parties. A poster from the Bavarian People's Party, issued in 1919 or 1920, showed

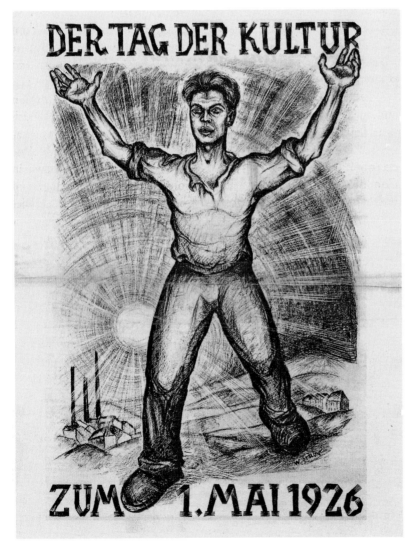

78 *Der Tag der Kultur* (The Day of Culture), SPD May Day poster (1926)

79 Invitation Card to
May Day Celebrations
in Dresden (1927)

a mounted knight in armour attended to by his wife
and children. He is obviously about to depart, to re-
spond to the call to 'Save the Fatherland' as the poster
proclaims.

Such differences in style and form also emerge if we
compare prewar May Day illustrations with those of the
Weimar period. The distinction is in part formal but
it is even more significant in respect of the intellectual
and the emotive character of the May Day illustrations
before 1914 and those of the Weimar years.

May Day illustrations before 1914 had addressed
themselves largely to the future, and the large, elaborate
and frequently allegorical drawings reflected the hopes
of the proletariat for a better future and a juster society,
for peace and progress. These illustrations, with opti-
mistic, sunny images, were expected to strengthen the
self-confidence of workers whose own beliefs, nurtured
by a progressivist Marxism, matched the tenor of the May Day
imagery.

But images avoided any reference to political violence as a way to
change society or reflect current ideological controversy. If anything the
tenor of the prewar May Day art was in line with the expectations
of August Bebel, the venerable leader of the SPD, who had spoken
for years of the imminence of the *Grosse Kladderadatsch*, the day of
the great sweep, when bourgeois society would collapse and the new
socialist society would arise, phoenix-like, from its ashes.[30]

Such almost utopian beliefs took a hard knock from the experience
of the war. The international Labour Movement had hoped to pre-
vent war breaking out, but its well-laid plans for a general strike in
the warring nations and for an international protest collapsed in the
reality of working-class patriotism. The leaders of the SPD, who had
been internationalists almost to a man, assisted the conduct of the
war by voting for war credits and by effectively abandoning the inter-
party struggle through the *Burgfriedenspolitik*, an agreement for civil
peace during the war years. This caused the virtual split of German
social democracy and with it a real split within the working class.[31]

The split became institutionalised in the form of two separate party
organisations, both with large popular followings and both affected
by the great upheaval which had taken place on the political, social
and international plane. The changed political structure and the
greater power of the 'post-revolutionary' German Labour Move-
ment were reflected in a new type of illustration for agitation and

celebration. These were now more
widely publicised throughout the media
and were used in special events, meet-
ings and demonstrations, especially if
the gatherings were devoted to partic-
ular issues, such as the move to dis-
possess the old ruling houses or the
fight against anti-abortion legislation.

The May Day art also reacted to the
new political situation – the eight-hour
day was no longer an issue – and this
is reflected in the policies of the two
major working-class parties, which
tended to organise separate celebra-
tions and demonstrations. Thus the
SPD often sought to present itself,
even in official 1 May broadsheets, as
a major pillar of the Weimar state,
believing that it would bring about
social improvements. On the cover
of the 1926 May Day broadsheet a
worker proclaims with a prophet-like
gesture that 1 May Day was a 'Day of
Culture' (Plate 78). On a postcard of
the period a stylised figure of a giant
worker symbolises the strength of the working class by making his
shoulders act as a bridge for the demonstrating masses (Plate 79). But
there were images of hope as well. In 1931, when Germany was
already deep in crisis, one May Day illustration shows a small group
marching underneath a huge banner in a wide and sunny landscape
(Plate 80). As a clear indication of hope for the future the caption
reads: 'There is light above their heads'.

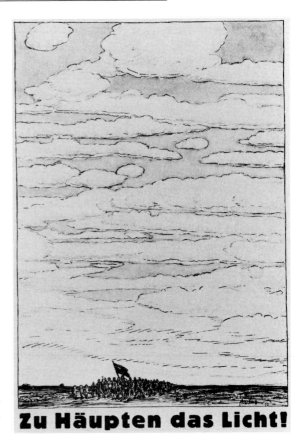

80 A. O. Hoffmann, *Zu Häupten das Licht!* (There is light above their heads!), *Volk und Zeit* (May Day 1931)

The Communists' May Day art and posters made greater use of
the symbolism of the struggle and of the serried ranks who fought
in it. A drawing by Grosz, reproduced in the *Rote Fahne* for May
Day 1929, shows an imprisoned worker who breaks his chains and,
Samson-like, shatters the columns of the house (Plate 81). The sun
shines in the background here as well, but with the sign of the ham-
mer and sickle inside it.

There is, however, evidence that towards the end of the Weimar
Republic, when a quarter of the labour force was out of work and
when fascism posed a growing threat to the democratic institutions,

81 George Grosz, *Dem siegreichen Mai entgegen* (Towards a Victorious May), *Rote Fahne* (May Day 1929)

the spirit of combativeness grew in the SPD as well. It brought about the rise of the paramilitary organisations for the defence of the Republic, the Reichsbanner and later the Eiserne Front. Their uniformed marchers, led by bands of fife and drum, also affected the character of May Day and presented the worker with new visual stimuli. At a Hamburg May Day demonstration, a participant recalled: 'We moved in closed ranks and we kept to a steady rhythm: One-Two, One-Two. Things were done on a big scale, with a march-past in the City Park. And all with military precision.'[32]

Images of closed ranks, of marching in step, were brought out not only in the actual events but also in the appeal of the pictorial record created in connection with such demonstrations. In 1931 the Hamburg Communist Party called for participation in a *Kampf Mai* – a 'fighting May Day'. The poster was presented with a highly stylised drawing of marching workers wearing hammer and sickle armbands. A 1930 May Day postcard conveys similar sentiment with a very similar design, appealing for a vigorous but disciplined demonstration on the day (Plate 82).

The message of these two designs is obvious. 'Join the ranks of the demonstration with your head held high and your face set to express your resolution to fight. Subordinate your person to the will of the formation. What better vision than that of the masses in uniform-type dress, displaying a fighting spirit.' In a wider sense the visual aspect of a demonstration becomes an independent image which impresses itself on participants and onlookers alike. The way the demonstrators move, their demeanour and their gestures, are clearly part of a body language between participants in the marching columns and the spectators.[33]

Already in the context of the pre-1914 May Day literature we find reference to armies, battalions, serried ranks of marchers and to *Parteisoldaten* (party soldiers). Yet the demeanour and behaviour of those who participated in the early May Day demonstrations or at other mass events was neither soldierly nor overtly aggressive. A poem in the 1899 May Day broadsheet might speak of the *Massentritt*, the

heavy step of the masses which threatened obstacles in its way and 'drowned the groaning of the defeated'. But the original socialist demonstration, unlike that of the Nazis, never sought to imitate military formations; it emphasised the solidarity of workers.

The general pacifist and anti-military sentiments to which early May Day illustrations had already alluded was strengthened by the experience of war itself. A change of attitude came about eventually because the parties of the Right, especially the Nazis, engaged from the beginning in paramilitary activities and glorified the spirit of militarism and extreme Nationalism. Even so, the pacifist sentiments of the Labour Movement remained strong. As late as in the 1930 election the Young Socialist Workers carried a placard contrasting young socialists in their casual dress, carrying hammers and other tools with Nazi Stormtroopers in military uniforms carrying sticks and truncheons.

The posters and the political prints reproduced and analysed here are inevitably a small fraction of a much larger total. They indicate certain traits in the political imagery of the Weimar Republic, but they could hardly be fully representative of the way in which the two major parties translated their ideologies and their current political aims into a visual language.

82 Communist (?) May Day postcard (1930)

NOTES

1 Posters with text only were already being used before 1914 but the election campaigns and other agitation relied mainly on leaflets, handbills and pamphlets.
2 O. Bauer, 'Das politische Gesicht der Strasse', *Das Plakat*, 10, 1 (1919), p. 75.
3 See *Das politische Plakat* (Berlin, 1919), p. 10.
4 For archive material relating to the Werbedienst and of the Reichszentrale für Heimatdienst, with which it amalgamated in the autumn of 1919, see Bundesarchiv Potsdam, Akten des Ministerium des Innern, 14200, ff. 78–9.
5 Bernhard Kellermann, 1870–1931; Paul Zech, 1881–1946. See also Zech's autobiographical novel *Deutschland, dein Tänzer ist der Tod* (Frankfurt, 1981).
6 H. Friedeberg, 'Das Künstlerplakat der Revolution', *Das Plakat* (1919), pp. 260–77 at p. 275. The experiment of commissioning expressionist posters came to an end in March 1919.
7 See *Die Zwanziger Jahre in München* (exhibition catalogue) (Munich, 1979), p. 254.

8 Unfortunately we know very little about the majority of the graphic artists who illustrated the working-class press. Only a minority are listed in Thieme/Becker, *Künstlerlexikon* (Leipzig), the major biographical dictionary for artists. Even if they are listed, the entries are usually very brief, indicating that they were not held to be important artists in traditional terms.

9 The poster is reproduced in *Politische Plakate der Weimarer Republik, 1918–1933* (exhibition catalogue) (Hessisches Landesmuseum, Darmstadt, 1980), no. 27.

10 Gottfried Fritz Kirchbach, 1888–1942. Principally a graphic artist and designer, also illustrated children's books and films.

11 See I. Spürk, 'Die Imagologie des Weiblichen: Symbolische und reale Frau in den Bildern der österreichischen Maifestschriften' in S. Riesenfelder (ed.), *Freiheitsbilder* (Graz, 1990), pp. 21–40; B. Leopold, 'Schwestern, zur Sonne, zur Freiheit . . . oder Was versprach der 1. Mai den Frauen' in I. Mariolek (ed.), *100 Jahre Zukunft: Zur Geschichte des 1. Mai* (Frankfurt, 1990), pp. 258–87.

12 The ambiguous role of the working-class wife and unmarried woman is reflected in a Russian poster dating probably from the time of the 1905 revolution. It shows two workers shaking hands over a fallen comrade. A woman stands slightly to a side, her arm is stretched out as in the representation of Liberty but the arm is shackled (copy in Revolution Museum in Moscow).

13 At the Reichstag election the Nazi vote increased from 0.9 million in 1928 to 6.4 million in 1930. With 107 deputies the party became the second strongest group in the parliament.

14 A reproduction of the photomontage is in *John Heartfield* (exhibition catalogue) (Berlin, 1991), pl. 101, p. 201.

15 Some documentation of the *Drei Pfeile* propaganda campaign is in the partial archive of the German Trade Union Federation (ADGB), 1919–33 in the Historische Kommission zu Berlin, Band 106B. See also C. Mierendorf and Tschachotin, *Grundlagen und Formen politischer Propaganda* (Magdeburg, 1930).

16 The poster was probably issued after Liebknecht's death.

17 The Communist Party grew in strength and popularity as the economic situation deteriorated, and in parts of Germany, notably in heavy industrial areas, it was for some years the principal working-class party.

18 The Central Graphic Studio was undoubtedly of great importance, but relevant contemporary documentation about its activities is now virtually unobtainable.

19 This Grosz drawing in particular was widely reproduced in magazines, and copies chalked on walls and pavements. This was also reflected in the captions. Apart from Schiller's text 'Das Recht ist beim Ueberwinder' (Right is with him who overcomes) and 'Abrechnung folgt' (the Day of Reckoning) from the collection with that title, we find it reproduced as a plate in Kanehl's *Steh auf, Prolet* (Arise ye workers) and as 'Über die Gräber des März' (Over the tombs of the defenders of the Republic), referring to the fighters against the Kapp Putsch.

20 For an interesting and very full assemblage of Communist pattern and amateur drawings see W. Grape, *Aufruf und Anklage: Kunst für die Bremer Arbeiterbewegung* (exhibition catalogue) (Bremen, 1983).

21 See Bremen, Staatsarchiv, 4.65 Bd. 244, f. 1501.

22 The cut-outs were life-size and they were carried about in demonstrations. It is not clear how the various parts were activated.

23 Especially good were the illustrations and models produced for the plebiscite on the *Fürstenabfindung*, the proposal to strip the former Royal and Ducal Houses of their property in return for compensation payment, held in 1926. The referendum was supported by SPD, KPD and the trade unions as well as by a group of liberal-thinking individuals. Cf. Zentrales Partei Archiv T 2/8/13.

24 Zentrales Partei Archiv 1/2/11, Lecture by Ernst Schneller, head of the Agitprop
 Department of the KPD at 1928 conference of the Central Committee.
25 One example is a drawing by Rudolf Schlichter entitled *Mutter* (Mother), refer-
 ring to a dead woman, killed in the fighting, whom a soldier recognises as his
 mother. It was published in *Der Knüppel* and also as a postcard and as a large
 poster. See also Gertrud Alexander, 'Rudolf Schlichter', *Hammer & Sichel* (1924).
26 'Durus', 'Grafik in Betriebzeitungen', *Rote Fahne* (8 October 1930). The work-
 place broadsheets were of particular importance as during the last years of the
 Republic the KPD sought not only to found an oppositional trade union organ-
 isation, the RGO (Rote Gewerkshafts Opposition), but to shift the basis of its
 organisation to the workplace rather than the dwelling place.
27 Victor Slama, who generally drew under the pseudonym Malsov, was an Austrian
 graphic artist with socialist sympathies, who drew political posters as well as
 commercial publicity material. Why the SPD commissioned him to design such
 a large number of posters I have so far not been able to establish.
28 For examples of posters threatening violence see reproductions 66, 103, 109 and
 111 in *Politische Plakate*.
29 See *Politische Plakate*, no. 173 issued in 1919 or 1920 under the heading *Rettet
 die Heimat* (Save the Fatherland).
30 For Bebel see Brigitte Seebacher-Brandt, *Bebel Künder und Kärrner im Kaiserreich*
 (Berlin and Bonn, 1988).
31 Co-operation between the two parties was more common at the local level than
 the national situation suggests.
32 See *'Vorwärts und Nicht Vergessen': Arbeiterkultur in Hamburg um 1930* (exhibi-
 tion catalogue) (Hamburg, 1982).
33 The semiotic significance of demonstrations and marches has recently been dealt
 with in a series of studies by members of the University of Tübingen Institut
 für Empirische Sozialforschung.

10 Art and ideology

The previous chapters dealt with the relationship between visual art and political ideas and the relevant leisure-time pursuits of the German working class. This chapter takes events from the beginning of the political and industrial mass organisation of the German working class to its violent demise at the hands of the Nazis.

The art discussed included a wide range of works, mostly German and mainly modern, presented in all kinds of media. Works of art appeared as plates and reproductions in articles, as individual prints and through other media. They reached their public through the workers' press, through journals and magazines, books and other publications. Equally important was the area of agitational and propagandist art which was produced, displayed and distributed by the two working-class political parties (SPD and KPD) and by other political organisations. These took on greater significance in the years of growing conflict at the end of the Weimar Republic.

These 'public' political images were either selected from the volume of existing art or commissioned specially. They were widely circulated in the form of posters, handbills or leaflets. The system also incorporated major political symbols and visual allegories which, as in the series of May Day broadsheets, are of particular interest. A large number of political posters and other ideologically significant icons were published during the years of the Weimar Republic and, although much was destroyed by the Nazi government or lost in the war, enough survived to enable us to draw fairly reliable conclusions about the art and imagery which many German workers saw and about the influence which these may have had on their general and political attitudes.

This concluding chapter will deal with some aspects of general and of political and socially critical art and imagery in its broader aesthetic and didactic framework. To assess its significance we must look at it with reference to the social and the ideological development of the German Labour Movement and its expanding cultural institutions, and the educational and cultural role of visual art as it might influence individual taste and the art of the workers' movement.

The visual arts were a relatively new element in the growing field of workers' cultural interests. They brought new and 'progressive' ideas to the shaping of the domestic environment of the working-class home. This was part of a move to widen the aesthetic experience of individual workers, it also revealed the conservative taste of most workers.

The growing range of activities in the visual arts was linked to the expansion of the Labour Movement after the November revolution. The new state, with its liberal constitution, made possible the expansion of the working-class press and other media, and these carried illustrations as examples of visual art, able to educate or to arouse interest in things visual.

We can link this assessment of the role of the visual arts to the general belief in the emancipatory role of culture whose beginnings we traced back to the early days of the Labour Movement. After the revolution the range of cultural activities of the German working class grew in size and in sophistication. With it went a growing belief in the importance of culture and of the arts. In parallel with this went the identification of sizeable sections of the Labour Movement with institutions of the Weimar state and its democratic system. The use of visual art to convey political messages and engage in agitation is part of the wider field of educational and cultural activities which emerged with the growth of the German Labour Movement and above all of the SPD.

The establishment of workers' cultural societies did not start *tabula rasa*. Earlier proletarian customs and traditions, dating possibly from the pre-industrial milieu, were absorbed in the new politically oriented working class and the working-class cultural organisations which developed in the new Germany. As the historian Gerhard Ritter wrote nearly twenty years ago, 'the identification of workers' culture with the culture of the socialist workers' organisations . . . obscured many central features of workers' lives'.[1]

The economic and social changes which took place in Germany after the foundation of the Empire in 1871 also influenced the character of the Labour Movement and its cultural activities. The industrial expansion and technological changes led to an increase in the white-collar sector and a growth in public services. This expansion was reflected in the changing social character of the Labour Movement. The membership of the SPD became more middle-class, and the white-collar trade unions grew in size and influence.

As the membership of the SPD widened, a growing section of the party began to say that the institution was on the way to becoming

a *Volkspartei*, a people's party. Many members welcomed this development and wished to see it embodied in the programme of the SPD.[2] But this would have meant rejecting the time-honoured idea of the SPD being essentially a party of the working class, and the majority of members did not accept that. At the same time the SPD did not attempt to assimilate the new strata culturally; it set out to absorb a middle-class culture appropriate to a 'people's party'. Its attitude towards the new state, however, became more positive and the rhetoric of class struggle became more restrained, although it did not disappear.[3]

These changes, often referred to as the 'embourgeoisement' of the workers' party, also in some way affected the role of the visual arts and the workers' choice and taste in art. The revolution had improved the workers' social and economic status and given them greater cultural freedom of choice. Workers' cultural associations in music and the dramatic arts experimented with texts which were more politically meaningful. At the same time, the achievements of workers' cultural organisations, and in particular the high standard of many theatrical and musical performances and other events, were seen as signs that workers and their organisations were now becoming socially acknowledged and institutionally integrated. Within the movement itself this on-going incorporation of the working-class institutions into the new state was far from fully accepted, and such divisions in the party are reflected in the ambivalent attitude of the working class towards the visual arts. The views and feelings cannot be quantified; we can only indicate trends and attempt an evaluation, as for art exhibitions and of the coverage of art and artists in magazines and journals and by working-class organisations.

To satisfy the demand for pictures for the home and for public places, the Amalgamated Printing Unions, for example, set up an enterprise to print reproductions of works of art, mainly copies of older, politically neutral art. Works by Menzel, Cézanne and Spitzweg were among those reproduced. None of the themes related to the industrial or political struggle of the working class, although the enterprise claimed that the display of such art was, indeed, part of the emancipatory advance of the working class.[4]

Similar advice and aesthetic judgements were offered to the readers of the *Proletarische Jugend*, the journal of the youth movement of the Independent Social Democrats, who otherwise followed a more radical political course. They were urged to look at and enjoy art books and peruse portfolios. Artists mentioned included some masters of Romantic art like Richter, Schwind and Thoma and some more contemporary

painters like Liebermann or Klinger. The tenor of the advice was again in favour of the pursuit of the culture of the past and, above all, the pursuit of beauty in all things. 'There was so much beauty that it made the heart ache.'[5]

But the visual arts were rarely at the centre of the workers' cultural movements. The fostering of visual art lacked both an institutional framework and the kind of membership organisation which existed in other traditional workers' culture movements. Attempts to develop artistic skills, or to train workers in one of the visual arts could not build on traditions within the proletarian milieu or on any specific link between manual workers and painting, sculpture or other fields of arts or crafts. Discounting the limited field of prints produced specially for the working-class home (discussed in Chapter 1), there was little tradition of visual art in the German working-class milieu. There was also no tradition of viewing art in museums and galleries.

Above all, the national system of elementary education did little to develop and foster an aesthetic feeling, let alone traditional artistic skills. The German system of public education, dating back to the years after the defeat of Napoleon, served the needs of industry and the army well but it did not aim to enrich the emotional life of successive generations of children. In the view of some contemporary observers this restriction was justified because ability to understand great artistic achievement was related to the background of the observer. Members of the lower classes could not be expected to understand the relative grandeur and sophistication of some types of art. The working class could appreciate only simpler and popular works, not masterpieces or grand monuments.[6]

Attempts to improve the aesthetic sensibility of the German worker can, however, be traced in other fields. At the beginning of the twentieth century a group of younger architects and others influenced by the British Arts and Crafts Movement formed the Deutsche Werkbund. Some of its leading members were anxious to improve the design of German products and thus make them more competitive abroad. Those concerned, including the publicists and politicians Hermann Muthesius and Friedrich Naumann, also expected that such practices would bring about greater industrial harmony, in that the workers would derive more satisfaction from their work if the objects they produced were more attractive. This meant that productivity would rise and with it wages, and hence the industrial climate would improve.

German workers, hardly surprisingly, did not respond to this attempt to bring about industrial peace, and later attempts in this direction by

the progressive designers and social reformers in the Werkbund were equally fruitless. They were not inclined to give up the industrial struggle merely in exchange for more satisfying work, a more beautiful product and a more attractive industrial environment.[7]

Paradoxically, the aesthetic ideas of the Werkbund and its basic thinking about design for housing, furniture and furnishing was also advocated by the Labour Movement, in particular by the SPD and its affiliated organisations. The concept of *Wohnkultur*, the character of the interior of the home and the quality of design in it, were valued among the theorists of the socialist working class. Hence agitation in favour of a new style of living was a serious aim. In the words of *Vorwärts* in 1927, '*Wohnkultur* was an important part of the workers' culture as such'.[8]

The ideas of the Werkbund and others were to a large extent directed against the Kitsch so often found in the working-class home and against all that was over-elaborate, over-ornate and non-functional in furniture and utensils, as well as pictures, prints, furnishings and other decorations. Examples of simply designed alternative objects featured prominently in the very popular Christmas fairs which the SPD and the Unions put on each year to help workers choose presents. In addition trade unions, consumer co-operatives and other organisations put on exhibitions of modern and functional furniture. The case for functionalist design would thus reach a broad section of the working class, most of whom would not have been persuaded by written accounts of the new trends.

The reasoning behind functionalism was painted with a broad brush. The argument ranged from favouring the simple, the functional and the anti-philistine on the one hand to showy and ostentatious bourgeois taste on the other. Such views would be strengthened by a belief in the force of a unique, proletarian lifestyle, of which 'history would be able to say that [items of furniture] were documents [which demonstrated] the view of life and energy of the proletariat which had found its own way'.[9]

In more concrete terms, simple forms, plain strong colours and the need for practicality were all thought to be in line with proletarian lifestyle and demands for economy of effort. 'The masses are yearning for colour. The greater the workers' pride, the stronger their desire to find their own lifestyle. And where the environment is drab, strong and lively colours will give a cheerful atmosphere to the dwelling.'[10] Functionalist style in the home and simple furnishings and decorations were not simply an assertion of independence. The innovators based their argument also on the purity, clarity and sobriety which

matched their idea of the workers' role in the world and the scientific character of its Marxist ideology.

This, in effect, amounted to an architectural and sociological argument in favour of functionalist aesthetics in the working-class home, and agitation for these styles and ideas in the workers' dwelling was extended throughout the proletariat. But its effects were limited, the adoption of new fashions hampered both by the workers' lack of funds and by the traditionalism of large numbers of workers. Many working-class people felt that the simplicity of functionalist design reminded them of the poverty which they were anxious to put behind them.

In other ways, the revolution had opened the sluice-gates for a flood of art which had been held back by the harshness of war and by a frequently hostile society thereafter. Much of it consisted of graphic art, a relatively cheap technique which could now reach a large public. Artists produced all manner of prints in single sheets as well as in cycles and they also distributed portfolios of prints. Many of the designs criticised the old society or expressed the hope of a new and better way of life.

Some prints had already appeared during the war. Karl Schmidt-Rottluff had produced a series of woodcuts on the life of Christ. One plate portrays Christ, with the date 1918 on His forehead and with the caption 'Did Christ not appear to you' (Plate 83). After November 1918 many single prints or cycles used the revolution as their theme, but the artists treated the subject of revolt, struggle and peace in terms of general human emotions, suffering and triumphs rather than in terms of contemporary politics, let alone as a blueprint for the future. In the event, these examples of modern and mostly expressionist art met with little positive response among workers.

In other areas the link between class and arts was stronger. Some established artists felt their affinity with the proletariat particularly strongly and co-operated in political agitation. One of these was Conrad Felixmüller, a painter with a working-class background who held strongly left-wing and anarchist views, which were often reflected in his work. He portrayed workers

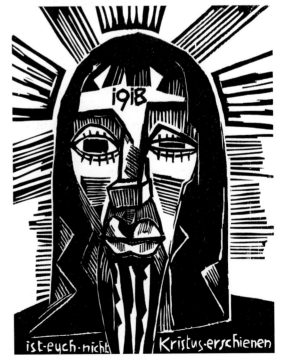

83 K. Schmidt-Rottluff, *Kristus* (Christ), woodcut (1918)

in their industrial environment in prints which commemorated major events in the history of the working class, such as the sailors' revolt in Kiel in 1917 or the murder of Liebknecht and Luxemburg in January 1919. In a 1920 lithograph entitled *Comrades* Felixmüller shows two workers in mourning black, their hands solemnly clasped as if in a silent oath (Plate 84). Placing the scene in a cemetery and giving the print the caption 'ein Matrose gewesen' (once been a naval rating), Felixmüller recalls the revolutionary spirit which had shown itself in the naval mutiny three years earlier. Other artists, too, gave expression to their solidarity with the working class through such paintings and prints.[11]

Felixmüller described his solidarity with the proletariat in a thinly disguised piece of autobiography under the name of Poennecke, which he published in the left-wing monthly *Die Aktion*.

Poennecke saw the bent workers of the whole world in a struggle for their existence, saw the masses as cannon fodder . . . he realised that he had been a traitor and rebelled. He distanced himself from those at the top . . . and henceforth he worked on his canvass, his fanatical vision of man suffering, peace, war and fraternity. His paintings should accuse as well as liberate. He was opposed to the war and, as a proletarian who had woken up to his situation he suffered for his belief. The revolution drove Poennecke on to the street: he demonstrated, agitated and distributed leaflets. As one of the restless multitude he pressed forwards in the heat of the revolutionary fervour.[12]

84 F. Felixmüller, *Genossen* (Comrades), lithograph (1920)

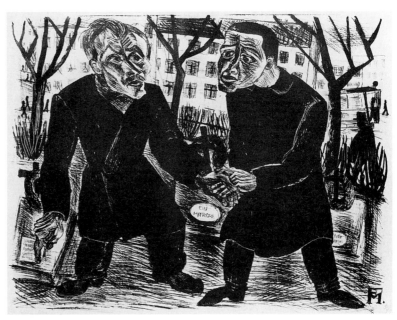

Felixmüller was one of a comparatively small number of radical artists who in the immediate post-revolutionary period took an active part in political agitation and tried to persuade fellow artists to join. But they had little success. At the same time attempts to organise working-class support for expressionist and other radical art occurred only in a few places where artists had organised themselves for the purpose and where the Left had strong influence on the workers. Such was the case in Dresden, a centre of avant-garde work, and in Munich's Räte Republik where the government controlled art and used the press to publish drawings which expressed revolutionary sentiments.

A limited number of intellectuals in the parties and organisations of the Left had some links with and understanding for the ideas and practices of the avant-garde, but the great majority of the organised workers – not to mention the unorganised ones – had very little understanding of the theory or the practice of Expressionism or most other new art forms. They could not 'read' works in these admittedly difficult styles, or any other which were not sufficiently realistic to be comprehended in terms of their customary surroundings and experience. The art of working-class hobby painters or of workers who trained in the Marxist Worker Schools tended, with few exceptions, to be conventional and naturalistic.

Even the Novembergruppe, set up as a radical organisation, soon abandoned these ideas and concentrated on exhibitions, although convinced radical artist members protested strongly against the decision. In the 'Open Letter' of the Opposition in the Novembergruppe the group confirmed its continuing support for the aims of the revolution. Members regarded themselves as 'fighters at the side of the labouring masses' and rejected the idea of a so-called revolutionary aesthetics as a means of cultural advance and of the liberation of humankind. In their view the aim and essence of an artistic existence was to be 'an instrument of the slumbering hope of the masses for a pure and unpoisoned life'.[13]

Some radical artists who were also members of left-wing political organisations were not content with merely expressing solidarity with the working class. They sought to link political commitment with the development and propagation of a corresponding style. George Grosz and his friends (Heartfield, his brother Herzfelde and others) argued that the political struggle always had preference over the artistic and he urged the need to adopt a factual, unemotional style of painting. Grosz likened the artist to a technical draughtsman whose pencil recorded reality unemotionally and accurately.[14]

In Cologne Franz Seiwert and other painters who called themselves 'political constructivists' went even further in their attempt to create a new form of communication between the politically committed artists and the workers. Seiwert created a unique new style of art, a quasi-social iconography, using mainly linocuts and woodcuts. These were often used as a cheaper alternative to printing blocks for the syndicalist and anarchist political groups to which he belonged.[15]

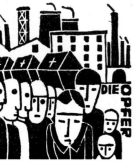

85 F. W. Seiwert, *Die Opfer* (The Victims), linocut (1920)

Seiwert depicted men and women in virtually all his work purely as stereotyped outline figures, for example in *Die Opfer* (The Victims) (Plate 85). His figures, whether of individuals or of groups, expressed their economic position and their place in society by their attributes of their occupation – a collier with pickaxe and miner's lamp, a banker with money-bags and so on. So formal were his representations that, according to another member of the group, individual figures might as well be produced through stencils. Seiwert assumed that his comrades and the majority of workers would recognise themselves in these stereotype figures and accept them as a direct though conceptualised interpretation of social reality. With the help of such stereotypes they would be encouraged to understand social conflict and working-class oppression better and gain more insight into the inevitable course of social revolution.

The political constructivists wished 'their art to help tear down the structure of the old society'. They added: 'It is propaganda, aimed to illuminate social contradictions, illustrate social possibilities and not simply criticise them from a moralistic point of view. We want to analyse society, to expose how it functions.'[16]

But there is little evidence that this approach to education and agitation was successful among the radical workers in the Rhineland to whom it was addressed. It is more likely that they were put off by works which were stripped of all reality and depended upon the purity of forms. Ideological concepts and basic political ideas could nevertheless be presented through the medium of paint or print. Thus we find in the period of the Weimar Republic, and even in the decades before, examples of art which took its impetus and its message from the ideology and the policies of the socialist movement. Such art was not just social reportage – like the *Elendsmalerei* of the nineteenth century – but it served to illuminate the underlying social antagonism and basic dichotomy in German society and the suffering and cruelty which resulted from it. These themes attracted some of the leading radical artists of the period.

These designs were realistic, at times even exaggeratedly so, as seen in the satirical magazines. The cartoon was perhaps the most

appropriate medium for illustrating the basic economic and social differences.[17] The pen or the burin were the favourite tools to add vitriol to the natural bitterness of the caricature. The art of Grosz offers a number of works which make their impact through the principle of the juxtaposition of opposites. This is seen in a double exposure drawing of a capitalist and a general, both heavily armed, driving into battle, while in the sketch below blindfolded soldiers are dragged to execution.[18]

Hans Baluschek is said to have referred to such art and to the public art of the Labour Movement as *Gemalter Marxismus*, Marxism expressed in colours. This is surely an exaggeration. The use of social contrast as a didactic weapon in art may become a mere record of social conditions. Using the basic contrast between 'above' and 'below', artists like F. M. Jansen might satirise injustices in the distribution of wealth or power through a sectional drawing of a building or mine (Plate 86). Gerd Arntz, in particular, 'translated' social statistics into a visual framework. In the series of *Twelve Houses* he drew the distribution of power and wealth through the example of a mine. More dynamic were cartoons or designs which refer to causal or historical connections between different events or social processes, for example by linking pictorially the low and falling living standards of workers and the rising dividends accruing to the rich, and the debauchery to which this leads.

The Marxist approach to the visual arts, as to all art, was very clearly ideologically defined. The place of art in proletarian culture, and in its political, educational and agitational activities, had to be judged in terms of drawing on the experience of the working class. It was used to encourage the revolutionary struggle and hence art had to embody 'the highest thinking and the deepest truth accessible to the period'. Art was considered to be great only if it transcended the material limitations and oppression

86 F. M. Jansen, *Das Grossstadthaus* (The City Dwelling), woodcut (1920)

under which it laboured in bourgeois society and absorbed the truth of the proletarian struggle.

Only when the work of art incorporates the proletarian 'tendency' can it be a true work of art, great and truly significant. The potential contribution of works of art was to be evaluated in terms of their being understood by the proletariat and of their contribution to the revolutionary struggle through their work. The artist need not be ashamed of producing art with the right philosophy. On the contrary, only by expressing in his work the most significant experiences and desires of his class, and by having the courage to present the proletarian tendency, will he create a truly great work of art.[19]

The individual image had to convey a clear political message which would encourage the workers' self-respect and draw them to the Communist movement. On a long-term basis for the KPD the role of visual art was to create a wider proletarian culture and to ensure that the highly visible art influenced the less committed and knowledgeable worker. The instruction of some workers in drawing (through the MASCH), and attempts to encourage *Arbeiter Zeichner* and working-class photographers to use their skills for the production of politically meaningful pictures, indicate the importance attached to amateur agitational and ideological art. This was conceived in strictly functional terms, but some past developments suggest that these might have led to more independent artistic development.[20]

Equally illustrative of the attitudes to art, and of the way it reached a working-class audience, are the reviews of art exhibitions, especially those by and for workers and backed by working-class organisations. Looking at the way in which contempory art is seen by workers across the political divide allows us to adduce in a concrete way the discussion of these theories. Käthe Kollwitz, one of the leading artists of her time and one who dedicated her work to the service of the working class, is worth looking at.

Throughout her life Kollwitz depicted 'suffering humanity' in her prints and drawings. Her work, reproduced in working-class publications of virtually all shades of political opinion, illustrated the problems of working-class life, including hunger, illness and the burden of childbearing. Other Kollwitz pictures looked at the horrors of war and the joys of peace.

But Kollwitz's virtues and her all-embracing humanity were also a focus for criticism and a reason for attack. Given the depth of Kollwitz's emotional involvement with the fate of the poor and her wish to be of use in those days when people needed so much help and advice, her critics averred that she could record the reality but

not the conclusions of her insight. Neither could she show how the evils can be attacked. In Durus's view, 'Käthe Kollwitz is the artist of the reformist workers who have not got the strength to find a way out of the mire'.[21] Kollwitz's work provides a good example of inter-play between art and ideology. The artist herself felt at times torn in her loyalties between the social democrats and Communists, and later both parties claimed her.[22]

In the Weimar years the attitude to the visual arts of the pro-revolutionary parties of the extreme Left was more radical and more circumscribed than that of the great majority of the socialist working class. Given the monolithic character of the Communist Party and the almost total commitment which it expected from its members, this is hardly surprising. Political agitation and the political struggle domi-nated the commitment of the members, and political topics were cen-tral in the books and other literature and imagery issued by the KPD.

This emphasis on the party political and agitational aspect of Com-munist art meant less concern with aesthetic and technical accom-plishments. The 'correct' interpretation of events and policies meant that the works of ideologically trained amateurs could be just as relevant as that of trained artists. Indeed, some critics, above all 'Durus', saw in this 'the beginning of a new art of the broad masses, the *Volkskunst* of the revolutionary proletariat'.[23]

By contrast with the KPD, the character of the visual art and of the relevant cultural practices which affected the lives of the major-ity of the working class, was less political, and the selection of works for reproduction in the various media or in posters was more catholic.

This was related to wider social developments which influenced German workers. Significant sections, principally in the ranks of the SPD, now believed that the economic and political struggle of the working class was gradually being won. The party could now pay more attention to one of its original aims, the intellectual and cul-tural emancipation of the working class. Culture should henceforth form a third, independent, column of the socialist edifice in addition to the political and the economic. We can see how the ideologies of the two parties gave rise to different art and visual symbolic if we look at certain rituals.

The *Jugendweihe*, conceived as a socialist parallel of the Christian confirmation, was one such ceremony. The two political parties approached the event in different ways. For Communists the cere-mony was to emphasise that the youngsters were now joining their older comrades in the world of work and in the revolutionary struggle of the proletariat. They should therefore appear in workaday clothes.

The SPD, on the other hand, celebrated the boy's and girl's entry into the world of the adults and their becoming ready to accept civic responsibilities. It was appropriate to wear 'best' clothes to mark the solemnity of the occasion. Similar differences appear in the books which the celebrants were given. Books presented by Communist organisations contain more political illustrations than those of the SPD.

The social democratic policies probably reflected a greater emphasis on respectability by a section of the working class which had experienced a certain embourgoisement. The new perception by some socialists of the place and role of the SPD led to new thinking about the nature of socialism and the importance of culture in shaping socialist policy. This intellectual stand became known as *Kultursozialismus* – cultural socialism. As we have seen, this new trend in socialist thinking was also influenced by the general movement towards new lifestyles and initiatives in communal living.

Young socialist workers, in particular, aimed to use culture and the arts for a fuller and richer life. The young worker, who was interested in visual art, would be taught to appreciate an individual work, experience its impact, appreciate its quality, enjoy it and hang a reproduction over his or her bed.

In a wider social context visual art was seen by some socialists to have also a more all-embracing function. Looked at in terms of the lifestyle of the individual worker, cultural pursuit should go hand in hand with political activities. The aim of 'cultural socialism' was nothing less than a genuine concern with enhancing workers' status in society, improving their material conditions and providing them with cultural activities which would rouse them from being 'mere workers'.[24]

'Cultural socialism' hoped to make workers aesthetically sensitive through familiarity with visual arts, but there was no formal organisational framework where this could take place, and where works of art could be discussed. The ultimate aim of the workers' cultural movement would be the 'creation of a line of strong and mature men and women [*Vollmenschen*] who would be conscious of their political and social obligations', but they would also 'search indefatigably for beauty however hidden'.

This approach to a change in the character of the German socialist worker could not have operated extensively and easily. One proposal for making visual art a basic part of the leisure-time life of members was to revive the *Volkskunst* (folk art) which was still practised here and there in the country and which would be relatively easily understood throughout the working class.[25] Handicrafts would also help to encourage communal activities in the same way as the

community of craftsmen had done in the Middle Ages.[26] Valtin Hartig argued that the creative instincts of the proletariat tended to be stifled by their poor material conditions, but with improving economic well-being, an interest in creative skills was bound to develop.

The expansion analysed in this book of visual art throughout the German working class and in its cultural institutions does not fully support the claim quoted at the very beginning of the book that it was the Cinderella among the cultural subjects pursued in the Weimar period.

The impact of visual art on the working class before 1914 was rather limited in scope. It was restricted in use to a small number of media and subject to strict control by the Wilhelmine state. Of the art which reached the workers during that period the series of May Day broadsheets, the *Mai Zeitungen*, were artistically more splendid and politically most important.

Compared with other activities in the wide field of *Arbeiter Kultur* and especially with mass organisations for workers' sport and workers' music, which catered for the leisure-time interests of the proletarian family, visual art remained a minority interest. At the same time, in the new freer economic and political climate after the war there was a greater volume of visual communication in the world of the media, including the film, in advertising and in posters. The images used in these communications are bound to have made an impact in the ranks of the working class. The growth of photography as a hobby also provided visual stimulation and, significantly, there was the expanding medium of the workers' press. The two illustrated magazines, *AIZ* and *Volk und Zeit*, which addressed themselves to the working class, jointly reached a circulation of well over half a million copies.

After 1918 a variety of works of art reached individual workers and their families via the growing number of periodicals and other publications issued by organisations of the Labour Movement. Only a minority of this material was concerned mainly with culture or the arts, but many magazines, including trade union journals, now carried illustrations, original drawings or copies of works of art. Much of this art was selected for the enjoyment of readers, but some articles and reviews of exhibitions aimed at their education and political persuasion. Opposition to some contemporary art was generally related to style but there was also some protest against designs which were regarded as too condemnatory or defamatory.

In spite of much effort to influence the taste of the great mass of the working class, it remained largely conservative and in favour of the realistic and the uncontroversial. The workers' difficulties in under-

standing political and, even more, symbolic art extended to dialectic art. The Central Committee of the KPD became aware of this and resolved to publish fewer prints of that kind.[27]

Considered from an ideological point of view, however, the choice of visual art material to be used for the workers presents a more varied and a more interesting picture. We observed earlier the way the political split within the working class was reflected in the selection of art and its use for the persuasion and agitation. The Social Democratic Party aimed to educate and to make the worker receptive to the emotional message of art. It selected from the great store of available art the beautiful works and those of high merit.

Social and political art was equally important but, according to the organisers of the 1924 Leipzig Exhibition, it was as much a 'Tableaux Mores' as a collection of evocative and protest art. The extreme Left took on the role of conveying damning critique (of the order of things) and strong protest. The Communist Party made use only of art which was created in the spirit of Marxist dialectic and would be understood as such by the public.

After the war, the cohesiveness of political aims and their visual representation came largely to an end. At the same time the failure of the left-wing movements to establish concrete links with the ideas and practices of the avant-garde was most significant. It destroyed the chance of widening artistic skills and diminished potential support from these groups.

This failure was probably connected with the general 'immobilism' of both the SPD and the KPD in the face of the fascist threat, which prevented them from co-operating with each other, and also from co-operating more fully with the liberal middle class. The two main political parties of the Left wasted some opportunities through polarising the use of visual art, for presenting their own ideals while reflecting their own animosity towards each other. The Communists were particularly given to use art to express their disapproval of the SPD, whom they considered to be lackeys of the bourgeoisie.

Visual arts have great power of persuasion. In spite of the vituperative poster-warfare between the parties, the artistic value of the art created by many politically engaged artists stood the test of time. They filled many roles. They presented crucial political issues of the time and dealt with them critically. They commented on social conditions, attempted to educate and to stimulate the workers' understanding of art so that they could enjoy some of it in their homes and in their daily lives.

The expanding communications industries unleashed a growing volume of images; some of these were of artistic value. Older cultural institutions of the working class and more recent developments in the field of workers' culture spread the knowledge of art and encouraged familiarity with it. The potential of visual art to influence the working class politically was recognised by the Nazis when they came to power. They condemned much of it as 'Entartete Kunst' (Degenerate Art), seized many examples and destroyed them.

Nowadays, the art discussed in this book is not only a reflection of the culture of the Weimar years in Germany but it is acknowledged as significant art in its own right. During those years only a comparatively small number of workers were interested in visual art. Nevertheless, it helped to mobilise and strengthen political beliefs, stimulate the workers' self-confidence and feelings of solidarity to their class. It also gave them new hope for a better future.

NOTES

1 G. A. Ritter, 'Workers' culture in Imperial Germany', *Journal of Contemporary History*, 13 (1978), pp. 165–89 at p. 180.
2 H. Mommsen, *Sozialdemokratie zwischen Klassenpartei und Volkspartei* (Frankfurt, 1974).
3 On the relationship of the middle class and the SPD see a series of articles (1928–32) by Theodor Geiger, mainly in *Die Arbeit*, the monthly theoretical publication of the German trade unions.
4 See *Typografische Mitteilungen* (1921), p. 8.
5 F. Schelzig, 'Kunstempfinden', *Proletarische Jugend*, 5 (1920).
6 E. Mai, *Kunstpolitik und Kunstförderung im Kaiserreich* (Berlin, 1982), p. 89.
7 See J. Campbell, *The German Werkbund* (Princeton, 1987).
8 C. Rülcker, 'Arbeiterkultur und Kulturpolitik im Bildwinkel des Vorwärts', *Archiv für Sozialgeschichte* (1974), pp. 115–55 at p. 128.
9 S. Günther, 'Arbeitsmöbel', in *Werkbund Archiv*, 3 (Berlin, 1978).
10 W. Gropius, in *Das Hohe Ufer*, I (1919), p. 180.
11 S. Von Wiese, *Grafik des Expressionismus* (Stuttgart, 1972).
12 For 'Poennecke' see among others Conrad Felixmüller, *Werke und Dokumente* (Klagenfurt, n.d., *c.* 1985).
13 'Offener Brief an die Novembergruppe' in U. M. Schneede, *Die Zwanziger Jahre: Manifeste und Dokumente Deutscher Künstler* (Cologne, 1979), pp. 92–101.
14 On George Grosz see L. Fischer, *George Grosz* (Reinbeck, 1976).
15 On Seiwert and the Political Constructivists see among others H. U. Bohnen, *Das Gesetz der Welt ist die Aenderung der Welt: Die Rheinische Gruppe Progressiver Künstler 1918–1933* (Berlin, 1976).
16 See G. Arntz, 'Der Ludergeruch der Revolution: Gerd Arntz – der unbekannte Meister der Arbeitergruppe', interview in *Aesthetik und Kommunikation*, 29 (1977), pp. 4–19.
17 H. Olbrich, *Sozialistische Deutsche Karikatur* (Berlin, 1979).

18 Grosz regarded Rowlandson as the caricaturist with whom he wished to be compared.

19 See K. A. Wittfogel, 'Zur Frage einer marxistischen Aesthetik', *Aesthetik und Kommunikation*, 3 (1971) (originally published in 1930 in *Die Linkskurve*).

20 The effect on the art and practice of Communist photographers of new trends in photography arising from the *Neue Sachlichkeit* was noticed and commented on. See the relevant discussion in Chapters 6 and 8.

21 'Durus', i.e. the Hungarian-born Alfred Kemenyi, was the leading Communist critic in the visual arts.

22 Kollwitz was herself at times uncertain where her political loyalties lay. See among others R. Hinz, 'Bemerkungen zu Käthe Kollwitz', *Wem gehört die Welt* (exhibition catalogue), Zentrales Partei Archiv (Berlin, 1977), pp. 258–62.

23 'Durus', 'Die Woche der Arbeiterzeichner', *Rote Fahne* (3 March 1931).

24 M. Adler, *Der Sozialismus und die Intellektuellen* (Vienna, 1910).

25 On the aesthetic value of folk art see comments in *Der Blaue Reiter* (Munich, 1912). Reprinted with comments by Klaus Lankheit, 1965 and later.

26 There is a link here with some of the ideas for dress and utensils developed by the youth movement which went back to older 'folk' forms and customs.

27 See Zentrales Partei Archiv 2/707/7 and I/2 2/1.

Artists featured in five socialist or Communist periodicals 1918–32

	AIZ	FW	KW	ES	V&Z
Altenkirch, Otto					√
Baluschek, Hans (1870–1935)	√	√	√		√
Böcklin, Arnold (1887–1908)					√
Bruegel, Peter the Elder (1525–69)		√		√	
Busch, Wilhelm (1832–1908)	√		√		
Cézanne, Paul (1839–1925)		√			
Corinth, Lovis (1858–1925)		√			
Courbet, Gustave (1819–77)		√	√	√	√
Crane, Walter (1845–1915)			√		
Daumier, Honoré (1808–79)	√	√	√	√	√
Delacroix, Eugène (1798–1863)		√		√	
Dix, Otto (1891–1964)	√				
Dürer, Albrecht (1471–1528)			√		√
'Fidus' (i.e. Hugo Höppner) (1868–1948)			√		
Geiss, Karl (fl. 1920s)				√	
Götsch, Hans				√	
Goya, Francisco (1746–1828)	√	√		√	
Greiner, Otto (1869–1916)			√		
Griebel, Otto (1895–1972)	√				
Grosz, George (1893–1959)	√	√	√	√	
Hasse, Sella (1878–1963)	√	√	√		√
Heartfield, John (1891–1968)				√	
Hodler, Ferdinand (1853–1918)			√		
Holtz, Karl (1899–1977)		√			
Jaeckel, Willy (1888–1944)		√	√		
Jørgensen, Aksel (1914–73)				√	
Klinger, Max (1857–1920)			√		
Kollwitz, Käthe (1867–1945)	√	√	√	√	√
Kubin, Alfred (1877–1959)		√			
Leibl, Wilhelm (1844–1900)		√			√
Liebermann, Max (1847–1935)		√	√		√
Marees, Hans von (1837–87)		√			
Masareel, Frans (1889–1972)	√	√	√	√	
Meidner, Ludwig (1884–1966)		√			
Menzel, Adolf (1815–1905)		√			
Meunier, Constantin (1831–1905)				√	√
Millet, Jean François (1814–75)				√	
Minor, Robert				√	
Modersohn, Otto (1865–1943)					√

	AIZ	FW	KW	ES	V&Z
Morgnes, Wilhelm	√			√	
Münzer, Käthe (1877–?)					√
Murillo, Bartolomeo (1617–82)		√			
Nagel, Otto (1894–1967)	√				
Österle, E.					√
Raemaker, Louis (1864–?)		√			
Rembrandt van Rijn, H. (1600–69)		√			
Reni, Guido (1575–1641)		√			
Reimann, A. J.			√		
Richter, Ludwig (1803–84)		√			
Rivera, Diego del (1886–1957)		√			
Robbia, Luca della (1400–82)			√		
Rodin, Auguste (1840–1917)		√	√		√
Schneider, Hermann					√
Scholz, Georg (1890–1945)				√	
Schönbauer				√	
Schrag, Martha (1875–1957)			√		
Schwimmer, Max (1895–1960)			√		
Steinert, Martin (1902–60)		√			√
Steinlen, Théophile (1859–1923)	√	√		√	√
Stern, Ernst (1876–1960)		√			
Thoma, Hans (1839–1924)		√	√		
Tombrok, Hans (1895–1966)	√		√		
Trump, Karl (1891–?)					√
Van Gogh, Vincent (1853–90)		√	√	√	
Weinhold, Kurt (1896–1905)				√	
Wernicke, K.			√		
Wunderlich, Paul		√			
Zeller, Magnus (1883–1972)		√			
Zille, Heinrich (1858–1971)	√			√	√

KEY

Artists given without dates all worked in the Weimar period.

AIZ *Arbeiter Illustrierte Zeitung* (1924–33) Published by the Neuer Deutscher Verlag under the direction of Willy Münzenberg. Communist in tendency.

FW *Freie Welt* (1918–22), weekly paper published by the USPD.

KW *Kulturwille* (1924–33), social democratic monthly published by the Leipzig Arbeiter Bildungs Institut.

ES *Eulenspiegel* (1928–31), fortnightly satirical magazine published by the Communist Party. Successor to *Der Knüppel.*

V&Z *Volk und Zeit* (1921–33), illustrated weekly supplement to social democratic daily newspapers. Published at times in regional editions with differing text and/or illustrations.

1919

Exhibition of works by Berlin artists in schools in East Berlin arranged by city author-
ities (*Sozialistische Monatshefte*, 2 (1919), p. 1108; *Volk und Zeit* (21 September
1919))

General art exhibition organised by Genossenschaft (Bund) sozialistischer Künstler
in various locations in Berlin, including the AEG factory in the Brunnenstrasse
(*Sozialistische Monatshefte* (1919), p. 675; *Volk und Zeit*, 137 (1919), p. 8)

Expressionist paintings from the Sturm Gallery shown in Haus der Proletarischen
Jugend, Petersburgerstrasse, Berlin (*Freiheit*, 11 July 1919)

Naturfreunde organisation showed works produced by workers (*Freiheit*, 23 February
1919)

Exhibition '*Für das werktätige Volk*' in Cologne Kunstgewerbemuseum

1920

Exhibition by socialist artists in Vorwärts bookshop in Berlin (*Volk und Zeit*
(5 December 1920))

'*Arbeiter-Kunstausstellung*' organised by Arbeitsrat für Kunst in the Galerie Friedrich
in the Haus der Proletarischen Jugend, Petersburgerstrasse, Berlin (*Arbeitsrat für
Kunst* (exhibition catalogue) (Berlin, 1980), p. 82; *Sozialistische Monatshefte*
(1920), p. 64; *Freiheit* (5 January 1920); *Cicerone* (1920), p. 116)

1921

'*Arbeiter-Kunstausstellung*' in the Galerie Friedrich, Haus der Proletarischen Jugend,
Petersburgerstrasse, Berlin (*Volk und Zeit* (3 April 1921))

1922

Christmas exhibition in Berlin Gewerkschaftshaus, organised by trade unions (*Volk
und Zeit* (17 December 1922))

'International Exhibition of Revolutionary Artists' in the Haus der Proletarischen
Jugend, Petersburgerstrasse, Berlin (see Chapter 6, note 3)

'*Arbeiter-Kunstausstellung*' in the Galerie Friedrich, Haus der Proletarischen Jugend,
Petersburgerstrasse, Berlin (*Sozialistische Monatshefte* (1922), p. 66)

1924

'*Grosse Solidaritäts Ausstellung*' in Wertheim Department Store, Berlin Alexanderplatz,
organised by Otto Nagel and the Künstlerhilfe of the IAH (Nagel, *Mein Leben*

(Berlin (1952), p. 33, *Brot und Not*, 29/30 (1924), reprinted in *Wem gehört die Welt* (exhibition catalogue), Zentrales Partei Archiv, p. 310). About five hundred works were shown and about 250 sold for the IAH

Exhibition '*Der Kampf*', organised by Gert Wollheim in Kunsthalle Düsseldorf (see J. Krempel, *Das Junge Rheinland* (Düsseldorf, 1985); text of catalogue by G. Wollheim)

Exhibition by the Rote Gruppe, '*Wir schaffen für Euch*' in Dresden (*Kunstblatt* (1924), p. 61; *Revolution & Realism*, section on *Künstlerbiographien*, p. 46, article on Johansson)

Exhibition at Leipzig Kunstverein in connection with *Sozialistische Kulturwoche* (see account in Chapter 6)

1925

Exhibition in connection with *Proletarische Kulturwoche*, Gotha (W. Lindemann, *Die Proletarische Freidenker Bewegung*, 1926, p. 64)

Exhibition in connection with *Kulturwoche*, Gera (see *50 Jahre Leipzig ASSO* (1979), p. 11)

1926

Otto Nagel's '*Volkstümliche Kunstschauen*' in various department stores in Berlin. Some of the exhibits were subsequently shown in the exhibition '*Proletarische Kunst und Anti-Kriegsausstellung*'. See below. *Wem gehört die Welt*, p. 171; *Rote Fahne*, 18 February, 12 March, 6 May, 22 June, 31 August, 3 September, 9 October 1926

'*Proletarische Kunst und Anti-Kriegsausstellung*', organised by Rote Frontkämpferbund in ULAP (Urania Landesausstellungspark) (*Rote Fahne*, 31 August, *Welt am Abend*, 4 September 1926) (model for similar exhibitions in other cities)

1927

Exhibition arranged by Deutsche Kunstgemeinschaft in Berlin-Neukölln and elsewhere in Berlin

Exhibition '*Das Wochenende und die Bildende Kunst*' in Berlin, Märkisches Museum, organised by Baluschek and supported financially by ADGB (ADGB, District Berlin, Report [*Geschäftsbericht*] (1928), p. 126)

Exhibition by Kunstgemeinschaft in Hamburg Gewerkschaftshaus (photograph in *Volk und Zeit* (December 1927))

1928

Exhibition of '*Soziale Kunst*' organised by Bezirksamt Lichtenberg, Berlin (mentioned in Otto Nagel, *Berliner Bilder* (Berlin, 1955) and E. Frommhold, *Nagel* (Berlin, 1974), pp. 141–2)

1929

ASSO exhibition '*Kapital und Arbeit in der Bildenden Kunst*' in Berlin Europahaus (*Welt am Abend*, 6 May 1929; *Kunst im Klassenkampf* (exhibition catalogue) (Berlin (DDR), 1988), p. 94)

Exhibition on theme of Peace and War organised by Bund der Kriegsgegner in Leipzig, Dresden, Munich, Erfurt, Zwickau (*Kulturwille* (1929), p. 12; Hütt, *Bildende Kunst* (1962), p. 224)

1930

Exhibition by the Freie Bildungskartell, Hannover, '*Die Welt der Werktätigen in Buch und Bild*' (*Sozialistische Bildung* (1930), p. 377)

Exhibition '*Kunst, trotz alledem*' organised by Education Committee of Hamburg SPD in Kunsthalle. A small exhibition of photographs by members of the Arbeiter Foto Gilde was attached (*Hamburger Echo* (December 1930), passim)

Exhibition '*Rote Kunst, Rotes Kabarett*' in Berlin-Wedding (*Rote Fahne*, 192 (1930))

1931

Anti-war exhibition organised by Bund der Kriegsgegner in Leipzig and elsewhere

Frauen in Not touring exhibition, organised by magazine *Weg der Frau* starting in Berlin in the Haus der Juryfreien 9 October to 1 November 1931 (see Thierse, *Proletarische und Revolutionäre Kunst*, 197. p. 134; *Magazin für Alle* (October 1931); *Sozialistische Monatshefte*, 1 (1931), p. 104)

ASSO exhibition of all the works by its members originally exhibited in the 'Grosse Kunstausstellung' in Berlin, following the removal of some by the police

ASSO started a series of six exhibitions of works by ASSO artists on theme of '*Künstler im Klassenkampff*'. Apparently only four were staged. Subjects: *Der proletarische Zeichner als Explorer*; *Die satirische Pressezeichnung*; *Photomontage und Buchgraphik*; *Revolutionäre Bildmontage*

Exhibition of works by Käthe Kollwitz in Wedding district of Berlin, organised by Otto Nagel. Very successful (Nagel, *Leben, Werk und Wirken* (Berlin, 1932))

1932

ASSO exhibition of all works by its members following the removal of forty-one from the Berlin '*Grosse Kunstausstellung*' (as 1931)

Index

Note: page references in *italics* refer to illustrations.